SLOGAN T-SHIRTS
CULT AND CULTURE

Andy Warhol's
BAD

SLOGAN T-SHIRTS
CULT AND CULTURE

STEPHANIE TALBOT

B L O O M S B U R Y
LONDON • NEW DELHI • NEW YORK • SYDNEY

First published in Great Britain 2013
Bloomsbury Publishing Plc
50 Bedford Square
London WC1B 3DP
www.bloomsbury.com

ISBN: 9781408157541

A CIP catalogue record for this book is
available from the British Library

Stephanie Talbot has asserted her rights under
the Copyright, Design and Patents Act, 1988,
to be identified as the author of this work.

Publisher: Susan Kelly
Design: Evelin Kasikov
Photographer (unless otherwise stated): Richard Reyes
Managing editor: Davida Saunders
Copy editor: Judy Tither
Proofreader: Julie Brooke

Typeset in 9 on 12.5 pt Bliss Light

This book is produced using paper that is made
from wood grown in managed, sustainable forests.
It is natural, renewable and recyclable. The logging
and manufacturing processes conform to the
environmental regulations of the country of origin.

Printed and bound in China

Where garments are uncredited they are from the
author's own collection. The author has made every
effort to contact copyright holders as appropriate.
In the event that these attempts have been
unsuccessful, please contact the publishers who
will be happy to correct any errors or omissions
on reprinting.

Frontispiece and inside back cover t-shirts author's
own · Model: E-Sinn Soong

Acknowledgements

First and foremost this book has been a team effort. Sincere thanks to every single person who has made a contribution.

I would like to thank Susan Kelly who commissioned the book and has been a source of much appreciated encouragement - honestly, I cannot thank you enough Susan. Also, thank you to my editor Davida Forbes who has been nothing less than terrific!

A zillion personal thanks to Richard Reyes for being such a dream photographer to work with – everyone commented how you put them at ease and what a delight it was to work with you. May I also take this opportunity to say what a valued friend you are.

A huge thanks to Evelin Kasikov whose design prowess has brought this book alive.

Thank you also to all my creative soulmates – your unrelenting support has been astonishing: Alex Papadakis, Emma Day, E-Sinn Soong, Fiona Cartledge, Ian Stallard, Kevin Chow, Liz Thompson, Patrik Fredrikson, Reem Charif, Scott Maddux, Silvia Ricci, Victoria Ophield, Yvonne Courtney, Zach Pulman and Annick Talbot.

Both Julian Vogel and Kenneth Mackenzie have been so damn brilliant throughout – your generosity has been overwhelming (thank you!).

Last but by no means least, I am deeply grateful to all the following: Albert Kang, Amy Thompson, Eric Rose, Gosia Cyganowska, Greg Davis, Heather Holden-Brown, John Dawson, Kate Monckton, Lindsay Freeman, Mark Moore, Martin Bull, Odilo Weiss, Sebastian Boyle, Tyen Masten and Yu Ling Huang.

Many thanks to all those who kindly supplied T-shirts for our centrepiece spread 'The Gendered, The Technological, The Questionable and The Marvellous 'n' Miscellaneous'.

Amy and Claire at Truffle Shuffle • *www.truffleshuffle.co.uk*
Bethan Wood • *www.woodlondon.co.uk*
Carol at Force 18 T-shirts • *www.force18.co.uk*
Charli at the National AIDS Trust • *www.nat.org.uk*
Christian at Anonymous • *www.designers-anonymous.com*
Daniel at Red Mutha • *www.redmutha.com*
Eike at Spreadshirt • *www.spreadshirt.co.uk*
Emily at Respect For Animals • *www.respectforanimals.co.uk*
Heather and Jane at MoreTvicar • *www.moretvicar.com*
Ian and Patrik at FredriksonStallard • *www.fredriksonstallard.com*
Jerry at Lazy Oaf • *www.lazyoaf.com*
Jon at Magma Books; • *www.magmabooks.com*
Kevin at Spamshirt • *www.spamshirt.com*
Lavinia at T-Shirt Town • *www.tshirt-town.com*
Mark at Mash Creative • *www.thisisourshop.com, www.mashcreative.co.uk*
Richard and Jo at 8 ball • *www.8ball.co.uk*
Robin at A-non Brand • *www.a-non.co.uk*

Extra thanks to Matt Snow

This book is dedicated to Sam Bully.

Part One: Commentators

Part Two:
Designers

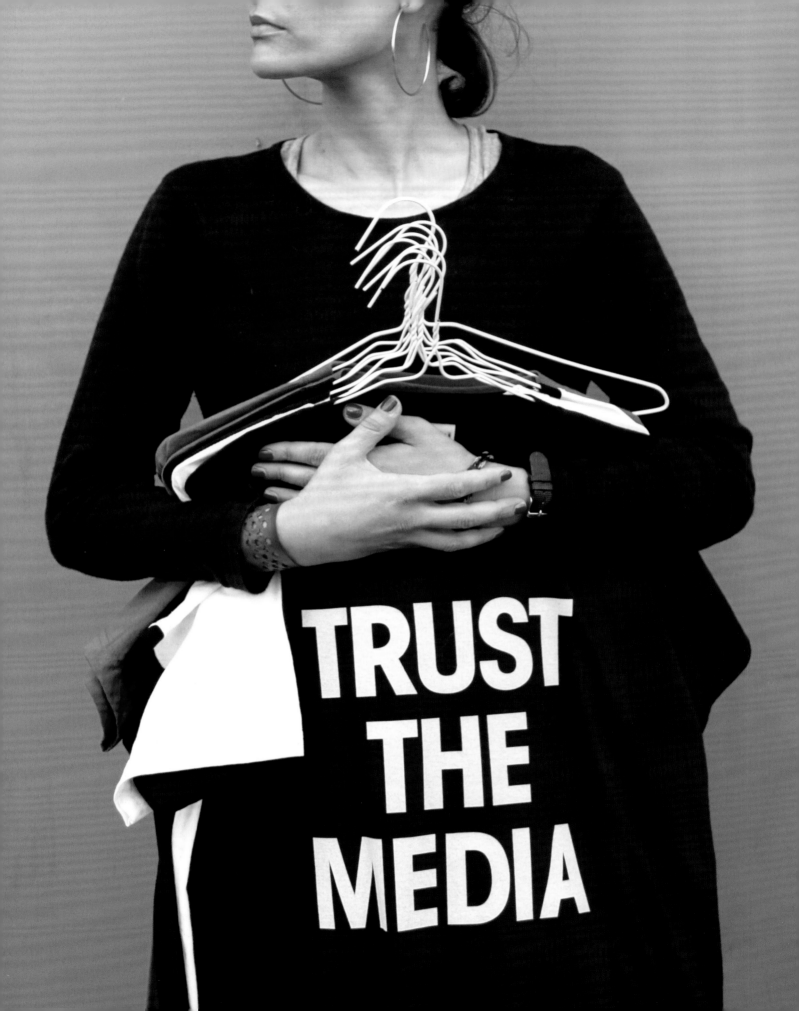

Introduction

Rural Ghana. Early 2002. It has taken a five-hour wait beside a dirt track in debilitating heat for a bus to arrive to take me 50 kilometres to the nearest market. Once at my destination I am bewildered by the sight of several people wearing T-shirts featuring Osama Bin Laden with a bold 'I heart' above his face. I soon learn this is a militant, extremist Islamic region where anti-capitalist expressions are revered and the protagonist of America's emotional and fiscal collapse is claimed as a figure of worship. Almost every corner I turn has stalls selling pro-Bin Laden tees... Back in London, the 'I heart' is replaced by a more cautionary 'Wanted'. These diametrically opposed encounters exemplify the slogan T-shirt's cultural currency; its ubiquitous power to position oneself and connect, and likewise disconnect, with others is potent.

Fast forward to London 2011. I am about to interview someone for this book. We have never met. A figure walks towards me, but before I see the man I see his T-shirt. It is red with the classic visual of the First World War militaristic face of Lord Kitchener pointing outwardly, but replacing the patriotic overtones of 'Your Country Needs You', are the words 'You're a Twat'. My first impressions of the interviewee are coloured. Not only is the interview itself empty and prosaic, but I cannot vanquish my distaste for his T-shirt. Conclusively, subjectively, evidently, the slogan T-shirt is not *just* a printed piece of fabric, it's an emotive and vigorous item of clothing that carries and conveys values. Words, however trivialised, are never simply 'only words' and that is what is central to the power of the slogan T-shirt.

On first contact a slogan T-shirt appears as a candid form of self-expression. However once you start to investigate its role as an emblem of political, social, cultural, recreational and sartorial trends its complexity becomes apparent. *Slogan T-shirts: Cult and Culture* explores the many incarnations of the slogan T-shirt, examines how it operates as a message delivery system and engages with the slogan T-shirt as both a sartorial item and a multifaceted artefact. Each interview in the book operates as a cultural snapshot within the versatile framework of slogan T-shirt culture. In spite of this, the book is neither a chronology nor a historical critique, although it does draw on the slogan T-shirt's recent historical past. Neither is it a definitive exploration into the slogan T-shirt revolution; given the multitude of slogan T-shirts that are produced, to achieve that would be to compose a book that challenges Marcel Proust's *In Search of Lost Time!*

Rather, *Slogan T-shirts: Cult and Culture* performs as a conduit for the slogan T-shirt's many different forms of embodiment, its contexts, subtexts and anecdotal qualities. In essence, the book unfurls as a cultural library of perspectives, nuanced positions and eclectic sources. To all intents and purposes, slogans behave as signifiers of social meanings and *Slogan T-shirts: Cult and Culture* has been devised as a compendium of those meanings.

But that's not to negate the slogan T-shirt's surface impression because it is this that

T-shirt: 'Trust the Media', kindly supplied by 8 ball; www.8ball.co.uk

exposes the meanings underneath. The visuals in this book alone demonstrate the wide spectrum of creative, commercial, political and ideological practices that employ the slogan T-shirt. In a number of cases the accompanying narratives do not labour the point over slogans but reveal the reasons that support the interviewees' relationships with slogan T-shirts. As social commentator and co-director of independent record label, only lovers left alive, Sam Bully posits: 'The best designers understand the medium they are dealing with which is a piece of clothing, they understand the nature of it being temporary, which is ultimately disposable, to wear a slogan T-shirt is to express a lifestyle.'

Slogan T-shirts: Cult and Culture also glances into the inner worlds, inside stories and mechanisms of those involved in the orbits of fashion, design and the production of media. The common thread that unites why many T-shirt designers and enthusiasts choose this item of apparel as their preferred mode of communication is the memory of either their first T-shirt or their favourite T-shirt. Many of the narratives emerge as lived experiences of T-shirt culture; T-shirts seem to hold an immediacy that triggers memories of time, place, people and belonging and the prevailing tastes of a given period. Several of the interviewees addressed the nature of DIY practices from their adolescence, however DIY practices no longer seem so prevalent, perhaps reflecting a dictatorial consumer culture where the price point begins at an increasingly affordable level. Consumption habits and the rapid cyclical nature of fashion and trends often result in people replacing their T-shirts and their DIY creations as soon as they are either out of favour or can afford a replacement. It is this that gives the slogan T-shirt expression, albeit, a sometimes temporary one.

Whilst countless slogan T-shirts have a lifespan either as fashion timepieces or as markers of the zeitgeist, the popularity of many revolve in cycles and a high proportion transcend the dynamics of time achieving a sense of longevity or even iconic status, thus elevating their worth as collectables.

Historical and cultural moments have been mapped on slogan T-shirts including political rhetoric, social conditions, epic events and popular culture vignettes. As the Vexed Design (formerly Vexed Generation) duo remark, slogan T-shirts reflect a natural change of values and are therefore often attributed with a temporal importance principally because, 'culture changes over time ... the slogan T-shirt's relationship to culture is one that has a dual connection with its audience since it can function as an item that serves its purpose "apposite at the time" [yet] a good slogan can last over time.'

What is interesting is that the majority of the interviewees in this book creatively endorsed the slogan T-shirt as a means to articulate personal concerns; many of which are mutually shared, whilst some may even enter the lexicon of cultural concerns such as fury at both national and world politics and the homogenised nature of commodification. So although resistance to the slogan T-shirt does occur (some of the interviewees express counter positions too), depending on content and intention, the slogan T-shirt as social capital no longer sees its concept as flippant or shallow.

Inevitably, when creativity and reason, in whatever format they manifests as, are released into the public domain their reception and interpretation are beyond the control of their founder; often the visual characteristics overshadow objectives and connotations. Whilst most of the T-shirt designers interviewed in this book recognised that many of their customers bought their T-shirts purely for their aesthetic qualities, it is worth considering that a personal investment in clothing is a personal investment in constructing one's self and social identity. The overt nature

9-11-01 5-1-11

WE DIDN'T FORGET!

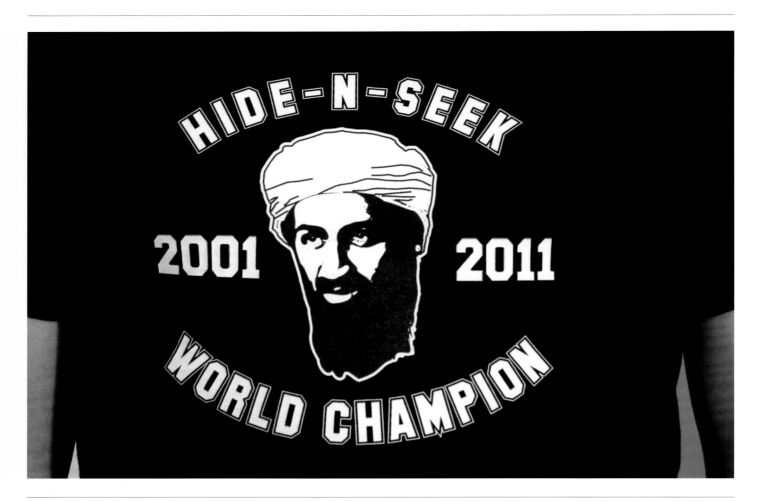

of words on a T-shirt — even if those words allude to opacity — signal outwardly a projected self.

In 1964 philosopher and media theorist Marshall McLuhan coined the term 'The medium is the message' to denote the symbiosis between medium and message. Despite McLuhan's 'medium' influencing how the message is received, in terms of the slogan T-shirt, whilst this aphorism applies, it is perhaps more appropriate to transpose the operative words, ergo 'The message is the medium'. Beyond themes of self-expression, why do people voluntarily wear text across their chest? More so when one considers clothing as an extension of the person, which sees the triumvirate of clothing, body and demeanor fused via the explicit use of language positioned at people's line of vision, and however innocuous or ambiguous the message the play on words suggests, its very suggestion is, arguably, non-negotiable.

In effect the T-shirt surface can be likened to an exhibition space; one that generates a discursive and comparative space in response to the culture we inhabit, so to assert oneself so visibly is rarely accidental. One only has to look at the plethora of celebrities who use the seductive properties of the slogan T-shirt as a media tool to broadcast their thoughts to the press.

In 2005 the socialite Hilton sisters professed their individual alliances to the feuding Hollywood actresses Jennifer Aniston and Angelina Jolie through their 'Team Aniston' (worn by Nicky Hilton) versus 'Team Jolie' (as worn by elder sister Paris), whilst Eva Longoria declared 'I'll Have Your Baby Brad' across her chest in the same year. Three years later, in 2008, Longoria's T-shirt read 'I Want More Privacy!'; no further comment necessary! During the 2000 US presidential election, Hollywood A-listers and best friends Cameron Diaz and

Drew Barrymore wore matching T-shirts on MTV's highly-viewed programme *Total Request Live* declaring 'I Won't Vote for a Son of Bush', four years later rap artist and record producer P. Diddy encouraged the American population 'To Vote or Die'. Back in England Alexander McQueen showed his support towards seemingly 'disgraced' supermodel Kate Moss wearing a T-shirt emblazoned with 'We Love You Kate' as he took his catwalk bow in 2005.

Fashion as both an industry and as a creative sector is often undermined within the hierarchy of cultural industries. However fashion is not only a cultural resource embedded in popular culture, but *is* popular culture itself. Categorically, whether or not one is in favour of slogan T-shirts, their power as a messaging tactic and a carrier of knowledge is compelling. The reasons for this are exhaustive. The slogan T-shirt's ability to multitask several roles at once is formidable. Frequently people use clothes to establish credibility and whilst wearing a slogan T-shirt is a public display of one's social inclinations and allegiances, its competence as a personal branding medium is also an effective source in which to divulge fragments of one's self-identity. Within the pages of *Slogan T-shirts: Cult and Culture,* the slogan T-shirt emerges as a *tour de force* for its capacity to highlight personal beliefs, announce cultural points of view, endorse politicised content, motivate social rebellion and non-conformist values, declare one's affiliations with the 'transgressive' or a particular group ideology, circulate colloquial language, expose personal status and lifestyle choices, refer to one's achievements, mobilise trends, play with pop values, transport levity from one milieu to another, flaunt innovative artwork and design ideas, identify with kindred spirits through exposing one's taste, court recognition and social approval by other wearers of similar statement T-shirts, and let us not overlook its decorative merits ... ultimately the slogan T-shirt is a personal souvenir. Imbued by symbolic significance, the slogan T-shirt wearer can become their own maker of cultural meaning through its adoption. Cultural commentator Shumon Basar sees the role of language as an inseparable corollary of clinical therapy and advertising: 'In order to sell someone something they don't need you to understand the mind that is being sold to, what their fears and hopes and dreams and nightmares are.'

Although originally worn as an undergarment, the T-shirt has since become a sartorial item that features in most people's wardrobes, even if it is used as was originally intended. Spanning all ages, part of the T-shirt's appeal, as Vexed Generation share, '[is that] the individual can be spontaneous and free about their purchase because of the relatively low cost.' However, since the T-shirt's price tag stretches from economical to exclusive the traditional notion of it being 'classless' invalidates this notion.

During the entire process of writing and researching this volume, one line of argument has consistently accompanied the book's premise and that is, 'what constitutes a slogan on a T-shirt?' Can a single letter of the alphabet, a single word, a random series of words, a person's name, a brand name all qualify as a slogan? Or is it cheating? This has been contested and challenged and my own definition, as the following pages confirm, is rather elastic, as supported by my opinion that intonation animates speech. Yes. Yes? Yes!

Slogan T-shirts: Cult and Culture is a compilation of slogan T-shirt stories that spans the controversial to the cavalier. Fundamentally this book sees the T-shirt as an artefact of language, surrendering to slogan culture. As 6876 designer Kenneth MacKenzie carefully reflects: 'A slogan T-shirt is a reaction ... other [T-shirts] are merely words,' whilst interior designer and design expert Scott Maddux asserts: 'If you wear a slogan T-shirt, *be* the slogan!'

Part One

GLENN ADAMSON
The slogan T-shirt as a postmodernist device

SAM BULLY
John Lennon and Yoko Ono's use of slogans on T-shirts

JON SAVAGE AND JAMIE REID
Punk's use of slogans on T-shirts

DR MATTHEW WORLEY
The slogan T-shirt as a subcultural tactic

SHEHNAZ SUTERWALLA
The slogan T-shirt as a site of resistance

ERIC ROSE
Vivienne Westwood enthusiast

HOLLY JOHNSON
Frankie Goes To Hollywood frontman

CHRIS SANDERSON AT THE FUTURE LABORATORY
The slogan T-shirt as a lifestyle tool

CHRIS COLEMAN AT WGSN
The slogan T-shirt's relationship to trends and appropriation

JULIAN VOGEL AT MODUS PR
The slogan T-shirt as a marketing tool

NEIL BOORMAN
The slogan T-shirt's relationship to branding

SCOTT MADDUX
The cult value of the slogan T-shirt

SIMON LEE AT SIMON LEE GALLERY
The relationship between the slogan T-shirt and high art

LARISSA CLARK AT EJF
The slogan T-shirt as a campaign tool

SHUMON BASAR
The slogan T-shirt as a political tool

HOWARD BESSER
Political slogan
T-shirt collector

DR MATT COOK
The slogan T-shirt's
relationship to
queer
culture

DR CLARE ROSE
The morals of
language
on slogan T-shirts

**FIONA
CARTLEDGE**
The presence of
female empowerment
on slogan T-shirts
during the '90s

**DANIEL
PEMBERTON**
The presence of
dance music on
slogan T-shirts
during the '90s

**PHILIP DE
MESQUITA**
T-shirt
entrepreneur and
former Camden
Market vendor

**ROBIN BENNETT
AT A-NON
BRAND**
The slogan T-shirt's
presence on the
festival circuit

MARK WIGAN
The slogan T-shirt's
relationship
to club culture

**ROGER BURTON
CONTEMPORARY
WARDROBE**
The vintage value
of the slogan
T-shirt

**MICHAEL
KOPELMAN
AT GIMME 5**
Stüssy T-shirts

**NAMALEE BOLLE
AT SUPERSUPER!**
BOY T-shirts

**NAVAZ
BATIWALLA
AT DISNEY-
ROLLERGIRL**
Martin Margiela
T-shirts

**ALEX FURY AND
PAUL
HETHERINGTON
AT SHOWSTUDIO**
The downloadable
T-shirt project

**ZACHARY
PULMAN**
The Tourist T-shirt

MATT SNOW
A visual chronicle
of the
screenprinting
process

Glenn Adamson

The slogan T-shirt as a postmodernist device

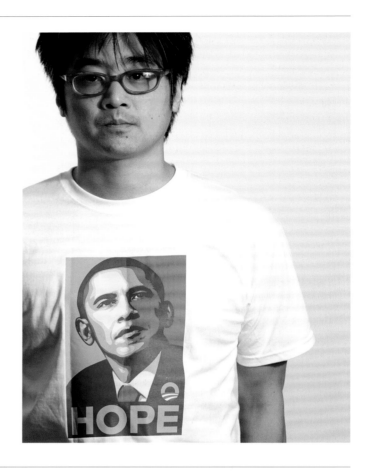

'We live in a world
of reproductive media,
so it makes sense the idea
of transporting letters
from the page to the body.'

'I tend to think about postmodernism as a stylistic tactic that expresses or responds to modernist conditions,' posits design historian Glenn Adamson, whose role at the V&A Museum as Deputy Head of Research and Head of Graduate Studies has seen him also co-curate the seminal postmodernism exhibition *Postmodernism: Style and Subversion 1970 to 1990*. 'So you could think of certain things as being postmodernist, for instance, architecture and clothing design, and that's quite conscious, and then there's postmodernity as an overarching condition of life and that's where you get things like hypercapitalism and mediation which happen because of the economy or collective behaviour … but I think that the slogan T-shirt seems to strategically respond to the condition of postmodernity in the sense that it is a personalised version of soundbite culture, and the slogan T-shirt is always both a visual presentation of style and language.'

Postmodernism. A movement that began in the 1970s challenging its modernist antecedent's loyalty to purity, austerity and harmony. An era that spanned two decades, and two decades after its expiration its legacy continues to permeate Western daily life.

The postmodernism universe broke modernism's rules to establish new capitalist values, cultural codes and eclectic visual cues that often saw discordant, yet innovative, results. Authenticity and depth were substituted for reproducibility, fluidity, artifice, acceleration, hedonism and a culture that placed a premium on surface engagement. An era that created a new critical language that fragmented and collaged together its historical past resulting in a destabilised and sometimes schizophrenic present. A present that embraced mass appeal whilst juxtaposing highbrow, mainstream and pop cultural characteristics. A paradigm that favoured simulation; where meaning was flexible and therefore was open to interpretation and transformation. Speed-driven and all-embracing, postmodernism's processes regularly operated without the restriction of fixed rules.

Postmodernist themes were symptomatic of a commodity culture and capitalist ideals that saw excess and exaggeration manifest in numerous domains such as branding, advertising, business and wealth fashions … Conclusively, style was a lifestyle.

According to Adamson to help one understand

if something is postmodern is to ask whether it departs from or subverts something that one would associate with modernism: 'For instance, the last thing modernists would have done would have been to put language on clothes because the clothing was supposed to work *as* clothing. Modernism was very formalist, but what happens in the case of the slogan T-shirt, as a postmodern device, is it moves away from the form and instead becomes a matter of labelling.'

Rather ingeniously Adamson likens post-modernism to a cartoon character with a thought bubble coming out of its head, thus framing the slogan T-shirt *also* as a thought bubble on account of its metacommentary of 'here is what I'm thinking, I don't even have to say it'. 'That's one way I think of the slogan T-shirt as being intrinsically postmodern,' he

notes. Equally, Adamson correlates the slogan T-shirt to that of a delivery system; a message is defined and then sublimated, yet on the other hand it operates as a focal point from a production story perspective and together those factors ultimately merge to form something effective and communicative.

Adamson attributes the quick-cut nature of soundbite culture and print media as open strategies that nourish the slogan T-shirt's consistency with many other patterns associated with postmodernist practices. He cites the cut-and-paste techniques first pioneered in magazines, and then adopted by the culture of MTV, as methods that ultimately anticipate the media explosion of the '80s and '90s. Adamson elucidates: 'What happens on news programmes in the '80s and '90s is

you go from a quite in-depth model of news reporting which is relatively expansive to news bulletins that have a quick turnaround of snappy soundbites ... that ever increasing rate of experience is also seen on MTV or in an '80s film ... It's all about the speed and of course speed is one of the characteristic things in modernity and postmodernity. For me, the slogan T-shirt is a way of owning that idea of the soundbite or "particulate" rather than a long experience.'

Adamson's position also approaches the slogan T-shirt in relation to other fields such as art, architecture, magazines et al. 'The graphic designer Peter Saville said to us that record design, posters and music videos were the primary mechanism by which postmodernism got into the heads of the public. But it is

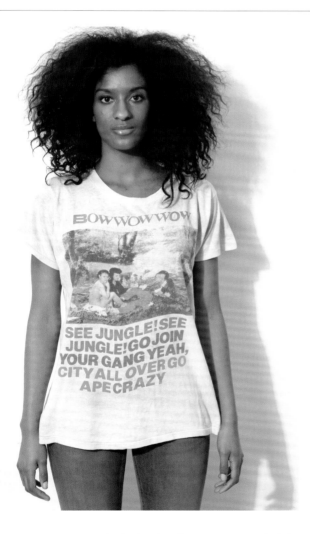
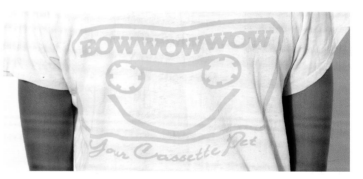
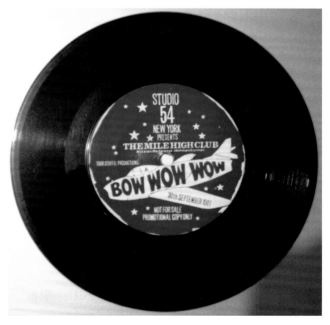

Above: Sam Bully's own 'Bow Wow Wow' T-shirt, bought at their gig in 1981 at London's The Lyceum. He says: 'The T-shirt came free with a promotional single, *The Mile High Club* – the track was unreleased. Even at that time the T-shirt was collectable. They sold it in the shop [Worlds End] later on to coincide with the release of their first album *See Jungle! See Jungle! Go Join Your Gang, Yeah. City All Over! Go Ape Crazy*. The album cover and T-shirt were art-directed by Malcolm McLaren and utilised the Situationist tactic of détournement: a re-creation of prominent imagery or theory to convey new meaning, often mimicking the original. McLaren reinterpreted the legendary composition of Impressionist Édouard Manet's 1863 painting, *The Luncheon on the Grass (Le déjeuner sur l'herbe)* in a purely postmodernist parody'. Models: Albert Kang and Lindsay Freeman

architecture – a very academic, a very in-house architecture – where postmodernism's story begins before it circulates in the '70s and affects other disciplines.'

However, as Adamson identifies, postmodernism's visual repertoire really developed after its initial architectural period. 'Music artists such as Grace Jones, Talking Heads, and Joy Division, to name just a few, become conduits for postmodernism's proliferation as do the graphics associated with the music industry, especially the style press like *i-D* and *The Face*. For instance, if you think about *The Face* magazine, it says what it is, it's this idea of complete, external projection, and this concept can be applied to slogan T-shirts as they make it clear that you are aligning yourself to something outside of yourself and there's an honesty in that allegiance. That's why slogan T-shirts have a validity.'

This idea of the slogan T-shirt as a projection and subsequently extension of the self, in terms of transposing one's internal self into a public self, is a reoccurring theme in Adamson's lexicon. He eloquently suggests that one of the reasons that makes the slogan T-shirt so distinctive is that at least one of the possible references is always the person wearing it, so the slogan T-shirt is usually about the tacit message of 'this is me', 'I identify with this', and therefore the identification component is exchangeable with some part of the wearer; it functions as part of 'me', as part of my identity. As a postmodernist motif the slogan T-shirt is a very explicit form of 'performance' in much the same way that one's identity comprises a 'self' that has the capacity to 'perform' and connect with others. Subsequently, by wearing a slogan T-shirt a facet of one's identity can be seen to be played out in graphic and/or textual form.

To wear a slogan on the body starts to raise the question as to what the relationship is between those words and the person wearing it. Given that humour and play are postmodernist qualities that are still active now, should there be some visual discrepancy between wearer and message or something visible that doesn't 'fit', the slogan T-shirt offers occasion for irony or self-commentary. Adamson continues: 'I think there is something very interesting about how the slogan T-shirt externalises the content of the person, rendering themselves into this one line; the slogan T-shirt turns into the person and they too into the version of the decorated shirt, and what comes out of that is this tension

of power between possible political balances involving the wearer and the slogan T-shirt being worn.'

'What's interesting about the use of text instead of image is that it really lends itself to a certainty,' proposes Adamson. 'If you consider artist Jenny Holzer's slogan work, which do appear on T-shirts, 'Protect Me From What I Want' being one of the most prolific, her anti-corporate stance expresses itself more like an activist. Whereas someone like Katharine Hamnett and her influential slogans accentuate message delivery and this idea of certainty.'

It is rather pertinent that these two references (as well as the reference to *The Face* magazine) are from the mid-1980s, a time when postmodernism was at its height in terms of its dissemination, via popular culture mediums such as design, music, fashion and literature. Yet in terms of its 1970s origins, as a radical architectural movement, it was equally entering its demise; Adamson's postmodernist story begins its lineage in academic culture, followed by its assimilation into subculture and then adopted by dominant culture. 'Our exhibition looks at postmodern strategies as a way of branding and the T-shirt is part of that story.'

To illustrate how Adamson draws on branding culture and its relationship to the slogan T-shirt, he uses the ubiquitous branded experience of corporations. Besides corporate culture having a domineering presence in contemporary society, Adamson reasons the opportunities it provides for an individuated sense of 'ownership' and 'self-styling', raising yet another complex question as to what is one's own relationship to the branded slogan, considering that branded slogans are relatively inflexible mediums of expression.

It is evident that wearing a corporate brand's slogan on one's chest is a voluntary gesture, no one has obligated the individual to do so, and as Adamson postulates: 'If one wears a brand's slogan on your T-shirt you are indicating that you don't mind having been persuaded by corporate branding, but at the same time you might think "what does it mean for me to adopt that slogan?", especially as the wearer needn't commit to the brand in a totalitarian way.' However, Adamson maintains that whilst a branded slogan, such as Nike's 'Just Do It' catchphrase tells you everything you need to know in a 'tidy and wrapped up' way, other types of slogan T-shirts facilitate 'a sum of much more set of open meanings.'

Similarly, Adamson references the cult of the celebrity and the monetised endorsements that sees public figures, who are brands in their own right, wearing branded slogans across their chests too, resulting in the union of at least two brands mutually profiting from each other. Adamson elaborates: 'In the same way that a celebrity has a relationship with the brand, the non-celebrity can too but with less power, but still with some power ... the key thing to me is to realise that the brand itself is not the thing that dominates entirely, although it does to some extent, but it also offers the consumer a degree of expression and that's what is typical about a brand, it does possess a degree of openness.'

Given that English words appear on T-shirts across the world, Adamson reflects upon the slogan T-shirt's relationship to the English language and the manner in which it serves as a connective thread in terms of its global projection, owing to the high number of people who have a fundamental grasp of the English language: 'The slogan is a tight piece of language that operates really effectively almost the same way that architecture does, because most people have a sense of what basic English words are.'

Adamson concludes with a modus operandi that incorporates a century's worth of visual tactics in the form of the fêted 'Hope Obama' slogan T-shirt: 'This T-shirt is a great example of post-postmodernist design, it is both very historicist and modernist ... the actual image of Obama is constructivist in its styling yet it doesn't concern itself in explaining its logic, you either take it or leave it, it's an "either you identify with it or you don't" type of statement and stitched together are all these design references such as Bauhaus, Robert Rauschenberg, Jamie Reid ... It's interesting that Shepard Fairey's promotional image for Obama wasn't designed for a T-shirt, but you couldn't imagine a better use for it. Immediately iconic when it was designed, it hovers somewhere between patriotism and humanism. Obama looks up into the middle distance, a heroic figure, and is splashed with red, white and blue. But he is not just a symbol; the word "hope" and the direct, no-nonsense framing present him as a thoughtful, even vulnerable man of contemplation; a real left-winger, then. So the image sits right at the intersection of two dynamics that motivate all slogan tees: advertising, and an invitation to self-identification.'

Sam Bully

John Lennon and Yoko Ono's use of slogans on T-shirts

www.onlyloversleftalive.co.uk

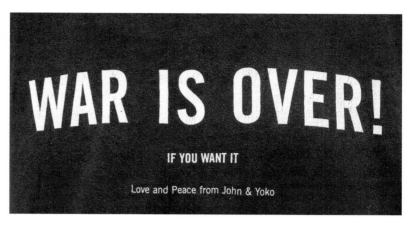

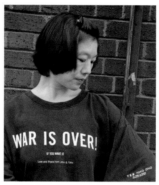

T-shirt: 'War Is Over! If You Want It', kindly supplied by Sebastian Boyle; www.boylefamily.co.uk

'John and Yoko gave
rock 'n' roll another layer,
they showed how it can
be a force for social change,
not just a good time …
so what you have is
rock 'n' roll forming an alliance
with the anti-war movement
and influencing youth culture
and that was very powerful.'

There are several versions of the story of how musician John Lennon met avant-garde artist Yoko Ono. The most persistent takes place in November 1966 at the Indica Gallery in London. Ono was previewing her conceptual art exhibit *Painting To Hammer A Nail In* which comprised a of hammer chained to a white wooden board inviting patrons to knock a nail into it thus creating an evolving art piece. Apparently Lennon wanted to be the first person to interact with the sparse slab of board but Ono refused. The gallery owner John Dunbar was astonished, asking her if she knew who he was. She didn't. But she relented providing he paid her five shillings, to which Lennon famously replied, 'I'll give you an imaginary five shillings and hammer an imaginary nail in.' Lennon and Ono married in 1969, a year after their affair began.

In a television interview in the early '70s, John Lennon expressed how as a Beatle, despite money and fame, 'there was no joy' and so when he met Ono, together they looked for a mutual goal in life 'because she couldn't rock 'n' roll with me and I couldn't avant-garde with her … so we decided the thing we had in common was love and from love came peace so we decided to work for world peace.'

Lennon and Ono's promotion of worldwide peace has been heavily reproduced on T-shirts, and since T-shirts not only engage with popular culture but are indigenous to popular culture and likewise popular culture is a primary form of contemporary expression, the T-shirt surface was a befitting medium for their iconic 1969 statement 'War Is Over! If You Want It'. Sam Bully, social commentator and co-director (with musician Marco Pironni) of independent record label, only lovers left alive, posits: 'Lennon was *selling* the idea of peace, he said it himself; I think the intention was to sell peace as a product. Lennon and Ono used advertising slogans that drew on an artistic heritage, but ultimately it was advertising so it doesn't matter where you took it, the initial idea was intact.'

Acknowledging the concept of the city as a public setting that accommodates both subliminal and confrontational messaging such as those that adorn billboards, street signs, retail displays, T-shirts et al., the original 'War Is Over! If You Want It' statement was affixed with 'Happy Christmas from John & Yoko' as a poster event disseminated around the world. The simplicity and visual authority

of Lennon and Ono's aphorism divided public opinion, as did their relationship.

Lennon was considered the mouthpiece for his and Ono's values, but contrary to the media's portrayal of Ono as Lennon's sidekick or in its most cruelest, misogynistic depiction, a subservient, product of Lennon, Ono was an independent, highly acclaimed artist long before her life connected with Lennon's. It was claimed that Ono was Lennon's muse, but the fact is they were each other's muse; their creativity was the byproduct of a love affair.

Bully skilfully shares the value of Lennon and Ono's use of slogans on T-shirts, with its birth located in the roots of modern conceptual art, Andy Warhol being Pop Art's ambassador. Warhol's depiction of assembly line culture and recontextualising banal, commonplace items by multiplying them in correspondence to the way people encountered the repetition of provisions at the grocery store was not too dissimilar to Lennon and Ono's idea of selling peace in the same fashion advertising merchants sell soap, 'so you've got to sell and sell until the housewife thinks "well, there are two products; peace or war",' Lennon mused in the television interview mentioned earlier. Bully begins: 'The three predominant cultural obsessions of the '60s were the anti-war

movement, rock 'n' roll and Pop Art and they kind of coloured everything that everyone did, because although rock 'n' roll was 1958 it was on the cusp of the '60s. Artistically, the dominance of characters during this period were people like Andy Warhol, Roy Lichtenstein and Claes Oldenburg. This whole movement of modern contemporary artists played on conceptualising popular culture, so for instance Warhol employed very populist techniques which he used to present his own concepts of art and that's why Pop Art was so controversial, even to this day people talk about Pop Art as if it's not really art ... So Pop Art is undervalued because people misjudge it ... And then you have the war in Vietnam, and that had split America and England, in fact all the Western countries, really it was an imperialist war against the Third World and developing countries. It's a bit similar to now and that's how you can link it because no one really knows why we went to Iraq, and now why we have designs on Iran, and it's really about establishing a power base there and accessing all those resources that should belong to that country. So the youth culture of the time picked up on that and that became their cause, and factored into that is John Lennon and Yoko Ono.

'Without a doubt one of the biggest phenomena culturally was rock music and one of the most prevalent bands of the era was The Beatles and of course its frontman was John Lennon, so you have the most powerful music icon in the Western world meeting someone from the conceptual art world, Yoko Ono ... and people really don't give her the credit she deserves, she is so undermined and had she not met John Lennon she would have been a famous artist in her own right, but she's always going to be associated with The Beatles. So when culture presents Yoko Ono it overlooks her being an artist and actually it also ties in with people looking down on Pop Art because a lot of her work was centred on the idea of blank spaces and minimal art, and so when John Lennon and Yoko Ono unite these two worlds converge ... And remember John Lennon went to art school and his best friend when he was younger was one-time Beatle Stuart Sutcliffe who was destined to be a great artist but sadly died [young]. Sutcliffe was taught by Pop Art artist Eduardo Paolozzi and so Lennon definitely had an insight into the art world. It's also worth bearing in mind that The Beatles had released *The White Album* in 1968 [designed by Richard Hamilton] which had the band's name embossed across a

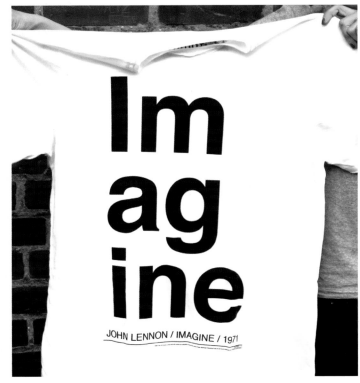

JOHN LENNON / IMAGINE / 1971

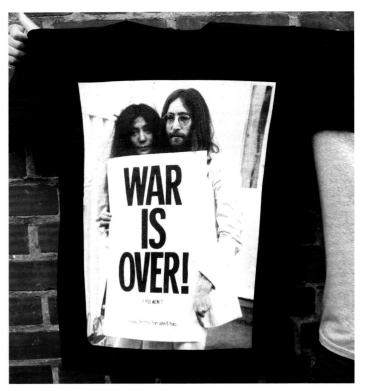

WAR IS OVER!

T-shirt 'Imagine', kindly supplied by Truffle Shuffle; www.truffleshuffle.co.uk

T-shirt: 'War Is Over! If You Want It', kindly supplied by MoreTvicar; www.moretvicar.com

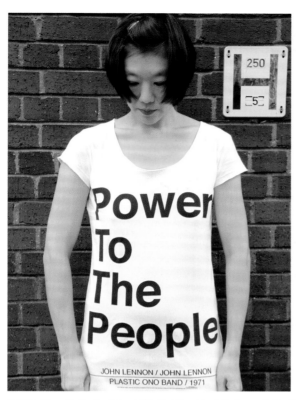
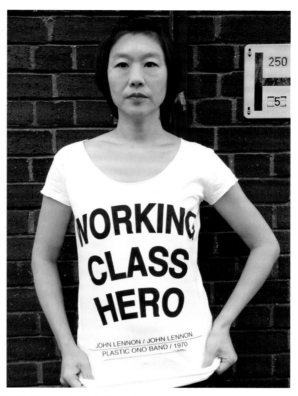

T-shirts: 'Power To The People' and 'Working Class Hero', kindly supplied by Truffle Shuffle; www.truffleshuffle.co.uk

white background and so there were all these resonances.

'I'm paraphrasing now but Lennon said himself: "The Beatles are the most famous band in the world and we always have cameras pointing at us and so if we are going to get attention we are going to use it towards something", and so when The Beatles toured America they were constantly being asked their views on the war in South East Asia by the media, and they were told by Brian Epstein [their manager] that basically it was too controversial to answer especially after John Lennon's comment about The Beatles being bigger than God. But it reached a point where George [Harrison] and John said they wouldn't go to America unless they could answer all these questions they were being asked about the war and say exactly what they thought. So they were very aware of the political situation in Vietnam. Also, the anti-war movement was feeding into the youth culture of the time; up until that point there was a youth revolution; economically people were doing fairly well and there was a sense of affluence and social mobility which was illustrated through all aspects of popular culture, whether it was the work of playwright Joe Orton or The Beatles themselves ... the

class divides were being dissolved and there was a real feeling of people being able to be what they wanted to be and to say what they wanted to say, and it was getting rid of the shackles of the past which had been very regimented, particularly in England where everyone was class conscious. So all this ties up. John and Yoko meet and Lennon is one of the most high profile people in the world and because she wasn't Caucasian there was a large degree of racism involved as it was quite controversial them being a mixed race couple, and remember up until twenty years ago or so people considered anyone with oriental features to be the same, people didn't consider the fact that that individual may come from Japan or Taiwan and the fact that Japan or Taiwan are different countries, in exactly the same way that society considered black people to be the same or Asian people, so yes there was this racist undercurrent happening too. I remember being in primary school and all our young teachers were talking about it and saying things like "and she's not even English and we think Cynthia is much better" because after all he was a married man which was taboo. But I think what is also really important about Yoko is that people probably thought being Japanese was the

same as being Vietnamese and there was this underlying notion that John had married the enemy. So there was this public perception of Yoko which is hard to articulate now because we've lost a lot of these racist perceptions or these perceptions have gone underground.

'John and Yoko were committed to this idea of using their fame to popularise their current obsession in an artistic way and that current obsession was the anti-war movement. So they conceive the slogan 'War Is Over! If You Want It' which is an advertising slogan executed in an explicitly Pop Art style and they *present* it like advertising as they hire all these billboards around the world, so for instance the slogan appeared on a colossal one in New York. They have this clear plan and specific agenda that they are going to use their notoriety to broadcast this massive, universal idea of war not being a good thing. And although Lennon is still in The Beatles, he's also formed the Plastic Ono Band with Yoko, which musically is very sparse; it's not a pop thing, it's a rock thing, it wasn't designed to sell millions: lyrically it dealt with raw issues born out of the "primal scream" therapy invented by controversial therapist Arthur Janov that the pair had immersed themselves in ... once again it was an attempt to break

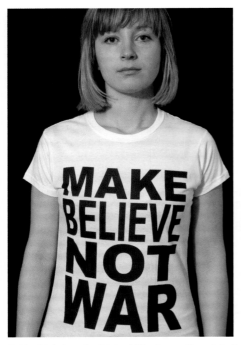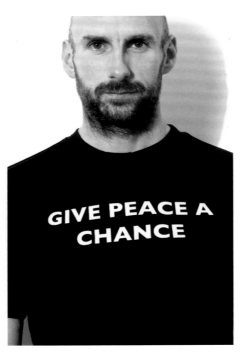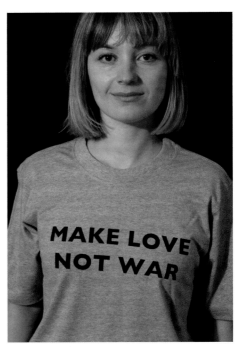

T-shirts: 'Make Love Not War' and 'Give Peace a Chance', kindly screenprinted by Matt Snow; 'Make Believe Not War', kindly supplied by www.8ball.co.uk • Models: E-Sinn Soong, Scott Maddux and Silvia Ricci

away from the traumatic past, this time on a personal level; this wasn't "I want to hold your hand" it was "I want to know why I want to hold your hand". They were questioning everything from themselves to the outside world to the way the outside world perceived them, it really was an avant-garde rock thing. So along with their albums, John and Yoko dedicate themselves for the next year or so to this mission which is to promote the idea of peace; so what happens is the most famous person in popular culture at the time [Lennon] makes a stand and they were very criticised for it by not only the media but also the public because it was like, "Well, what do you know about politics, how dare you, you're being really simplistic", but actually what John and Yoko were saying is that it *is* simplistic, it's not complicated; either you're for war or you're for peace and the subtext of that is that there is a war going on at the moment and we want this to end. I think what's important about Lennon and Ono's thing is that prior to their use of slogans, art in rock 'n' roll had been used decoratively, even Sir Peter Blake's artwork for The Beatles' 1967 *Sgt. Pepper's Lonely Hearts Club Band* album cover or Warhol's 1967 album cover for The Velvet Underground's eponymous release are both amazing, but what's important is that they were not overtly political; they may have meaning and subtext

but they are not explicit. I think what is also important is that Lennon and Ono's 'War is Over' slogan is very stark, just like the music and lyrics they were producing; it's just letters on a blank page, it's not an aesthetic thing at all; it's *all* about the words, and it is the purity of the words that give it meaning, so this has a very serious context to it as Lennon and Ono were really amongst the first people to do that in rock 'n' roll. It was like biting the hand that feeds you and that also links in with John and Yoko's Bagism theme in the late '60s where they derided racial prejudice and visual stereotyping by sitting inside a bag that concealed every part of them so people were unable to judge skin colour or gender or age or attire. They held a press conference whilst inside one of their bags and in a way turned themselves into a blank canvas so it was all about spoken words rather than the visual presence of them being a celebrity.

'So there are two threads that are interesting here, first how they deconstructed celebrity by turning themselves in effect into inanimate objects and secondly how there is an absence of slogans which in itself presents a powerful social and political message; this idea of everything, even a supposed nothing, such as a blank canvas, is something. John and Yoko really sowed the seeds for the rest of twentieth century popular culture by demonstrating how

politics and conceptual art can shape rock 'n' roll and how rock 'n' roll can be a political force that contributes to changing attitudes and perceptions. This is of course is arguable, but I think the war in Vietnam ended because public opinion was so adamant; America *lost* the war in Vietnam, they lost the war against a Third World country, can you remember the last war America lost?

'If you consider how all the pop and modern artists who had been involved in rock 'n' roll prior to that had been decorative, well that very directly feeds into punk because the imagery and statements and slogans etc. that were on punk T-shirts or on album covers almost all featured political content and without Lennon and Ono I don't think you would have had that, or certainly it would be very different.

'It's important to remember that this period of bright creativity came out of a luminous love affair, and not just dry, artistic theory, their love for each other was as genuine as their belief that war was bad. John and Yoko were a dazzling and thought-provoking couple who defined the latter part of the 1960s and signed off that decade. John and Yoko were arguably the first high profile revolutionary couple, the baton was picked up and carried into the next decade by another thought-provoking, romantic alliance, and that was Malcolm McLaren and Vivienne Westwood.'

Jon Savage
and
Jamie Reid
Punk's use of slogans on T-shirts

www.jonsavage.com

www.jamiereid.org

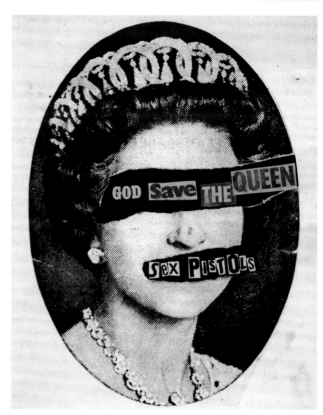

'God Save The Queen', Jamie Reid (1977) • Jamie Reid, courtesy Isis Gallery UK; www.isisgallery.org

'Punk is Year Zero in many people's idea of pop history. So it has a huge influence – not direct but pervasive.'

Jon Savage, 2011

According to the many punk denizens I spoke to whilst researching this book, none of them would ever have imagined that the T-shirts they wore throughout their cultural zenith would one day attain collectible status. Punk may have dissolved in 1978, when its figureheads the Sex Pistols disbanded as a four-piece after vocalist Johnny Rotten left the band, but its legacy has continued to permeate social culture to this day. Punk's influence has been felt across youth spectrums on a worldwide scale; it also fell victim to a media coverage that subsequently saw its sartorial vocabulary highly commodified and punk's concepts absorbed into a commercial system that diluted and anaesthetised its counter-cultural position. Punk lasted less than three years, yet its amplification proliferated for almost a decade longer. Centred on London with a couple of hundred proponents within its core movement, the initial wave of punk revolved around the Sex Pistols, rival bands such as The Clash and Generation X, and the 'Bromley Contingent' (a group of dedicated Sex Pistols fans who owed their name to the London suburb they originated from). Punk's magnitude has increased over time and despite its predisposition towards anarchic and socialist

values, it's been argued that its political content, although substantiated, has been exaggerated in its aftermath as a result of academics and cultural commentators over intellectualising each narrative thread.

Nowadays, punk seems to be used as a byword for any trend or style that is slightly unpolished, hard-edged or mildly irreverent. However, its British roots emerged against a backdrop of the worst economical recession since the 1930s and an unemployment figure of 1.6 million in 1977, the highest it had been since the Second World War. Punk was both a visual and a social revolution; it used fashion, music, graphics and behaviour as a strategy to challenge dominant ideology, capitalist power and social conformity. But where it differs from other subcultures is that its genesis was not embedded in traditional working-class culture, even though one of its characteristics was to honour working-class life, but rather it drew on avant-garde art and philosophical practices.

In 1967 Malcolm McLaren, the impresario behind the Sex Pistols and one of punk's chief protagonists, enrolled at Croydon College of Art and Design to study painting, two years after meeting Vivienne Westwood; his creative

collaborator and paramour. It was during this time that McLaren encountered artist Jamie Reid, the engineer behind many of the Sex Pistols' iconic cut-and-paste imagery including the infamous *God Save the Queen* artwork – a masterpiece that purloined Cecil Beaton's portrait of Queen Elizabeth II, piercing her lip with an oversized safety pin and camouflaging her eyes with swastikas. It was also during this time that McLaren was introduced to the work of the political group the Situationist International (SI) whose principal theorist was the French Marxist Guy Debord. Debord's critique of capitalist society reduced people's experiences of life as both commodities and spectacles, further heightened by the mediation of images. Incorporating the politically imbued, performance-art projects of Dadaism and the incongruous tableaus of Surrealism, Debord's 1967 book *Société du Spectacle* (The Society of the Spectacle) pivoted around the idea of the artist as provocateur whose resistance to comply with the status quo manifested through creating unusual interventions in urban environments. Inspired by the SI's socio-political agenda, McLaren adopted the approach that the media could be exploited through the production of

manifestos, collages and misleading information. Furthermore Situationnist statements such as 'The Barrier Between Friend and Foe is Thin', 'At Certain Times of the Day There are Only Us' and 'Create Hell and Get Away With it' were emblazoned on McLaren and Westwood's long-sleeved muslin T-shirts.

The SI's London compatriots, King Mob, promoted the idea of a global, proletarian social revolution and through them McLaren became acquainted with the work of Scottish Beat writer Alexander Trocchi and the American feminist Valerie Solanas who conceived the 1967 manifesto SCUM (Society for Cutting Up Men) and whose notoriety was magnified when she shot Andy Warhol in 1968. Both had a presence in McLaren and Westwood's SEX shop with quotations from Solanas' SCUM manifesto and extracts from Trocchi's *School for Wives and Thongs* upon its pink, latex-lined walls. It was via a composite of all these ideas that punk's iconoclastic gesture, which also operated as a signifier of social meanings, was nourished. Unreservedly, McLaren (along with Westwood, Reid, and punk consociate and former manager of English punk rock band The Clash, Bernie Rhodes) employed the slogan T-shirt to full

effect as a device for his own manifestos.

Punk's 'headquarters' was the Malcolm McLaren and Vivienne Westwood boutique Seditionaries, its clothes were identified as 'Malcolm McLaren and Vivienne Westwood Seditionaries, Personal Collection' with the slogan 'Clothes for Heroes' accompanying much of its merchandise. Many of the tags were embellished with the anarchist symbol of a capital 'A' within a circle and the droll textual espousal of 'For soldiers, prostitutes, dykes and punks'.

When the shop launched in the early 1970s as Let it Rock, McLaren had recently graduated in film and photography at Goldsmiths University, whilst Westwood was a primary school teacher. By the end of the decade McLaren and Westwood were household names.

In 1969 the shop's site at 430 King's Road had been occupied as a pop fashion outlet called Mr Freedom; its proprietor Tommy Roberts became a quasi-mentor to regular customer McLaren. In 1971 the shop found itself with a new owner and a new name, Paradise Garage. McLaren along with his friend Patrick Casey inhabited the back of the store as Let it Rock selling 1950s apparel such as teddy

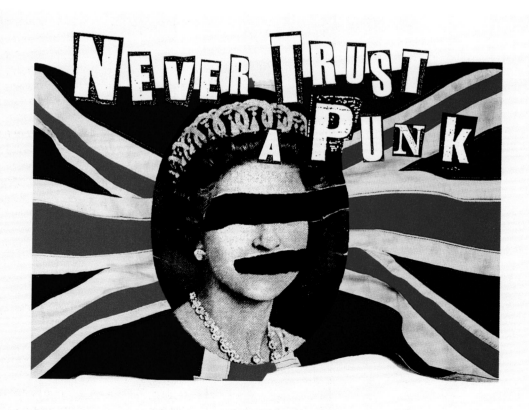

'Never Trust A Punk', Jamie Reid (2009) • Jamie Reid, courtesy Isis Gallery UK; www.isisgallery.org

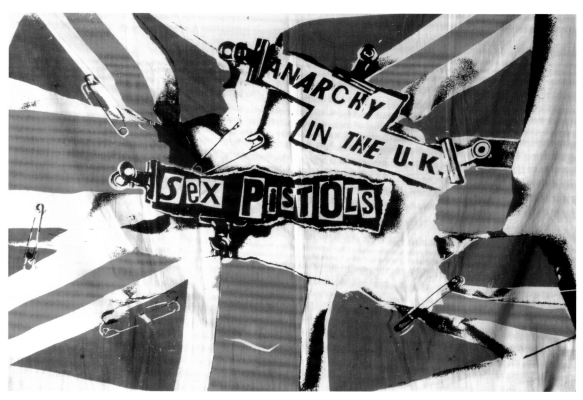

'Anarchy In The UK', Jamie Reid (1976) • Jamie Reid, courtesy Isis Gallery UK; www.isisgallery.org

boy clothes and rock 'n' roll paraphernalia. Before long McLaren took possession of the entire premises. In 1973 the shop was rebranded as Too Fast To Live, Too Young To Die, and a change of direction embraced 1960s 'rocker' fashions such as motorbike apparel and motorcycle memorabilia. In 1974 it was once again refashioned, this time as SEX, with an emphasis on asserting fetishwear as everyday garments. In 1976 the shop was unveiled as Seditionaries: Clothes For Heroes and finally in 1980 (to present) it re-emerged as Vivienne Westwood's opus Worlds End, although McLaren continued designing with Westwood until 1983. The various incarnations of both the shop and its merchandise reflected McLaren and Westwood's personal interests; evidently the cults of outlaw youths and renegade outcasts fitted their remit perfectly. Jettisoning commercial fashion, McLaren and Westwood actively distinguished themselves from the mediocrity of a perceived mainstream by targeting niche youth markets and intentionally disregarding prescriptive ideas of 'fashion'.

Against a backdrop of faded, hippy boutiques in the late 1960s with their peace-endorsing utopian ideals, and the outré glam rock fashions of the 1970s, McLaren and Westwood's enterprise was unlike any store in London. Its only real competitor was a few hundred yards further up the King's Road in the basement of Antiquarius; a labyrinthian space packed with antique stalls that also housed the offbeat clothing retailer Acme Attractions. Acme Attractions launched in 1974 as a joint venture between John Krevine and Stephane Raynor, however a couple of years later, at the height of punk, the store relocated to 153 King's Road and was renamed BOY London capitalising on punk-related clothing for the masses.

It was at Too Fast To Live, Too Young To Die that McLaren and Westwood began to design slogan T-shirts. Although Westwood was highly adept at tailoring, having made teddy boy clothes for Let it Rock, it was at this juncture that she started to develop the DIY aesthetic that would eventually be one of punk's leitmotifs, and even created a 'Do It Yourself Is King' T-shirt during the Seditionaries years. DIY practices functioned as a subversion of mass-produced and generic fashions, shifting its production and reproduction back into the hands of ordinary people, thus disturbing capitalist modes of fashion consumption. Although initially it was McLaren's instructions that shaped the nature of the T-shirts, in due course it was Westwood who seized McLaren's cavalier suggestions and made them a tangible reality, eventually contributing immensely to their sartorial oeuvre.

Inadvertently McLaren and Westwood played with postmodernist techniques, for instance cross-referencing disparate clothing genres such as the youth styles of teddy boys, rockers, mods and Rastafarians and partnering different materials and accoutrements to create a collage aesthetic recognisable as theirs. Another of their strategies involved deconstructing clothing and reconstructing its silhouette, and it was through these types of exploratory methods that Westwood developed her knowledge of dressmaking. T-shirts were hand-printed, many were deliberately destroyed or treated to look as if they had deteriorated, whilst others were turned inside out or overhauled to appear unfinished and distressed. T-shirts spelt out the names of rock 'n' roll idols in glitter and marker pen: 'Gene Vincent and the Blue Caps', 'Buddy Holly', 'Eddie' and 'Elvis' were favourites, other slogans such as 'The Killer Rocks On', 'Vive Le Rock' and 'Too Fast To Live, Too Young To Die' also championed 1950s popular culture; the latter slogan being a reference to James Dean's premature death (over the years many of the T-shirts from this era have

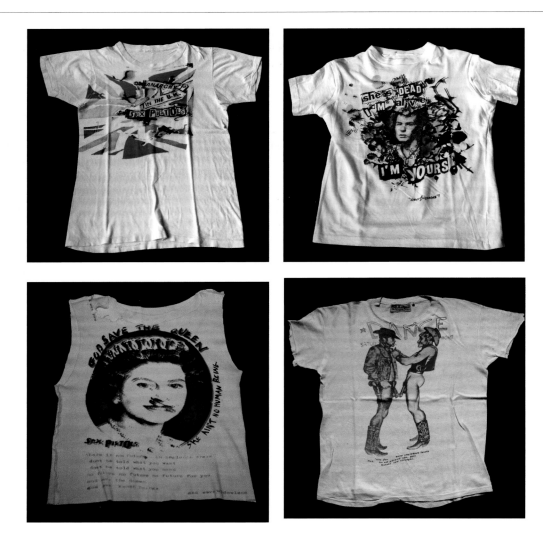

been reissued; both originals and their successors have been cemented as classics). Westwood also experimented with customisation. The 'Beeza' T-shirt was inscribed in brass studs and was further adorned with metal fastenings and bike tyres trimming the sleeve area, whilst 'Perv' was spelled out in chicken bones. Westwood also sewed zips along the breast area on some T-shirts to allow the wearer's nipples to peak through.

Sexual confrontation was a reoccurring them for McLaren and Westwood. It was during the SEX years that their designs bore deviant influences including pornographic implications and bondage wear. Inevitably, leather, rubber and vinyl clothing with their transgressive overtones were highly popular with their customers and were later adopted by the punk scene.

The early SEX T-shirts were hand-printed by Westwood using a child's printing set and stencil, and hand-inscribed with fabric dye; many were customised using horsehair, marabou feathers and rubber wheels. The later T-shirts were screenprinted. Westwood also played with the classic T-shirt's shape; cutting off sleeves, unpicking seams and either knotting them back together or allowing gaps to reveal the silhouette of the female form.

The SEX era also saw McLaren and Westwood's imagery evolve even more provocatively as was the case of the 'Smoking Boy' T-shirt in which multiple images of a naked pre-pubescent-looking fourteen-year-old, cigarette in hand, were superimposed upon the backdrop of a pink guitar and the name of the Sex Pistols. The 'Cambridge Rapist' T-shirt, also generated outrage. The T-shirt featured a leather mask with the words 'It's Been a Hard Day's Night'. The 'Cambridge Rapist' T-shirt was shocking not only as a self-contained visual but also because it had been reported that the criminal, the T-shirt referred to, had been a customer of theirs.

Yet it was the notorious 'Two Naked Cowboys' T-shirt that caused arrests for not only McLaren and Westwood but also their friend Alan Jones who stood trial in 1975 for wearing the image of the two 'unlcad' cowboys in Piccadilly Circus, London. Additionally a police raid on the shop resulted in McLaren and Westwood being charged with 'exposing to public view an indecent exhibition'; they were fined £50. However, they continued to sell the T-shirts from under the counter.

The Sex Pistols' story emerges publicly as a part of Malcolm McLaren and Bernie Rhodes' 'You're Gonna Wake Up One Morning And Know What Side Of The Bed You've Been Lying On!' T-shirt, which was one of the earliest SEX T-shirts (conceived in the autumn of 1974). Two triangular columns listed 'Hates' on the left (which included 'high society'; Mick Jagger, Bianca Jagger and *Vogue*; connections

to the law; and 'The narrow monopoly of media causing harmless creativity to appear subversive') and 'Loves' on the right (including cultural renegades such as Christine Keeler, Joe Orton and Eddie Cochrane). The 'Loves' list also name-checked the band Kutie Jones and his Sex Pistols; four working-class teenagers who counted guitarist Steve Jones and drummer Paul Cook as members. They would later be joined by Johnny Rotten and bassist Glen Matlock (who was replaced by Sid Vicious in early 1977) and renamed the Sex Pistols. Although McLaren developed the culture of punk, its roots originated in New York circa 1975. Centred around the music venue CBGB, performers such as the New York Dolls, Patti Smith and Tom Verlaine were amongst its dignitaries. In 1973 Sylvain Sylvain and Johnny Thunders from the New York Dolls had paid a visit to Let it Rock, however it was only when McLaren and Westwood were exhibiting their designs at a trade fair in New York that they met Sylvain and Thomas for the first time and subsequently introduced the British duo to New York's demimonde. The following year McLaren returned to New York with his sights set on managing the New York Dolls, but the plan was short-lived. Back in London McLaren turned his attention to Kutie Jones shortening their name to the Sex Pistols.

Contrary to punk's American counterparts, who were for the most part middle-class, cerebral and infused their lyrics with literary references, British punk was visceral, aggressive, more threatening and articulated a certain 'Englishness'. Aesthetically McLaren's punk offended the taste of the masses with their ensembles that underscored poverty, barbaric and unnatural appearances that countered a healthy lifestyle, and daring behaviour that was marked by a distaste for bourgeois lifestyles.

Visual devices that personified the core punk years and were later developed post-1978 included bondage trousers, tapered trousers, leopard-patterned trousers, tartan trousers and kilts, leather skirts, mohair jumpers, ripped fishnet tights, studded chokers, spiked jewellery and bullet belts. Preferred footwear included

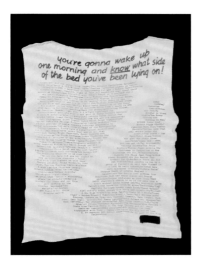
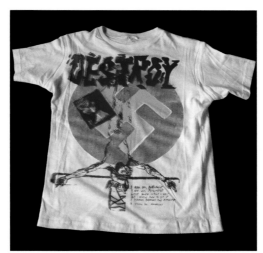

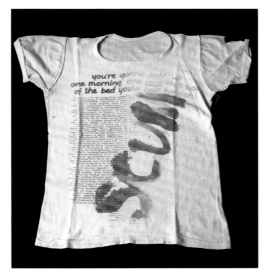

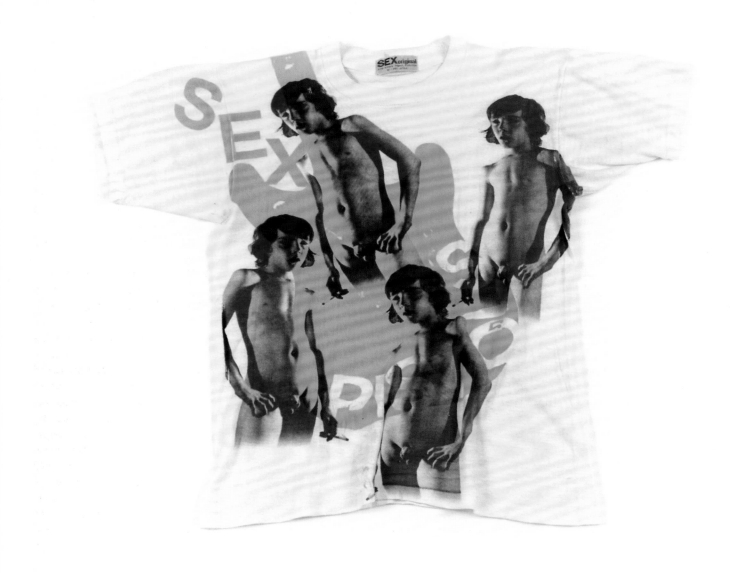

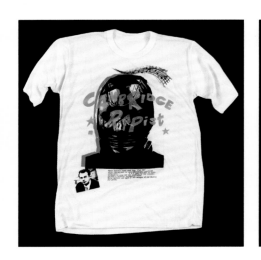

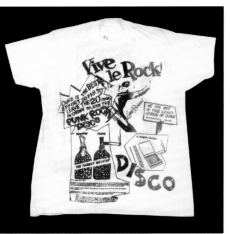

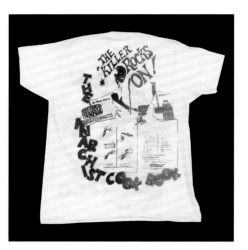

Dr Martens boots, combat boots and brothel creepers.

Punk fashions also incorporated everyday objects for dramatic and symbolic effect. Black bin liners were fashioned as garments, purposely-ripped clothes were held together with industrial tape, safety pins pierced the body and heavy chains and razor blades accessorised outfits. Hairstyles were equally indecorous: cropped, shaved, barbed and often bleached or dyed in bright colours; both genders sported the same haircuts. Heavy eyeliner was worn by both men and women. Similarities between male and female punks transpired as a characterising feature. Many female punks revolted against the stereotypical image of femininity by juxtaposing dainty womenswear with masculine attire, whilst others fostered a wholly asexual appearance. Female punks participated in the scene explicitly and directly, establishing the punk look as much as men. Conclusively there was an immediacy to punk clothing mainly on account of its DIY initiatives and negation of commodified purchases.

The relationship between McLaren's role as punk's architect and his and Westwood's business pursuits were mutually reciprocal with the clothes promoting the records and the records promoting the clothes. The Sex Pistols' lyrics were printed on T-shirts as advertising for their studio album *Never Mind The Bollocks Here's The Sex Pistols*, and together with Reid's artistic input became a source of fortifying punk's visual identity.

Often McLaren and Westwood's T-shirts featured the swastika intersecting with institutional symbols. They would strip it of its political meaning by using it as a means to sabotage right-wing politics. The 'Destroy' T-shirt had most of its surface occupied by a swastika overlaid by an inverted image of Christ and an oblique picture of a postage stamp of the Queen with her neck severed, above was the word 'Destroy' in shaky hand-written letters to communicate a sense of destruction.

Again a postage stamp appeared on a Seditionaries T-shirt, this time in response to Derek Jarman's 1978 film *Jubilee*. Jarman had cast Jordan, a much-liked employee of McLaren and Westwood's, as the narrative's female punk icon. Fuelled by resentment, Westwood wrote a 700-word vitriolic open letter to Jarman in the form of a T-shirt.

The T-shirt was once again administered as a method of personal communication in 1978, in the form of the 'She's Dead' T-shirt that saw Sid Vicious' image plastered with the words, 'She's Dead. I'm Alive. I'm Yours'. Allegedly Westwood had had a crush on Vicious and directed her feelings towards him soon after Vicious' girlfriend Nancy Spungen had died from a single stab wound to her lower abdomen; the knife had been traced back to Vicious. Sid Vicious' own death from a heroin overdose occurred in February 1979, shortly after the completion of McLaren's film version of the Sex Pistols' story *The Great Rock 'n' Roll Swindle* for which Vicious, Cook and Jones recorded songs.

Whilst subcultures frequently filter into the mainstream before exhausting themselves or expiring altogether, the early punk T-shirts have consistently been worn during different eras since their conception in the 1970s. Punk challenged the language featured on clothes, and although punk's principles pivoted around rebellion and socialism, for many it was cited as a reason to dress up, have fun and cause mayhem. In its aftermath punk clothing, which was initially manually produced, entered the vortex of mass production. Ironically punk has been an inspiration for not only many high profile commercial designers but the elitist domain of haute couture.

Jon Savage, author of *the* seminal book on punk culture *England's Dreaming* (1991), shared a few words on the value of punk's use of slogans on the T-shirt: 'T-shirts were already well established by the late '60s as carriers of slogans and information. As two people steeped in the radicalism of the period, McLaren and Westwood would have been very aware of that. They obviously took it further with deliberately provocative sexual and libellous material: i.e. the young boy T-shirt (which was sourced from a paedophile magazine and remains genuinely shocking), the black basketball player T-shirt, the 'Two Naked Cowboys' T-shirt and the 'Cambridge Rapist' T-shirt. There was nothing the two would not do in order to get a reaction. Their original link to the Situationists would come from the Existentialist/Lettrist habit of stencilling slogans on their clothes. Hence the inspired collages of the Anarchy shirts etc. The slogans on punk T-shirts gave voice to teenagers who could say anything that was on their mind, also to record companies and groups who could publicise themselves, by shocking means if necessary. Nowadays, you see children wearing CBGB's T-shirts, which is just wrong. The idea that T-shirts could form a political statement was taken up in the mid '80s by Frankie Goes To Hollywood and Katherine Hamnett.'

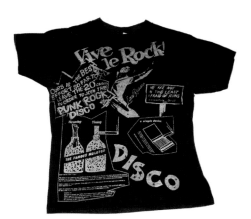
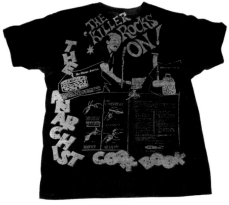
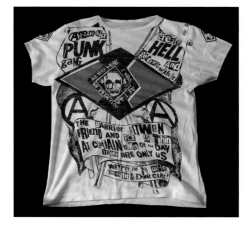

Malcolm McLaren and Vivienne Westwood's punk T-shirts kindly supplied and photographed by Grant Howard • T-shirt: 'Vive Le Rock' (black version) kindly supplied by Andrew Wade; www.only-anarchists.co.uk

Dr Matthew Worley

The slogan T-shirt as a subcultural tactic

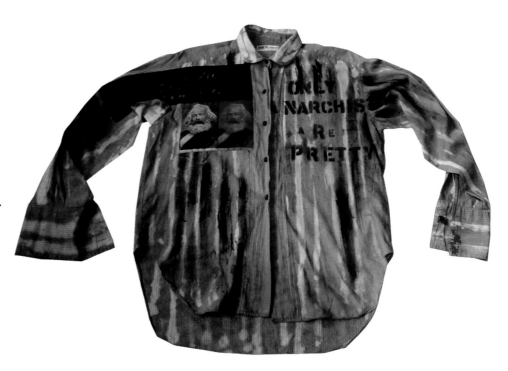

'The 'Anarchy Shirt' revealed the clashing symbols of punk: the clash of potent opposites that gave punk its power. By invoking Marx, fascism, and anarchy, the shirt pointed to the three principal alternatives to liberal capitalism: the three main fears of the mainstream establishment. It also meant that punk's politics were indeterminate and so could not be diagnosed and contained. It represented history, chaos and revolt.'

'Subculture, at a basic level, refers to a group of people with a culture, either hidden or stated, that differentiates them from the larger culture to which they belong. Such a concept can be applied to youth cultures that signify their difference in terms of language, musical tastes and clothes etc.,' so begins Dr Matthew Worley, Reader in History at the University of Reading, whose own compelling research interests include the links between British politics and youth culture in Britain during the 1970s and 1980s.

'My aim is to bring a historical complement to the work pioneered by the CCCS from the 1960s [CCCS: Birmingham University's Centre for Contemporary Cultural Studies – a centre that researched representations and audience reception of youth subcultures and popular cultures in the mass media including the semiotic resistances of creative consumers] building on the work of social theorists such as Stuart Hall and Dick Hebdige. Because I'm an historian by trade, so I'm looking *back* and looking at the emergence in the '70s of ostensibly polisticised youth cultures, and of course a part of that was very much punk culture and the slogans on their T-shirts.'

As Worley suggests, the idea of subcultures emerged noticeably although not definitively, as a sociological term in the late 1920s/early 1930s around the activity of street gangs. Manoeuvring outside the mainstream of society and within a cultural underground, this new social group was not immune to transgressive practices and acts of criminality; appointing its own tropes and codes of conduct and, as is the case with most subcultural movements, its own rituals. Following the Second World War subcultures moved into a different league as a result of a fully functioning consumer society and a youthful population that had in its possession a disposable income, more time and a burgeoning sense of its own position in society.

'I think punk is one of the subcultures that uses slogans on T-shirts the most explicitly. Its roots are very influenced by the political avant-garde, especially the Letterist and the Situationist movements from Paris. For instance, the punk aphorism "Be Reasonable, Demand the Impossible" was adapted from the Situationist's 1968 slogan "Be Realistic, Demand the Impossible" and was obviously

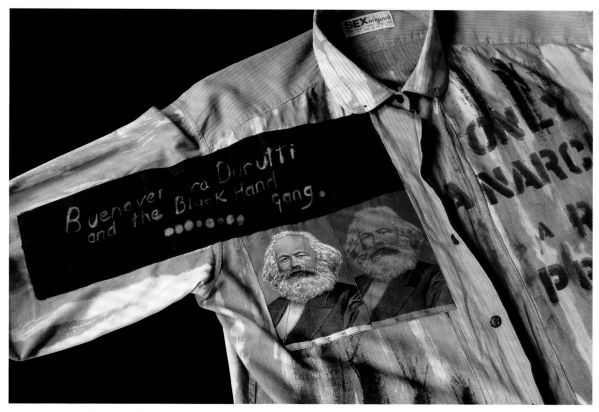

Images of Malcolm McLaren and Vivienne Westwood's 'Anarchy Shirt' kindly supplied by Grant Howard

constructed to fit the time. But contrary to the illusion that punk materialised organically, it was actually very aware of what it was doing', he explains. According to Worley, punk fashion didn't so much emerge from the streets as from collectively engaged ideas, accounting amongst its protagonists impresario Malcolm McLaren, fashion designer Vivienne Westwood, former manager of English punk rock band The Clash Bernie Rhodes, and artist Jamie Reid.

Punk's deliberate acknowledgement of clothes as signifiers had as one of its central strategies the idea of the production of sartorial values being reproduced by *anyone* through self-styling and DIY techniques. Accordingly, archetypal ideals of beauty and decency were detonated, whilst customising became a dominant theme. Using cast-offs as a building block, the punk aesthetic mutilated and vandalised garments. T-shirts were torn and distressed with commonplace items such as zips and safety pins, and handwritten words were applied over images in an insubordinate and deliberate manner. Nuanced by fetishistic undertones, punk's fashion lexicon extended to include apparel made from easily

attainable, domestic materials such as black shiny bin bags as well as found materials including remnants of old tyres and discarded strips of leather.

Worley expands: 'I think to understand punk's language you have to put the use of slogans into the context of the imagery too. The language is very much mixed up into a broader imagery, which was consciously designed to provoke, upset and shock.' To illustrate this point, Worley references the classic 1976 'Anarchy Shirt' as an example of the collage tactics that McLaren and Westwood employed. Not strictly a T-shirt, the 'Anarchy Shirt' occupies the same cultural space as other punk T-shirts; it was a forerunner to much of their experimentation on T-shirts. The shirt's symmetry is disturbed by the presence of two monotone images of socialist philosopher Karl Marx on the right breast pocket and the slogan 'Only Anarchists Are Pretty' stencilled in capitals on the left side. However, the story of the 'Anarchy Shirt' originated by default.

McLaren and Westwood's boutique, located at 430 King's Road, experienced many incarnations during the '70s: Let It Rock

(1971–73), Too Fast To Live, Too Young To Die (1973–74), SEX (1974–6), Seditionaries (1976–80) and finally as Vivienne Westwood's masterpiece Worlds End (1980–present). The prototype for the 'Anarchy Shirt' was produced during the SEX era. Against the canvas of a standard white shirt, McLaren printed the aforementioned Situationist-inspired slogan 'Be Reasonable, Demand the Impossible' using a child's stencilling kit. This coincided with McLaren purchasing dead stock from the shirt manufacturing company Wemblex; a brand worn by early Mods. These shirts had penny collars, were patterned with vertical stripes in muted colours and had buttons that lined the wrong side of the shirt (serving as a connotation to valet service), but the merchandise didn't sell and this is what led McLaren to develop his 'Anarchy Shirt' idea. It began with him dyeing, bleaching and painting the Wemblex shirts, he then sourced silk patches with pictures of famous Communist leaders from a supermarket in Chinatown, which were also dyed before being sewn onto the shirt, as well as attaching red silk patches on the shirts' sleeves and bodies. As a counterpoint to the Communist imagery,

McLaren further layered the shirt's surface by fastening inverted German SS and Second World War military patches and a picture of Karl Marx's face which had an upturned Nazi eagle to indicate that the wearer was anti-fascist. McLaren also experimented with assorted armbands such as swastikas which were again overturned and other typical anarchist symbolism such as the encircled 'A'. Slogans that made an appearance at one time or another included 'Dangerously Close To Love', 'Try Subversion, It's Fun' 'CHAOS' and 'A Bas Le Coca-Cola!' ('Screw Coca-Cola!'). All the shirts were handmade and over a two-year period different versions evolved and matured. However, due to their complexity, very few were made (speculation from a reliable source suggests around one hundred). The earlier 'Anarchy Shirts' were carefully constructed with individual details such as the yoke of the shirts being removed and repositioned so the stripes striated at different angles, yet as production increased they became less elaborate and adhered to a formula.

In September 2001, the 'Anarchy Shirt' worn by Sex Pistol Johnny Rotten fetched $6,000 at Sotheby's. In 1976 it had been for sale in McLaren and Westwood's Seditionaries boutique for £25. 'The 'Anarchy Shirt' would have sat on the shop rail besides other, now classic, T-shirts such as the 'Two Naked Cowboys', the fourteen year old boy smoking a cigarette, and the Myra Hindley T-shirt … as with all their T-shirts, the words were meant to be as violent as the imagery,' discloses Worley.

In keeping with Worley's argument of punk reinterpreting what already existed, repackaging it and then submitting it as merchandise, negates the definitive idea of it emerging from street culture, despite it habitually being associated as a street cultural form: 'I'd say that street culture almost takes punk and makes *it* its own, hence it's that thing where an idea is put out there and you lose control of its meaning, and that's exactly what happened with punk. Once it comes out of the shop, literally, and once the band play live wearing those clothes, then people take it and mediate it through their own contexts and interests, turning it into something else … which is why by 1977, '78 you have factions within punk fighting against each other and arguing about what it means. And by 1980

you have these recognisable strands; so you have Anarcho, the anarchists who take anarchy seriously, and you have the Oi! bands [a fusion of punk and skinhead subcultures] who take the working class rhetoric from punk very seriously, and then you have the post-punk bands such as Joy Division and Gang of Four who seize the artistic intellectual element of punk and take it in their own direction. Finally, you have people like journalist Paul Morley who is absolutely born out of punk and opens up a new cultural space in which popular culture rather than a political agenda cements an evolution from punk. So the cultural stepping stones begin with McLaren's Sex Pistols and then shift into a darker era that celebrates the savage with another McLaren-managed band, Bow Wow Wow [that has fourteen-year-old Annabella Lwin as its lead singer], and this culminates with Morley's involvement with the group Frankie Goes to Hollywood.'

Worley also argues that the mainstream adoption of punk doesn't so much devalue its credibility, but rather its original form is thus short-lived: 'Then again, what is interesting about punk is that it's very aware of its limited time span. It almost historicises itself the moment it starts; they were often filming themselves to have documentation of their "time", and when the record company signs them up, they are aware they'll be "sold out" and become like all the rest … There's a kind of media savvy within punk about how the process works, as in you have to make your impact quickly before it disappears and the next big thing replaces your triumphs.'

It has been suggested that subcultures have diminished or rather their visibility is confined to a more niche social space, and subsequently media labelling is hesitant to invest terminology to groups that are in transience. 'I wouldn't be so aware of current subcultures,' says Worley, 'because it *is* principally a youth thing, perhaps youth cultures rather than subcultures is more suitable … there is a big debate going on in cultural studies and sociology whether the current wave of groups, such as Emo kids, for instance, are subcultures or youth cultures. These are contested terms … we all know what we mean when we use these terms, but the boundaries are blurred and their meanings are slightly amorphous.' Since people have

become more sophisticated in their media readings of cultural life, the notion of shock no longer resonates; subcultures and youth cultures alike are, to some extent, predicated on scandal. Furthermore, the idea of generational and parental cultural difference has been somewhat dissolved in the last couple of decades with music, fashions, literature, entertainment et al. appealing to audiences across the age spectrum; as a result the gesture of alarming older generations and subverting parental demands no longer have the same impact due to the expanded freedom from parental constraint.

Arguably, another contributing factor to the demise of the traditional subcultural group is the idea of youths nowadays being consumer dictated, as opposed to the former social cohesion of like-minded, class-based compatibilities opposing dominant hierarchies of control. Additionally, subcultural groupings are more likely to be bound together in this day and age by creative pursuits and tastes rather than the disparity of social backgrounds. And in this context, creative pursuits and tastes often pivot around consumer choices and unsurprisingly these are never arbitrary as the espousal of commercially-produced items announce peer identification and likewise underscore peer differentiation. The slogan T-shirt continues to play a defining role for both subcultures and youth cultures; expressing difference to those on the outside and affiliation to those within. Thus, subcultural activity regularly affixes its sense of belonging and cultural direction on account of monetary-driven predilections, rather than the traditional conduits of community and the subversion of bourgeois conventions. Worley adeptly sums up subcultural values in contemporary society: 'Modern, post-war, subcultures have always been informed by consumerism, but they are not so much led as interactive. Subcultures apply their own meanings to the items consumed and thereby have the potential to transform them. This remains true today. So, for example, a sportswear symbol can now have a cultural capital relevant to street life and not just the playing field, or similar'.

Additional research relating to the 'Anarchy Shirt' courtesy of Sam Bully.

Shehnaz Suterwalla

The slogan T-shirt as a site of resistance

Badges kindly supplied by Fiona Cartledge; www.signofthetimes.org.uk. During the 1970s and '80s badges were hugely popular and were often worn on T-shirts, both as visual and coded embellishments. These punk badges are extremely rare since at the time badges were considered relatively disposable, so few were kept. 'These badges are special to me as they were from the bands I followed in 1977 [Adam and the Ants, Bow Wow Wow, The Lurkers, Buzzcocks and roots reggae band, Culture]. They were given out free at gigs and later became collectable', notes Cartledge.

'The punk ethos was carried on at Greenham Common peace camp, among other places, in the 1980s. Certainly the DIY processes of punk were critical to the layered look at Greenham, where the slogan, sometimes on clothes but certainly on badges, banners and posters, continued to be used as a political manifesto.'

According to Shehnaz Suterwalla, whose doctorate research project centres on the way British women have used alternative dress as a politics of resistance since the 1970s, the slogan T-shirt gives strength to marginalised voices through their means of expression: 'It spells out on the body a feeling, thought or belief. It can act like a personal manifesto or an expression of desire, including resistance. As an object worn on the body it acts as an embodied articulation of an individual's voice and practice of their gendered realities. This is critically empowering for marginalised voices, especially if they have felt silenced or been rendered mute by mainstream political forces and culture. It also makes the marginal body visible through "sticking out" or conspicuous design, critical strategies in politics of empowerment. The slogan T-shirt can be used by marginal groups for expressing "otherness".'

Suterwalla's research focuses on four different cultural strata of female identity: female punks, the Greenham Common women, black women in hip hop and the Hijab customarily worn by Muslim women. Suterwalla explains: 'I have been interested in women's identity politics for many years, and

worked on women's stories as a journalist and editor before starting my academic research. I wanted to move beyond the conventional scholarship regarding women's identities, and thought that by looking at dress I would be able to explore the complex ideas of women's subjectivity from a broad, interdisciplinary perspective that incorporates issues like their experience and feelings, as well as their histories and politics.'

Suterwalla's compelling research looks to the body as a site of resistance in which embodied style allows women to negotiate gendered social conditions and challenge prevailing ideals of female identity. If one considers one of the many definitions of 'a site of resistance' as an open space for developing practices and ideas, in Suterwalla's terms: 'The slogan T-shirt can interrupt the conventional processes that define the body in culture, so that the T-shirt subversively or overtly undermines traditional attitudes about gender or sexuality.'

Another strand of the slogan T-shirt as 'a site of resistance' accommodates the social position of a marginalised identity, apposite considering Suterwalla's four case studies inhabit this framework. Suterwalla elucidates:

'Women's history remains marginal in conventional scholarship which for the most part tends not to emphasise gender. In fact, gender is often relegated behind issues of class, but I think the embodied experience can only be fully understood within the matrix of class, gender, race and sexuality.'

In the context of Suterwalla's research, two contrary examples of clothing practices – how clothes are adopted and worn by the individual – and their relationships to the slogan T-shirt have been selected; one for its notable absence (the women at Greenham Common Peace Camp) and one for its palpable presence (the female punk movement); both occupy oppositional aesthetics that reject mainstream sartorial agendas.

In 1981 a group of Welsh women arrived at RAF Greenham Common in Berkshire to protest against the British government's decision to base cruise missiles at the site. Over the years, until its demise in 2000, over 70,000 women colonised the peace camp as a gesture of solidarity in resistance to nuclear weapons. Living conditions were extremely primitive and self-sustainability was practiced. Inevitably, vanity and sartorial gratification had no place for the women whose sole commitment was to disrupt the exercises of the United States Air Force. As Suterwalla affirms: 'In terms of the Greenham women what is important to remember is that it was the embodiment of the clothes that made them threatening, because the women were wearing clothes for practicality. Their clothes were anything they could get their hands on to keep warm and many of them were donations. They would have worn T-shirts during the summer months but in colder weather T-shirts would have been hidden under layers. And there would have been a social life to the T-shirt as the women would have shared their items. So you would have someone wearing a T-shirt that had been passed on to them for example, thus embodying the idea of collectivity, and through this process of recycling cast-offs, the garments would have morphed. Also, the way that the garments were actually handled was very particular to the Greenham women, they used unconventional types of washing, so not in a washing machine, and often the clothes would have had dirt on them, so making dirt visible on the garment was also a statement. Generally the Greenham women embraced

androgyny, so boiler suits were worn with monkey boots and they may have worn a T-shirt underneath that, but if anything their clothing lacked prints or motifs and that created a sense of androgyny which again was a statement about femininity.'

Suterwalla claims that it was the use of badges and banners with pithy phrases that were very much the communicators of choice: 'Customisation and craft practices such as embroidery were usual, the women wrote things on T-shirts and you would have seen symbols such as that of the CND and women's signs on the T-shirts, particularly those belonging to radical feminism and lesbianism. They would put either text or a symbol on the front of their T-shirt and on the back of them would be something different, so what you see is the layering of history.'

If we look to the slogan T-shirt as a semiotic tool in which to decipher and decode embodied and sartorial meanings then in Suterwalla's frame of reference: 'We would consider the wearers as the signifier and the clothing as the signs and as signs, they were interpreted and oppositional, now whether they were oppositional was always within the perspective of the wearer.'

The discipline of semiotics, reduced to simplistic terms, is the study of signs, symbols and forms; their meanings and how they relate to the ideas or things they refer to. In the case of fashion, semiotics considers how images or visual rhetoric and their respective ciphers can be read as a text. Therefore clothing as a 'language' or as an expressive statement by way of clothing choices alongside their configuration and presentation suggest coded and signified messages that may be read to interpret the individual in question. Thus, the clothed body can be regarded as a canvas to project one's internal and external identity. 'The slogan T-shirt can have a semiotic impact, in that it can create space for new expressions of freedom. The slogan T-shirt can, therefore, act as a powerful tool to subvert the status quo.'

In consonance with Suterwalla's address of female punk identity in the 1970s, which neatly captures the methods and aesthetics that saw female punks match their male counterparts in terms of disregarding and/or challenging dominant societal values: 'The slogan T-shirt formed part of a new politics of expression where the gendered body was used as a site of

resistance'. Furthermore, punk's DIY processes and use of slogans as political manifestos on clothes and also badges, banners and posters were subsequently assimilated by the women at Greenham Common.

Suterwalla illuminates: 'Through postmodern techniques of cut-and-paste and do-it-yourself, the mundane, such as an everyday T-shirt, was transformed into an object with currency: customisation meant that overtly, or semiotically, youth could challenge mainstream ideals concerning authority, femininity, the future. Text became critical in this process, with 'Destroy' as an iconic slogan on T-shirts, or lyrics from nihilistic songs being graffitied onto T-shirts that were ripped, torn, and held together with safety pins. What this meant for punk identity was that new expressions of subjectivity were embodied; in terms of gendered identity, women began to make themselves visible in public through abject techniques that subverted or indeed shattered any traditional or conventional female identity. As such, the slogan T-shirt was a politically powerful tool that fed into the feminist politics of the period, but that also left a more far reaching legacy for women's politics and emancipation.'

Eric Rose

Vivienne Westwood enthusiast

www.perfectpr.biz

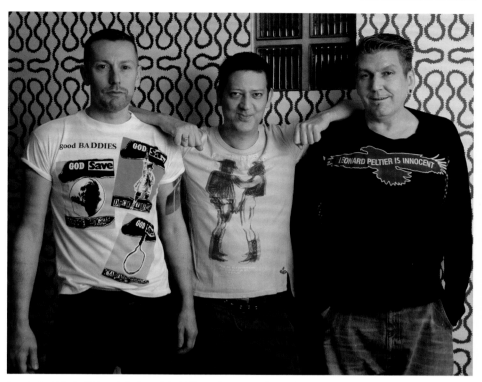

Reportedly, Malcolm McLaren's final words in 2010 were 'Free Leonard Peltier'.

'Westwood T-shirts are a bit like the British flag … without having to say anything, they say everything.'

Uncompromising, visionary and unique, the formidable Dame Vivienne Westwood's forty-year career as a fashion designer and style maverick has seen her position shift from challenging the establishment during the 1970s to joining its upper echelons in 1992 when she was awarded an OBE (Order of the British Empire; an official accolade given for services to the country or community) which she famously collected from Queen Elizabeth II at Buckingham Palace *sans* underwear. In 2006 Westwood advanced from OBE to DBE (Dame Commander of the Order of the British Empire) 'for services to fashion'. This is even more commendable when one considers that Westwood technically was self-taught, learning her trade during her thirties when she began making teddy boy attire for Malcolm McLaren's first retail enterprise Let it Rock (1971–73).

Westwood's post-punk designs have borne little reference to youth culture, if any at all. Instead, her influences are drawn from classic literature and seventeenth and eighteenth century art and culture, preferring to source inspiration from historical collections and books on the social history of dress at museums such as London's V&A and Wallace

Collection. A former primary school teacher, Westwood has maintained her enthusiasm for studying and educating.

To wear Vivienne Westwood's clothing is to wear her intellectual values; even in the days of punk, Westwood's ideas were exploratory and the T-shirt especially was used as a medium for experimenting with not only the cut of the fabric but also redressing the relationship between fabric and body and the silhouette of prescribed clothing shapes. The T-shirt was also deployed as a medium to 'publish' her ideologies.

Many of Westwood's (and McLaren's) early T-shirts were hand-printed and hand-dyed on her kitchen table, they were subject to dexterous customisation and their construction was rethought. Over the years, Westwood's T-shirts have been slashed, torn, distressed, deconstructed; their necklines have been pulled away from the collar to sit on the shoulder as an asymmetrical contour and in 1979 her influential, ripped T-shirt, sliced open under the arm, was draped over the body as a gesture of erotic display.

From Punk to 'Pirates' (Westwood's Autumn/ Winter 1981–82 collection) to 'Portrait'

(Autumn/Winter 1990–91) to 'Anglophilia' (Autumn/Winter 2002–03) Westwood's involvement with the T-shirt in its many incarnations has been consistent. In the mid-1980s, financial considerations led Westwood to lease the printing screens for her T-shirt designs to her punk-days retail rival, BOY. The terms of this lease are unknown, but it resulted in Westwood's artwork appearing on a profuse number of T-shirts which have subsequently proved difficult to authenticate. Nevertheless, both original Westwood T-shirts and their 'duplicates' have maintained a reputation as

being collectable, with their monetary value permanently increasing. In 1990, editor of *Women's Wear Daily,* John Fairchild declared Vivienne Westwood one of the six most important designers of the day, along with Yves Saint Laurent, Giorgio Armani, Emmanuel Ungaro, Karl Lagerfeld and Christian Lacroix. Twenty plus years later, this accolade is still valid and the exuberance for Westwood as a *tour de force* crosses generations, backgrounds and continents.

'It all started with Bow Wow Wow,' begins Eric Rose, Vivienne Westwood enthusiast and

one of London's most charismatic front-of-house doyens responsible for welcoming guests at the most prestigious clubs, fashion parties and music events. 'It was 1982 in Vancouver, where I'm originally from, they were playing live wearing head-to-toe Seditionaries [the name given to the apparel sold at McLaren and Westwood's iconic mid–late '70s London shop], but because they were English and Malcolm McLaren's brainchild, actually before I had even *seen* them or had even heard their music, already I was a fan. I just loved how Bow Wow Wow grew out of punk, which me

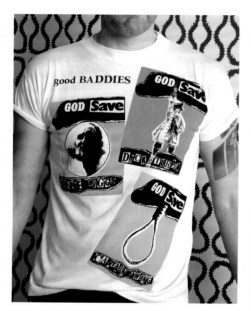
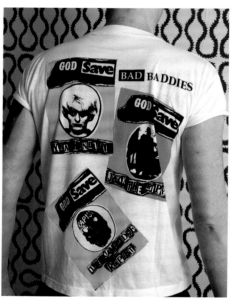
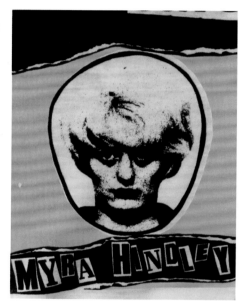
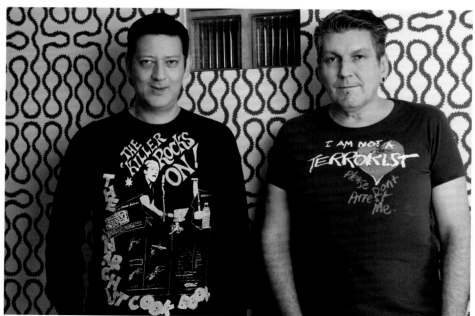
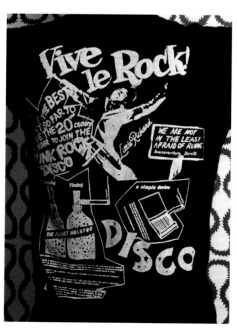

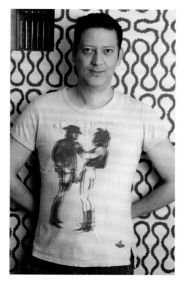

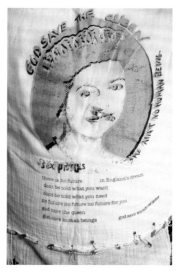

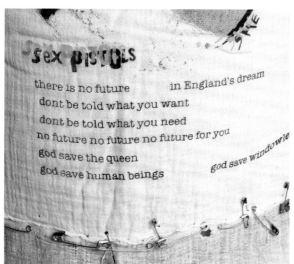

and my friends were really into, and what was so great about punk was that it really involved you as an individual, because it was all about making your own clothes and modifying things, basically *making clothes your own* rather than just buying the look.'

For non-London fashion and music-impassioned teenagers such as Rose, the strong-minded values and aesthetics of McLaren and Westwood were exhilarating, so much so that Rose moved to London in 1984 to experience the fashion and music scene first-hand. He has been ensconced here ever since. Rose recalls how the availability of fashion was relatively elusive compared to the convenience and expediency of the retail landscape that pervades the present day: 'At the time no one

stocked Westwood's clothes in Vancouver, so if you knew someone who was going to London you would give them money so they'd bring you back a T-shirt, any T-shirt, as that is all our budget could afford ... you couldn't just walk in a store like you can do now. So for instance if you wanted a band T-shirt you would make it yourself or you would alter clothes bought from department stores, and of course online shopping didn't exist, so in a way everything was more exciting and desirable because of its inaccessibility. I guess it was much more authentic because it was harder to obtain things, so you really had to want them, save up for them and actively go after them ... One of my friends holidayed in London and returned with a whole Westwood outfit, I remember she

told us all these amazing stories about the shop and the people who worked there, who were celebrities in their own right because magazines like *i-D* would feature them ... anyway, we were all completely in awe of her.'

Upon arriving in central London, Rose ignored his jetlag in favour of an excursion to the legendary King's Road, specifically Vivienne Westwood's boutique, Worlds End, 'I didn't come all the way to see Buckingham Palace,' he delivers comically, before adding, 'I felt I had arrived!' However, Rose's first London-bought Westwood item was not purchased on that day: 'It took a few visits before deciding what I wanted to spend my money on, because it was still quite costly, but my first purchase was the 'God Save the Queen' T-shirt, it was black with

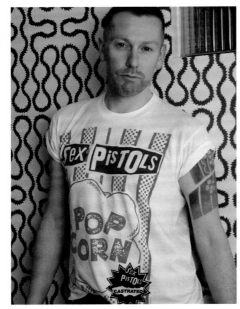

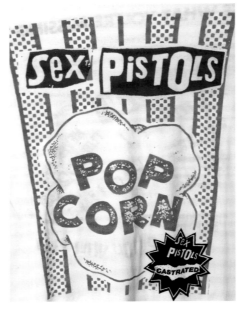

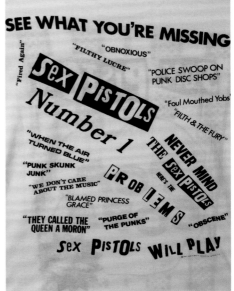

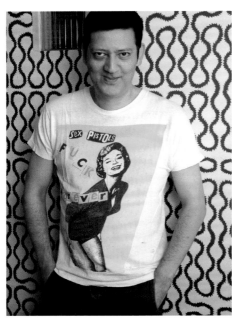

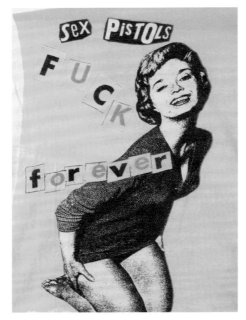

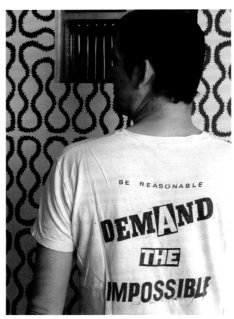

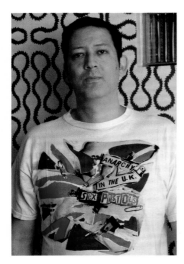

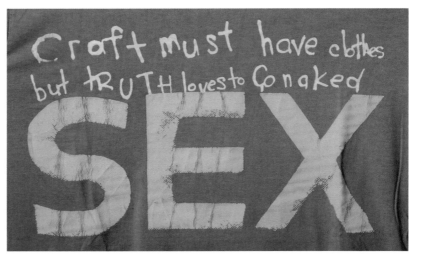

white print ... I think someone stole it but at some point I bought another one,' he remarks with his usual lack of grandiosity. 'And then, after that, it was probably her 'Too Fast To Live, Too Young To Die' T-shirt.' Before long Rose secured a job as a sales assistant at another iconic King's Road shop, the aforementioned BOY. 'You could buy Westwood T-shirt prints at BOY, but the thrill of going to Worlds End and making a purchase at her store was paramount.' Since Rose's income was unable to match the cost of buying Westwood's main-line collections, it was always the financially attainable T-shirts that diminished Rose's monthly pay cheque.

'What I really like about slogan T-shirts is that they are very easy to style and Westwood's T-shirts especially lend a rebellious feel to your look ... Also, Westwood's graphics and her connection to music and her sense of heritage are all really attractive to me. She's an extraordinary woman and the fact that she came from humble beginnings makes her story even more fascinating.'

Despite the volume of Westwood T-shirts that occupy Rose's wardrobe space, interestingly he does not consider himself a collector in the traditional sense, as in acquiring items to maintain an inclusive compilation of one's chosen interest, but rather a fan who buys and wears what he likes; *likes* being the objective. 'Sometimes I do hunt for certain T-shirts and definitely the Internet has made it easier for someone far away to sell to another "someone" even further away,' he posits again. 'And of course, selling my Westwood T-shirts I no longer wear on sites like eBay enables me to buy ones I am going to wear. It's worth mentioning that Westwood's T-shirts hold their price too'.

According to Rose the T-shirt's capacity to advertise one's allegiances is an effective connecting tool: 'I've made a lot of friends through bumping into people who were wearing the same T-shirt as me or wearing one I coveted ... I've found Westwood's T-shirts to be really great conversation starters, this happens a lot in London; I guess it's because you're closer to the actual source, all the same this type of Westwood-affiliated encounter does stretch worldwide.'

Slogan T-shirts have created narratives throughout Rose's life as demonstrated by an anecdote he discloses from his days as an adolescent: 'I was suspended from school when I was twelve for wearing a T-shirt that had 'FCK, all that's missing is U' on its front. My mum didn't approve of it but she said, "your T-shirt's clean, what's the problem, now go back to school", and so I did still wearing the T-shirt!'

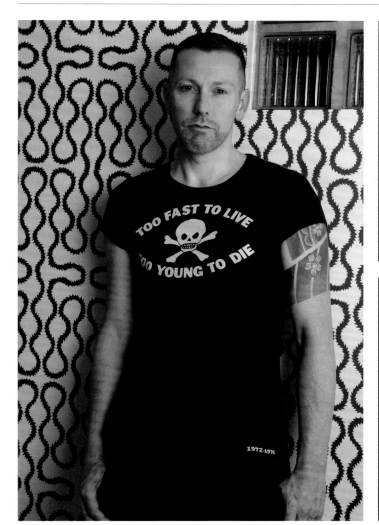

A selection of T-shirts featuring Malcolm McLaren and Vivienne Westwood's artwork kindly supplied from Eric Rose's archive, bought between 1986–present. • Models: Eric Rose, Mark Moore and Martin Bull • Location courtesy of Martin Bull

Holly Johnson

Frankie Goes To Hollywood frontman

www.hollyjohnson.com

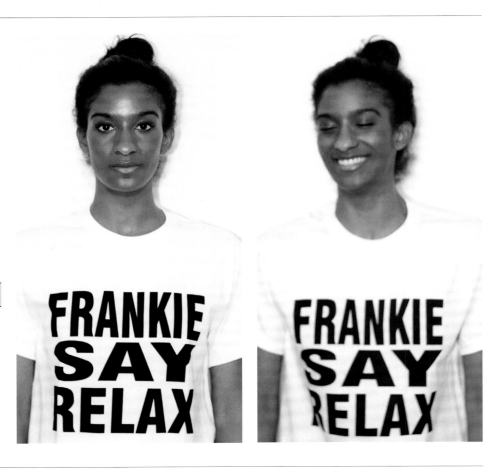

'As the band's popularity grew the T-shirt mushroomed and bootlegs appeared everywhere on market stalls with just the word 'Relax' on them or 'Who Gives a Fuck What Frankie Say' etc. This is of course the highest accolade in a sense.'

Although the 'Frankie Say' T-shirts are a cultural embodiment of the 1980s, their continued presence *as* popular culture is prodigious. Underscored by its controversial context and an economy of words the 'Frankie Say Relax' T-shirt was joined by the lesser known but equally provocative, politicised editions: 'Frankie Say War! Hide Yourself' and 'Frankie Say Arm The Unemployed'. Since the T-shirt's conception in 1984, the expressive coherency of the two opening words of 'Frankie Say' have been accompanied by a plethora of parodied versions: 'Frankie Says Chillax', 'Frankie Says Xanax', 'Frankie Says Relapse', 'Frankie Says Prolapse', 'Frankie Says A Lot of Things', 'Frankie Says Too Much', 'Frankie Says Free Lindsay', 'Frankie Says WTF' and 'Frankie Went to Hollywood and All I Got Was This Lousy T-shirt' are just a few examples that have recently been circuiting virally online and physically on the streets.

The 'Frankie' in question refers to the band Frankie Goes To Hollywood, although given that the appropriated 'Frankie' T-shirts misspell the 'say' as 'says' one would deduce that Frankie was an individual. Against a backdrop of safe pop music and safe pop music values, Frankie Goes to Hollywood (FGTH) were visually

arresting, fearless, openly sexual and lyrically seductive. Fronted by charismatic vocalist Holly Johnson, with backing vocalist and performer Paul Rutherford, Mark O'Toole on bass guitar, Brian Nash on guitar and Peter Gill on drums, FGTH's debut single *Relax* was released by the independent record label ZTT in October 1983, airplay was minimal but it entered Britain's Top 40 charts in January 1984. Following a performance on the BBC's *Top Of The Pops* the single escalated to chart position number six. Several days later, prompted by BBC Radio 1 DJ Mike Read's tirade directed at the song's lyrics, the BBC banned the record from all its TV and radio outlets, with the exception of its *Top 40* show. Rather than damaging sales, *Relax* topped the UK singles chart for five consecutive weeks. The song was comprised principally of a single line: 'Relax, don't do it, when you want to go to it. Relax, don't do it, when you want to come'. Both the single's front cover design and the uncensored video championed homoerotic and S&M imagery.

The follow-up single, *Two Tribes* was released in May 1984. Although its lyrics were claimed to represent any pair of warring adversaries, fears surrounding global warfare were a

topical subject and emerged as the focus of the accompanying video which featured look-alikes of US president Ronald Reagan and then Soviet leader Konstantin Chernenko wrestling in a ring, while FGTH band members and look-alikes of other world leaders rowdily watched the spectacle and placed bets. The single went straight into the UK charts at number one and stayed there for nine weeks, during which time *Relax* manoeuvred back to chart position number two.

All the narrative threads of the FGTH story are equally compelling, even their name derives from an interesting source; a photorealistic Guy Peellaert painting of a young Frank Sinatra shielded from hysterical fans by bodyguards and a cop. Designed as a newspaper cutting, the headline read 'Frankie Goes Hollywood: Bobby-sox brigades cause near-riot scene'. Peellaert was already an established artist having designed the album cover of David Bowie's *Diamond Dogs*, The Rolling Stones' *It's Only Rock 'n' Roll* and film posters for *Taxi Driver* (directed by Martin Scorsese), *Wings of Desire* and *Paris, Texas* (both directed by Wim Wenders).

According to pop culture legend, ZTT's co-founder Paul Morley transplanted the song's title onto T-shirts to flaunt the band's triumph over censorship. The 'Frankie Say Relax' T-shirt has also been misattributed to Katharine Hamnett whose own monochromatic slogan T-shirts featured text which occupied the entire front of the garment, as did the 'Frankie Say Relax' T-shirts. However, Morley has remarked that the design for the T-shirt was actively inspired by Hamnett's design prowess and her comment of wanting her slogan T-shirts to be 'ripped off' which in turn reminded Morley of writer and musician Mark P wanting his 1977 punk fanzine *Sniffin' Glue* (*And Other Rock 'n' Roll Habits*) to be mimicked too, thus instigating the idea of 'fanzine' T-shirts.

Holly Johnson recalls the birth of the T-shirt: 'I remember finding about fifty 'Frankie Say Relax' T-shirts in the cupboard at ZTT/Sarm Studios and thought the typographical format was obviously taken from the Katherine Hamnett T-shirt, 'Choose Life' etc. as FGHT had been visiting Hamnett's studio regularly and wore her clothes but not her slogan T-shirts. Paul Morley, who I had first met as an NME journalist, now worked for ZTT as a kind of marketing person told me the T-shirts in the cupboard had been made up by the design studio XL using his slogan (XL was Tom Watkins' company, they did all the artwork and interior design for ZTT) as promotional items for the media etc., but no one wanted them or would wear them. So they stayed in the cupboard until we went on tour, but we had no band T-shirt to sell as merchandise at gigs and we were desperate for a T-shirt to sell, as it was really the only way we were going to make some money. ZTT didn't have our merchandise rights, but had the lion's share of everything else. So as I remember it, we paid him around £150 for the T-shirt idea which he was quite happy with at the time.' Johnson continues: 'I don't think I ever wore one of those T-shirts. I did hold one up for [photographer] Anton Corbijn on a photo shoot. There was no furore surrounding the T-shirt as far as I remember. The T-shirt came quite some months after *Relax* was banned by the BBC because of the lyrics of the song and the first video directed by Bernard Rose at Wilton's Music Hall at the end of 1983. Another, tamer performance video had to be shot using a laser beam [directed by filmmaker Brian De Palma].'

The 'Frankie Say Relax' T-shirt has emerged as a celebrity cult in its own right; it made a cameo in the 1998 film *The Wedding Singer* and on US TV shows *Friends* and *The Simpsons*. As credible now as it was when it made its first public appearance, the 'Frankie Say' T-shirt has recently been photographed on actresses Lindsay Lohan and Mary-Kate Olsen, although they were both born two years after the T-shirt was conceived.

Johnson shares his thoughts on the T-shirt's continued cultural importance and its relevance as a cultural touchstone: 'I think it's an interesting piece of 1980s pop culture, everyone remembers 'Frankie Say Relax', but there were others ... the final one was a batch made up by Katherine Hamnett who got it slightly wrong when she did our stage clothes for the last FGTH tour in 1987. I asked her to make 'Frankie Say Use A Condom' T-shirts and she made a batch of 'Frankie Says (sic) Use Condoms' ... they were just used on stage as far as I recall. I still have some. I love the fact that it is a memorable and iconic signifier of '80s pop culture; even Sir Peter Blake has used the phrase in one of his pop collages. The word "Relax" is actually my song title which people sometimes forget so when 'Kylie Says Relax' T-shirts appeared at the V&A I felt rather non-plussed that they hadn't sought permission. I guess it's one of those typical *Spinal Tap*-like pop moments when the band T-shirt becomes a profitable exercise for everyone else except the band. Some of the band members are unhappy about the appropriation and commercial exploitation of the slogan,' ruminates Johson with an economy of words that befits his intelligence.

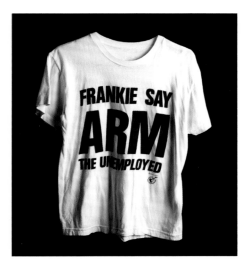

T-shirt: 'Frankie Say Arm The Unemployed', kindly supplied by Roger Burton at Contemporary Wardrobe; www.contemporarywardrobe.com • Model Lindsay Freeman

Chris Sanderson
at The Future Laboratory

The slogan T-shirt as a lifestyle tool

www.thefuturelaboratory.com

T-shirt: Chris Sanderson's own Henry Holland T-shirt bought at the Baltic Centre for Contemporary Art, Newcastle, 2005

'If there is text on the T-shirt it's making a statement and I suppose if I have an issue with the notion of the slogan T-shirt it's exactly that.'

'I think from a lifestyle perspective in the context of slogan T-shirts, you automatically have to recognise that there is a need or desire for the wearer to express themselves through the addition of a textual comment on the apparel that they are wearing. What happens is this extension of the way in which one's clothing can make a statement through a direct call of action via the use of meaningful copy,' states Chris Sanderson, co-director of superlative trend forecasting and consumer insight studio The Future Laboratory and creative director of the trend-forecasting magazine *Viewpoint*.

As Sanderson confidently proposes, brands also make a particular statement by tying themselves down to the neatness of a slogan in which to define meaning. As he explains: 'I grew up in an environment where we saw the huge development of branding in the '80s and so, for instance, the image of a man swinging a mallet on a horse in an advertisement became a lifestyle statement and that defined your lifestyle aspirations or social network or how you wanted to be perceived ... but the shift, I suppose, is then to take on a slogan which could to some extent be seen as the logical conclusion of something image-based. In a roundabout way it's about trying to create the social context of the need to have a slogan, and for many of us growing up in the '80s that did start with Katharine Hamnett. Hamnett really identified the genesis of the slogan T-shirt and of course her objectives were all about direct political action, she really set the agenda regarding the use of slogans on T-shirts, regardless of what maybe had happened before. In that sense Hamnett changed that type of sloganeering language ... I can't think of anyone else who did it as cleverly or as succinctly as her, until we fast track to Henry Holland's use of slogans because he too used language differently as well ... I bought his 'Swallow Me Whole Andy Warhol' from the Baltic Gallery in Newcastle, I love that T-shirt because it was a brilliant kind of linguistic conceit and it was designed in the way it looked as a graphic.'

Sanderson continues: 'So for me, over a period of twenty years, you have these two people who used it really effectively and in between there is just this morass of other brands sloganisng T-shirts. I suppose you start to see its kind of low point when you think about slogans like French Connection's FCUK campaign and how other named brands and their use of slogans on the

 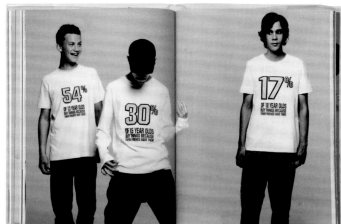

Sunshine Teens shoot; *Viewpoint*, Issue 14, Autumn/Winter 2003, kindly supplied by Chris Sanderson at The Future Laboratory • Photography: Donald Christie • Styling: Marcus Ross • Creative direction: Chris Sanderson

T-shirt appoints a low-cast, humour moment, but within that there are peaks and there are troughs and there are instants when you begin to see other people use the whole process of a slogan on a T-shirt to real effect and meaning, and if not meaning then some notion of merit which I think is quite interesting.'

As the creative visionary behind the exquisite magazine *Viewpoint*, Sanderson involved slogan T-shirts in a seminal photographic story, shot by Donald Christie, titled 'Rainbow Use'. The feature appeared in *Viewpoint*'s Sunshine Teens issue (issue 14) and explored what the next generation of youth were predicting in the age of a new millennium; their aspirations, their concerns, who their heroes were, what they felt towards peer pressure, gender differences and family frameworks et al. In essence, the objective was to identify the different ways in which adolescents communicated to each other. 'It was about how much information people were expressing about themselves as much as it said about ourselves,' notes Sanderson. To fulfil the project brief Sanderson handpicked a cross-section of optimistic, engaged and socially aware 13–19-year-olds. Subsequently, statistical data, both European and global, was generated from about ten different sources in which single facts were discussed in detail. Interestingly, when the issue was published circa 2003, 53 per cent courted the idea of fame, one wonders if nowadays the figure would be stratospheric.

The outcome revolved around the slogan T-shirt concept, with the resulting statistics and data printed upon the T-shirt surface. Conclusively, the statistics drove the slogans. As reasoned by Sanderson, the slogan T-shirt was the ideal medium by way of it being youth-associated apparel. Sanderson elaborates: 'By wanting to put data on T-shirts we were obviously looking at an idiom … at a way that information is often carried in culture and there was very much the idea of reading someone's T-shirt and asking what constructive information is obtained by that, and as most of us are painfully aware it's often nothing we haven't seen before, because the majority of information we see conveyed on a T-shirt is mindless and senseless, despite a few brands using it well.'

Being a trend specialist, it bodes well that Sanderson foresees the slogan T-shirt making a comeback, both as a social statement and as a political device: 'As we move towards a society that is becoming more polarised, social action and political thought become more important. I believe that we are moving into a period where the frivolous and meaningless are no longer so relevant or seen as fun, and I think we will see that clear demarcation of people who want to take a stand and wear something more meaningful. My own issue with the slogan T-shirt questions whether the text is actually witty or interesting, so many are moronic or offensive and are swamped by the number of occasions the sentiment has been used. I'm not sure I want to read something when I look at someone. I suppose in the same way that many of us have moved away from branded fashion very quickly, the idea of being associated with an obvious statement upon your T-shirt, be it the inappropriate use of language or misuse of language, is there written on your chest and once you are wearing it you can't really refute it.'

Although for Sanderson many of the slogan T-shirts currently in circulation may be meaningless, nonetheless they are inextricably woven into the fabric of daily life. Sanderson discloses: 'Twice a week when I go to the gym I wear a T-shirt provided to me by my trainer with the fitness company's name and slogan, I wear it without thinking about it. To some extent it advertises my trainer's brand but for me it's just something to exercise in, and I think that's the issue for many people, they are not looking behind the logo or label or the slogan. Still, I think increasingly the idea of a strong identity related to a slogan marks you out of a group affiliated with a particular persuasion, and that is maybe one of the reasons why slogan T-shirts will always be a mainstay.'

**Chris Coleman
at WGSN**

The slogan
T-shirt's
relationship
to trends and
appropriation

www.wgsn.com

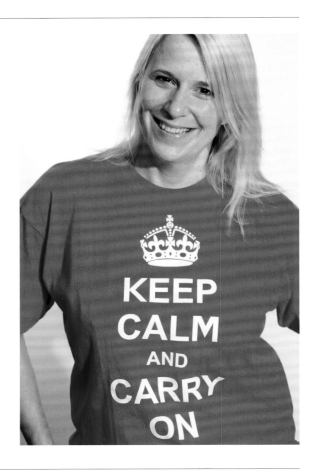

'Social media culture has really come through on T-shirts, it's all abut speed over process.'

'Slogan T-shirts have a very short shelf life, especially nowadays because everyone sees everything so quickly on the Internet, which is a shame because the world loses a type of word-of-mouth that made things like slogan T-shirts culturally exciting. Nevertheless, every so often you do see a big trend that defines the era,' proposes Chris Coleman, a trend authority and head of print and graphics at global trends forecasting company WGSN.

In recent years the slogan trend that has surfaced as a global anthem for the disenchanted was originally produced by Britain's Ministry of Information in 1939.Originally conceived as a morale booster in the event of war, the 'Keep Calm and Carry On' propaganda overtones continue to be symptomatic of society's unrest as world events persist in challenging its population. Although its debut appeared on a poster, since its resurgence in the mid-2000s the 'Keep Calm and Carry On' catchphrase has been parodied endlessly. It has also been employed as a lighthearted motto applied to popular cultural artefacts such as mugs, deckchairs, biscuit tins and of course T-shirts. Moreover, the plethora of websites offering customers a fully personalised version of the 'Keep Calm and

Carry On' adage inadvertently sees a return to a former generation that employed DIY tactics in which to fashion their own slogan T-shirts. 'Print on demand' has changed business models. Using digital technology to print T-shirts configured with one's own words enables an immediacy and availability that incurs little cost, little effort and results in a T-shirt that is wholly appropriate to the wearer.

Over the last few years 'Keep Calm and Carry On' has been customised incessantly. Pastiches of it have been reconfigured to include colourful expressions that subvert the proclamation's original meaning; 'Don't Tell Me To Keep Calm', 'Get Angry and Fight Back', 'Now Panic and Freak Out' and 'Resist, Revolt and Rebel' being popular motifs. Furthermore, the sovereign symbol above the text no longer performs reverently as intended by the 1939 poster, but functions as an emblem to overturn, as in the case of the 'Now Panic and Freak Out' T-shirt, or in the instance of the 'Resist, Revolt and Rebel' T-shirt the crown materialises as an oblique detail, thus negating its monarchical power.

Coleman explains how the 'Keep Calm and Carry On' phenomenon surfaced: 'In 2000 an original copy of the poster was discovered

in Barter Books bookshop in England's Northumberland by Stuart and Mary Manley. Since the fifty-year copyright of the poster had terminated they decided to reprint the poster on the request of their customers, but in 2011 it was trademarked by Mark Coop and this has caused a bitter dispute between the Manleys and Coop ... I think the attitude of 'Keep Calm and Carry On' resonated with people at a time when our global economy was tough and our outlook seemed quite bleak, and perhaps gave them the hope that we can pull together and get through these hard times.'

Serving as a socio-cultural and/or topical sensibility, the culture of appropriation habitually operates as a central theme for the slogan T-shirt and at times also enters the vernacular of trends. Historically, there has been a cultural tradition of borrowing forms, styles and genres in which to twist meanings and recontextualise the 'sampled' rhetorics. As a creative variable and a transformative device, appropriation engages with all themes,

positions and concepts of society and culture. 'Slogan T-shirts are fascinating because when they first appear they have this importance, but equally they can tire very easily and become *just* a fashion item and then at that stage they lose their impact,' notes Coleman. To illuminate this point as a paradigm, Coleman looks to the CND symbol as one that has over the years been reduced to a cliché, although not technically a slogan it does manoeuvre within the same framework. Coleman expands his argument eloquently: 'If you think to the campaign for nuclear disarmament from fifty years ago it now seems to represent something far removed from its intended meaning. I see kids sporting it but they have no idea what that symbol represents, and that type of manifestation is just as applicable to the slogans on T-shirts. So you have to look at it subjectively, as in what reasons are they wearing it for? Is it just to be fashionable or trying to fit in or do they actually support what that statement says.'

As described by Coleman, the modus

operandi of predicting and analysing trends is an accumulative process: 'Trends have to involve a big picture so we look at everything ... we research what's going on all over the world that potentially could create macro trends in a couple of years' time. Essentially, we come across information and inspiration and use them as influencing tools by taking them to the global stage. Trends get picked up at different points, there are early adopters and late adopters; the early adopters like to embrace new innovations, whereas a late adopter will be more receptive to new ideas once they have found their place in the mainstream.'

The 'Keep Calm and Carry On' maxim exemplifies how slogans can transpire as a characteristic of a prevailing taste across generations and at a time that personifies social turbulence. 'I think if you added "but" in there as in 'Keep Calm BUT Carry On' it would have made even more sense,' Coleman ingeniously concludes.

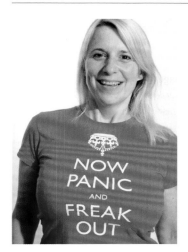
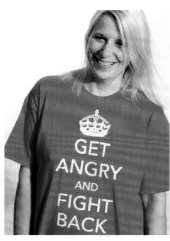

All T-shirts kindly supplied by T Shirt Town; www.tshirt-town.com • Model: Fiona Cartledge

Julian Vogel
at Modus PR

The slogan T-shirt as a marketing tool

www.moduspublicity.com

'The slogan T-shirt is your personal placard … in a way it gives the wearer a personality.'

'It just seems like everywhere you go whether it's an art exhibition, a festival or a pop concert there is a T-shirt available, there's a whole ethos of "been there, seen that, got the T-shirt". Friends in the music industry tell me that they make their money from merchandising rather than music sales, so what starts off as a by-product is now *the* product and that has become one of their main forms of revenue,' so begins Julian Vogel, co-director of one of London's leading fashion PR and marketing companies, Modus PR.

'When I think of brands I have worked with who have used the slogan, the obvious one is Katharine Hamnett,' recalls Vogel, who was Hamnett's press representative circa 1994–2002. 'Even after her famous encounter with Margaret Thatcher in 1984, Katharine carried on using it every season. More powerful than simply using the media to publicise a message, Katharine realised early on that, after her catwalk show, there would be dozens of camera crews and news channels queued up to interview her and there she could have the platform of fashion to communicate her concerns … It was the early MTV generation, and at the time there was a big satellite channel called Star TV which

covered all of Asia, so the coverage was huge … You had all these different audiences including a younger, fashion-conscious audience who were much more receptive to political ideas coming from a fashion designer rather than from a politician. Katharine was very astute at recognising this and realised that by doing all these interviews she was speaking to the world … and although she talked about her collection, she also talked about the causes she was championing, she *always* knew her facts and figures.' Rather insightfully, Vogel notes that what was particularly distinctive about the '80s and early '90s (often seen as a cultural hangover from the '80s) as well as the period he was working with Hamnett, was that it was a pre-social media era: '… But that power Hamnett tapped into has changed now because of the likes of Twitter and Facebook.'

A more recent client of Vogel's is Japanese high street clothing brand Uniqlo: 'Each season they produce around three thousand T-shirt designs including different kinds of licensed graphics, theirs are really great canvases for graphic designers too, not just fashion. Uniqlo have this initiative called UTGP, it's a competition open to anyone. The winner

receives a cash prize and their design is sold in the stores worldwide. They are currently linking it [the UTGP initiative] in with a corporate identity, for instance Coca-Cola, and what I thought was interesting was that our sense of belonging is so connected with branding and the passion one has for a brand. Personally, I can't imagine why someone would want to wear a corporate logo on their chest, but maybe that's an extension of your love for your chosen brand ... I suppose if you think of it in terms of Ralph Lauren's Polo motif or Lacoste's crocodile, then why wouldn't you have, for instance, your love for Coca-Cola on your chest? Corporates are always really excited about collaborations like this because it's free advertising ... and I still think the T-shirt is the garment to do that.'

On a personal level, Vogel cites the idea of collectivity such as stag and hen dos as 'getting it right' when it comes to wearing slogan T-shirts, 'mainly because the uniformity of the group

become its own community'. This idea of unity extends to familial kinship, which is strengthened by the visual display of a deeply personalised and shared slogan: 'I was at LA's airport recently and saw a large family all gathered together. The female members were wearing red T-shirts and the male members were wearing blue T-shirts, all with 'The Jones' family trip to LA', printed on them, it was very tribal, almost like a family tartan. I loved how their T-shirt looked like it gave them a sense of togetherness.'

However, there is a slogan T-shirt spectrum of a vulgar variety that Vogel finds aggressive: 'What we are wearing is a message we want to project to the world, but as the wearer you are sporting something you can't read, so it's easy to forget that you are wearing it and that your T-shirt is giving out that message ... so what you are seeing are people's reaction to your T-shirt, not the T-shirt itself. Where do you cross the line, because you are invading other people's

personal space with your own thoughts and the inappropriateness of that message.'

For Vogel a slogan T-shirt can be a great press tool, not only as a means to convey power, but also as an expression of marketing, 'because it's hard to market a T-shirt if it is plain. I can't think of a time when there hasn't been a T-shirt. I've never not owned one, even as a child T-shirts were everywhere. I guess the obvious reason for its appeal is that it's a very basic garment that's also trans-generational and adaptable, it fits in with whatever other items of clothing you have in your wardrobe ... you can always find one that will fit you. Yes, when I really think about it, the T-shirt is more than just a staple, it's a bit of a leveller ... a safe garment as you can customise it and completely make it your own, and of course cost wise it's easy to find one that suits your budget. So, as a functioning garment, it's very versatile and in a way that versatility has to be part of why it's become such a cult item.'

T-shirts: Katharine Hamnett backstage staff T-shirts for her catwalk collections Spring/Summer 1995, Autumn/Winter 1995/96 and Spring/Summer 1996, kindly supplied by Julian Vogel • Model: E-Sinn Soong

Neil Boorman

The slogan T-shirt's relationship to branding

www.neilboorman.com

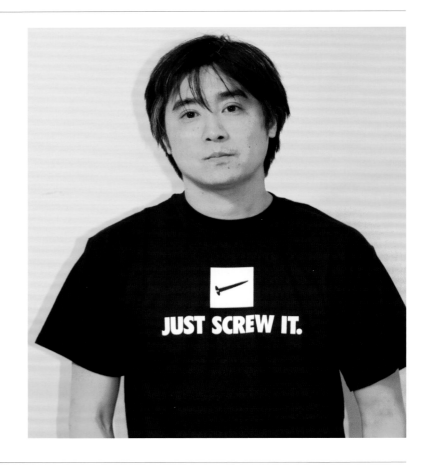

JUST SCREW IT.

'I think it's become too easy to define ourselves by the logos we wear. We have a whole generation of people who've been preoccupied by shopping for a pre-packaged identity that never have the time to find out who they really are. If a big fire swept through our cities and destroyed all our possessions, we'd have a mass identity crisis on our hands.'

The Western world is not only a branded world, but also a brand-obsessed world. Society inculcates brands with meaning. Furthermore, brands are so integrated in daily life that paradoxically their visibility is almost camouflaged by their own prevalence. Similar to fashion consumption per se the slogan T-shirt as a media surface is a branded experience. To wear a branded T-shirt is to parade a brand's values and to identify or aspire to its (arguably) prescriptive lifestyle. Furthermore, wearing a branded slogan T-shirt is not only a public display and endorsement of one's affiliations, but tacitly applauds capitalism's merits by proxy.

Typically a brand is a 'product' identified by a name, logo, symbol or trademark, in essence branding is the overall delivery and direction of the product in question. It is a vacillating debate whether brand names and logos can be considered slogans. If we regard slogans, in their most skeletal form as methods of expression and communication, and the forceful nature of brand names as carriers of meanings, then branded names upon T-shirts may qualify as one of the many variety of slogans that inhabit its flexible framework.

Considering that we live in an image-saturated economy that privileges a consumer's sense of identity and social positioning through the commodity experiences of a brand's symbolic and aesthetic values, the virtues of consumer culture and brand awareness are a hugely divisive topic. Writer Neil Boorman, whose route towards a brand-free existence was documented in a fascinating BBC programme, broadcast in 2006, and a book *Bonfire of the Brands: How I Learned to Live without Labels* published in 2007, is uniquely positioned to comment on the destructive qualities of *excessive* consumption as championed by the very nature of branding and marketing. Much of Boorman's recent journalistic worked has charted his shift from being brand-driven to brand-less. 'Brand logos, emblazoned on T-shirts, are slogans for people who can't think of anything to say. Brand T-shirts are a bit like ready-made frozen meals; mass-marketed and mass-produced, you pick them off the shelf for an instant hit because you don't have the time, energy or creativity to do it yourself. But with T-shirts, you're buying a ready-made statement that communicates how good you are at fitting in to a marketing demographic. So an Apple

Mac logo on a T-shirt is saying: "I want you to know that I'm creative and cool because I buy a particular brand of expensive gadgets". No one in their right mind would have that written on their T-shirt. But the brand logo allows you to say all that in a socially acceptable way, through the symbolism embedded in the logo.'

Images of an ideal self are nurtured through advertising and branding practices, however as Boorman asserts, advertising practices just publicise the messages of a brand, whereas branding practices are 'the sum total of a company's output, from product and packaging advertising and marketing'. He continues: 'A brand unifies all these elements and ensures that they are produced under a set of common values. That's how a successful brand can say so much in a simple logo – it symbolises the values and promises of everything the company does.'

Inevitably, different social groups and demographics will have different relationships with branded goods, based on logistical features such as the assigned gender or lifestyle roles attached to the product. A brand's ability to offer reassurance, familiarity and quality is generated by aggressively targeting its desired market. So the branded slogan T-shirt operates as an item that alludes to not only financial status, class, taste, aspirations, sense of collectivity et al., but are also as a sartorial form of unpaid advertising. No longer is designer apparel identified for its cut or silhouette, but rather its explicit display

of an emblem is often what makes it covetable. Although a cyclical and mutual relationship is at play (i.e. an individual wears an 'I love xyz' T-shirt to publicly display their credentials, but likewise 'xyz' exploits the individual's support of its brand to promote further their corporate strategy at the expense of the consumer), the notion of direct *and* indirect publicity emotes vitriol to those branding detractors.

Boorman elucidates with authority: 'All of us use brands to define identity; they're a convenient visual shorthand that we rely on to help us make quick decisions. Even the smallest of branded purchases communicate this; if you smoke Marlboro Lights you live in the south of England, Embassy in the north. The brand of coffee you keep in the house speaks volumes when people visit your home. The milk you add to the coffee, the cup you drink it from – all evidence of the person you are, or more often these days, the person you want to be. People often argue that the decisions they make aren't influenced by brands – especially people over fifty who have a clearer idea of their identity. But then you ask them what car they've got in the drive, and it's never "less" than a nice mid-market saloon – anything "less" and they'd somehow be letting themselves down. Their identity is tied to branded purchases just like everyone else.'

Arguably, the seductive properties of brands operate as both uniforms and vehicles of status and enchant consumers with the prospects

of social 'membership' to like-minded social groups. Still, this gesture is not necessarily one of benevolence but one that pursues commercial gain. Brands may be encoded with social values and ethical messaging, but their rudiments are often nurtured by corporate investment. The commercial spectrum of corporatisation manipulates a consumer's 'power' to *make* the sale and to secure loyalty to its product.

Given the size and reach of Western consumer fashion, the mass market appeal of branding is also a pleasurable object of consumerism, although the dichotomy of the effective, persuasive, exploitative quotidian emerges: 'As long as a brand has the right type of person wearing their T-shirt, they've got the perfect advertising billboard – people are mobile, highly visible, and best of all, in buying the T-shirt, the wearer pays the company for the pleasure of advertising the product. Its win-win for the brand.'

Boorman is currently a writer and producer at human rights organisation Amnesty TV, he concludes: 'When you pull on a branded T-shirt, you associate yourself with a whole range of cultural values and social tribes; you associate with the brand's celebrity ambassadors, if the logo is currently cool then you prove that you're up on the zeitgeist, and as long as the logo isn't a swastika or an anarchist 'A', you demonstrate that you are normal. On the face of it, you get a lot for your money.'

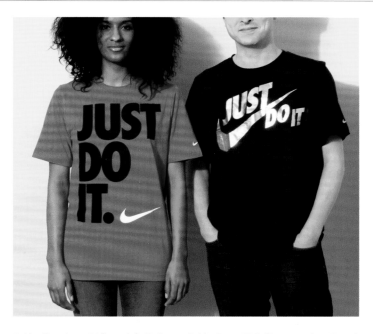

T-shirt: 'Just Screw It' (opposite), kindly supplied by Force 18 T-shirts; www.force18.co.uk
• Models: Albert Kang and Lindsay Freeman

Scott Maddux

The cult value of the slogan T-shirt

www.madduxcreative.com

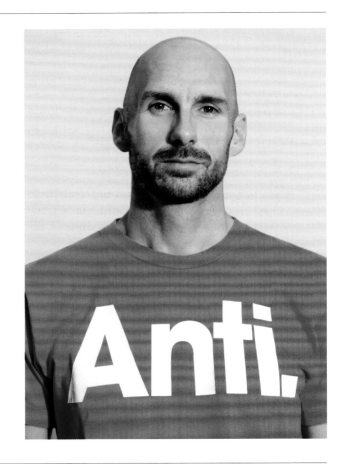

'I bought the 'Anti' T-shirt not only because it looks great, but it felt like a protest T-shirt without really having anything to protest about…'

'Anti' as an isolated word resolves itself as a straightforward statement. As a prefix, however, it gives direction to its following word and likewise its successive word has the ability to polarise the denotation of 'anti' *as* a prefix.

By placing the word 'anti' – which explicitly proposes opposition in a central position – upon a T-shirt (as in the case of Experimental Jetset's 'Anti' T-shirt design), it functions as both an uninhibited announcement as well as an uninhibited graphic. This is further reinforced by the visually definitive use of a serif-less font and the finality of a full stop. Thus, the T-shirt's meaning is constructed through the symbiosis between the singularity of the word, the capital letter 'A', the conclusive punctuation mark, and the visual of the typography. As a result of Experimental Jetset's typographical choices text also becomes image.

American–born, London-living, interior designer and design enthusiast Scott Maddux bought his 'Anti' T-shirt in 2000, as he explains: 'At the time there was a real capitalist consciousness in the atmosphere, my impression was that people were becoming more aware of *what* they were buying and how those things were being made; the idea

of ethics entered the equation. I was reading Naomi Klein's *No Logo* and watching Michael Moore's movies, I was really getting into the theme of branding and exploitation. In a way, despite ethical issues becoming more prevalent and a lot of rage against heavy branding and capitalism, there was still a certain apathy going on as there wasn't really anything to direct your anger towards other than where your shoes were being made … Looking back now there was a lot of doing without thinking, it was a relatively vacuous time, politics were pretty safe and flat, and *then* 9/11 happened and a shift into real politics materialised.'

Maddux shares how attached he felt to the T-shirt when he first purchased it: 'I loved that T-shirt, for me it was making fun at the idea of being anti, I still do love that T-shirt but post 9/11 I wore it much less, mainly because I think there was an undercurrent of politics in everything that we did including what we wore, everything became a little more poignant … Suddenly there were real issues, big issues, political issues that were affecting us all, so to make light of politics was more difficult.'

Maddux continues with his usual erudite

point of view: 'Post 9/11 the word anti really made you think about groups of people, so immediately the world became much more factional.'

Maddux reflects further: 'Slogan T-shirts signify a certain moment in time, they arise because of an event in a cultural climate and I think that's when fertile ground gives rise to cult items. I think the 'Anti' T-shirt has cult value insofar as the designers are pretty iconic themselves ... but the idea of something being "cult" is usually associated with the niche, and this particular T-shirt is really about the general.'

In Maddux's vernacular, cult T-shirts revolve around a sense of collective recognition and a group dialect: 'The common visual language exists because of the culture it is coming from and it also influences it, so for instance you don't necessarily think of your favourite T-shirt as a cult T-shirt at the time when you are wearing it. As with all movements and trends, if the cult T-shirt gets too mainstream visual saturation dilutes its meaning ... and however superficial, cult items tend to have an exclusivity to them, there is definitely a snob value. Cult is definitely related with the underground, so when it goes overground its allure is diminished.'

According to Maddux, the 'Anti' T-shirt possesses a timeless quality because, in his opinion, the word itself is 'quite vague'. He says: 'Because of that I suppose it can refer to anything, at any time, I would have thought that was the point of the 'Anti' T-shirt, it gives an opinion without expressing anything specific, it's *deliberately* vague ... Anti as a word in itself, is 'against', so it has a definite slant before you start exploring what it is you are against.' Maddux, himself a style rebel, professes an unswerving affection for T-shirt culture: 'Definitely as a youth you are defining yourself by what you wear ... actually you are defining yourself with *T-shirts* a lot more, but at the moment people seem to be dressing much more smartly, and so it seems that T-shirts are not enough presently but their day will return, it always does.'

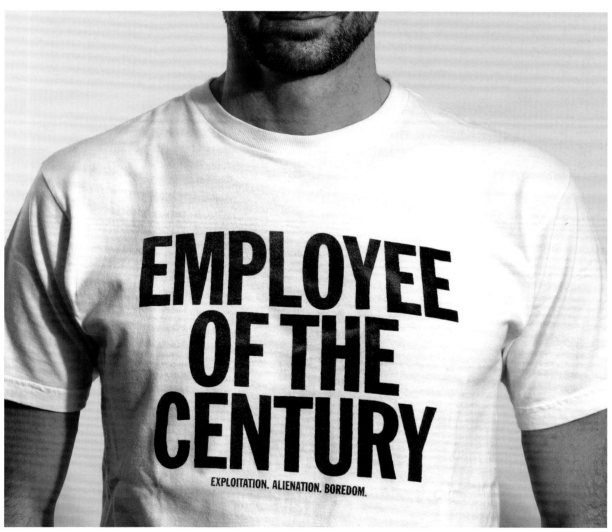

T-shirts kindly supplied by Scott Maddux • Model: Scott Maddux

**Simon Lee
at Simon Lee Gallery**

The relationship between the slogan T-shirt and high art

www.simonleegallery.com

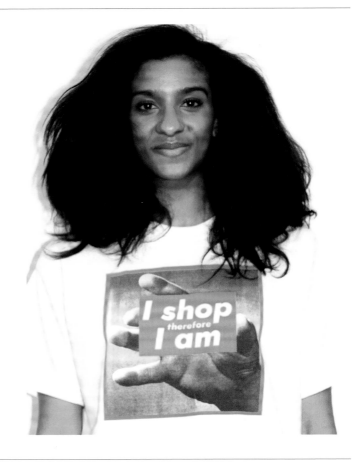

'The devaluation
of an artist's work on a
T-shirt depends on
the artist's *own* objectives.'

American artist Barbara Kruger's pithy aphorism 'I Shop Therefore I Am' (1987) is not only a cultural reference implanted in popular culture, but is a touchstone of popular culture itself. Kruger's recognisable colour palette of black, white and vermillion partnered with monochromatic, closely-cropped photographic snapshots and bold statements recalls her formative years as art director and picture editor for publishing house Condé Nast. In a world where the social multiplication of images dominate, and increasingly individuals across the globe have access to the same set of computerised graphics editing programs, establishing a trademark visual signature is quite a triumph. Kruger's tableaus are now so recognisable that they have become a template for imitation and appropriation.

Central to Kruger's work is the juxtaposition between critical thought that challenges gender stereotypes, consumerist values and the circulation of media content alongside images that are themselves sourced from mainstream print media. As a result of her adaptation of existing images Kruger's collages symbolically layered and materially layered meanings that critique the dominance

of mainstream capitalist culture, whilst her caption work concocts new motifs of contemplation. Besides Kruger's legendary 'I shop therefore I am', other notable quotes include 'Your body is a battleground' and 'Plagiarism is the sincerest form of imitation'.

This elasticity between art and commerce is demonstrated not only in Kruger's artwork but her chosen places of display, as was the case of the billboard space she hired in one of New York's foremost commercial intersections, Times Square. Thus, the question whether an artist's work is devalued by transporting it onto the surface of a T-shirt is, as premier gallerist Simon Lee reveals, 'dependent on the practice of the artist'. As Kruger's representative during a period that saw her classic tropes transferred onto T-shirts, Lee proposes: 'Kruger's work exists in the public realm, and considering that it appropriates the language of mass media such as ostensible consumption in art, demands of consumerism, luxury and degradation, it lent itself to that type of presentation ... it's a media-based work to begin with. The practices of artists like Kruger are predicated on a democratic, non-elitist type of art form, so in that sense they are like the common

denominator that the T-shirt represents.'

The T-shirts were manufactured in Japan by a company whose expertise was highly revered in the art world having produced T-shirt merchandise for the estates of Keith Haring and Jean Michel Basquiat et al. 'I seem to recall the T-shirts themselves cost twenty dollars each or thereabouts which really suited the nature of Kruger's ethos,' notes Lee.

Lee reveals that since the T-shirts were never exhibition pieces, the issue of critical acclaim didn't enter the equation, 'they were worn virally more than anything else and I think that is the disposition a T-shirt; that it's out there subliminally impacting on people and I think that could be a reason why artists are attracted to the T-shirt as a vehicle, because it has "street" appeal.'

Amongst Kruger's contemporaries, fellow American conceptual artist Jenny Holzer's use of aphorisms and maxims, known as 'Truisms' (1979–) also employs highly-populated public spaces as the medium in which to exhibit her work, including the public space of T-shirt-wearing bodies. As with Kruger, Holzer co-opts advertising strategies as both a means to formulate her work and the sites in which they are displayed. Street posters, LED signs, illuminated projections on public edifices have all succumbed to Holzer's textual insignia, whilst the application of her work on everyday artefacts such as bags, mugs, posters, postcards and T-shirts permits egalitarian ownership of her work.

However, whereas Kruger uses both upper and lower case type, Holzer capitalises her entire sentences. Interplaying sincerity with irony, Holzer's declarations that have appeared on T-shirt surfaces include her acclaimed 'PROTECT ME FROM WHAT I WANT', 'GOOD DEEDS EVENTUALLY ARE REWARDED', 'ABUSE OF POWER COMES AS NO SURPRISE' and 'RAISE BOYS AND GIRLS THE SAME WAY' which was shrewdly screenprinted on to a child's T-shirt.

Lee cites the work of Richard Prince as a contrasting counterpart to Kruger (and Holzer). Loosely stretched over frames as opposed to the convention of a tautly stretched canvas, Prince's distressed T-shirts function as both the canvas and the seemingly casually-painted, final artwork. Prince's use of the T-shirt elevates its status from a commonplace item of apparel to an art-based project adorned with abstractions, fragmented texts and visual overtones from hippy culture; all gently nodding to an era that one suspects was culturally euphoric for Prince. 'What Prince has excelled in is turning the T-shirt on its head by partnering it with a frame and contextualising it in a gallery space. He also made protest paintings and that came from the T-shirt idea,' concludes Lee thoughtfully.

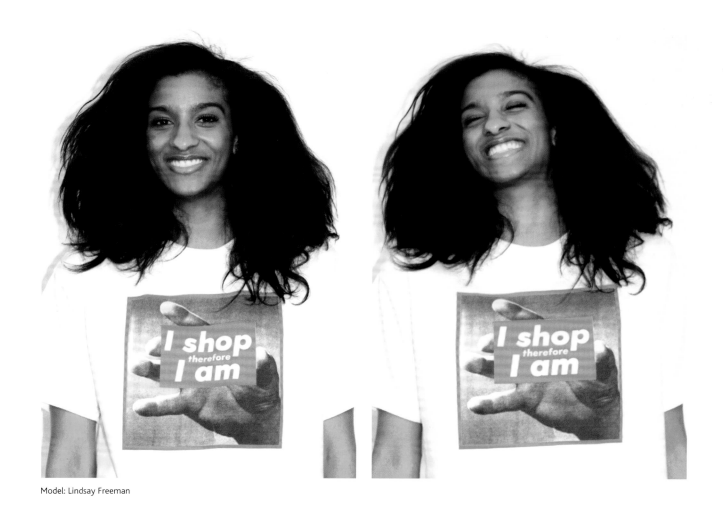

Model: Lindsay Freeman

**Larissa Clark
at Environmental
Justice Foundation**

The slogan
T-shirt as
a campaign
tool

www.ejfoundation.org

'Our campaigns are about
the rights of people in developing
countries, and if a T-shirt
can draw the public's attention
to our concerns then we will
incorporate it into our strategy.'

'For a campaigning organisation, the slogan T-shirt is a classic. It works for a start and it means people can buy into your company's beliefs and vision. Organisations like the Environmental Justice Foundation [EJF] are about raising awareness on issues that otherwise go ignored', begins Larissa Clark, the EJF's PR and marketing director. 'The more people talking about it [a campaign] the more action can come from it. T-shirts are a great fundraiser and we're a small organisation so to go out to raise money in a way that we are proud of is crucial ... If our designs excite activists it's an accomplishment, if our designs motivate consumers it's an accomplishment.'

So often environmental campaigns achieve a media momentum and then seem to quite suddenly vanish from the limelight and subsequently people's consciousness, but as Clark explains: 'Campaigns don't get dropped, the reality is that it is really hard to maintain the message in the media for a long period of time because the attention is all about "the latest"; everything has a shelf life, and so although the issues are still urgent, and as an organisation you are still involved in campaign advocacy, in terms of the media it's old news,

so you have to reinvigorate the message and develop it and hopefully it then becomes sufficiently retro that you can bring it back.'

Established in 2000, the EJF is one of the premier organisations in the UK that protects both human rights and the environment in developing countries. Amongst its wide spectrum of campaigns are the exploitative cotton farming issues in Uzbekistan, the world's third largest exporter of cotton. Cotton is the most prevalent natural fibre that exists in clothing manufacture, often grown in unsustainable ways, and as Clark reveals, 'Uzbekistan has a regime with a brutal history of human rights and environmental abuses in the cotton industry.' Considering that T-shirts, slogan and otherwise, are constructed from cotton, knowledge of their origins is vital.

Katharine Hamnett was the first designer to back the messaging side of a wider consumer campaign that addressed the conditions in Uzbekistan. The result was a white T-shirt with Hamnett's signature type asserting 'Save the Future'. The choice of words was created as much for its positive exuberance as it was to raise the question why the future needed, and continues to need, saving. This set the template for a large number of global fashion designers,

many whom are British, to contribute to the EJF's growing slogan T-shirt range.

The EJF recognises that for its merchandise to appeal to a wide audience 'to make our footprint' it is vital that contributions are from established designers. Likewise, by commissioning esteemed fashion mavens demonstrates how a sustainable T-shirt can also serve as a fashion-forward, covetable item of clothing.

Although the EJF's T-shirt campaigns are photographed on a number of recognisable

faces from the world of entertainment, Clark stresses that because it is a fashion product and a fashion issue, it makes sense that fashion designers create the artwork for the merchandise, rather then graphic designers or musicians. This enables the EJF to engage with the fashion industry in a way that the fashion industry works. 'We hope people buy the T-shirts to support our cause, but should they buy it for the design alone, then we have to accept that as a donation, even if it's an indirect donation.'

There are many factors that Clark attributes to the success of its T-shirt project. For a start the EJF does not promote a fast fashion mentality. Each year it *adds* a new wave of designers to its range alongside its existing designs, rather than replacing them. This allows the T-shirt series to maintain a long-term and ongoing presence in the public domain. The fact that they are stylish is a given.

Colours are kept to a minimum to reduce the costs of production, therefore more revenue can go to the project itself, and instead of a

traditional label, all the T-shirts are imprinted with messaging in their necklines informing of the EJF's commitment to low-carbon T-shirt production, and ensuring 90 per cent reduction in their carbon footprint in comparison with a standard T-shirt produced in a more customary way. The EJF also offers assurance that the T-shirt has been fair-traded, ethically made and is 100 per cent organic. 'Essentially we are promoting positive products.'

The misconception that the use of organic cotton conflicts with the aesthetic qualities of a garment often stems from a lack of knowledge of the fundamental facts of what organic cotton actually is. Quite simply, organic cotton is grown without the use of chemical pesticides and chemical fertilisers; not only do these cause incredible damage to the soil but also harm those working the fields. Clark elucidates: 'Farmers may be illiterate and therefore can't read the care label that may advise to wear protective clothing for instance, or the instructions may be in another language. This leads to accidental poisoning with one million a year affected. We have recently achieved a global ban with another NGO [Non-Governmental Organisation] on the chemical endosulfan, this is a triumph for us as we started working on its interdiction ten years ago, as one of our first ever campaigns.'

In addition to consumer awareness, the EJF also engages with the industries that are often the source of the problem. 'The issues we campaign on nearly all feed all the way back to consumer products from richer countries; from the clothes we wear; to the food we eat; to the products we consume. There has been a growing awareness of the importance of transparent supply chains and the understanding of provenance, because until where you know where something comes from you have no idea where and how it was made, who made it and in what conditions. It's very often the origin of the product where problems really lie because awareness of that route is unknown for the end user. It's also about the cause of why those problems are going on in the first place, for instance if things are being demanded too much too quickly or too cheaply, our work endeavours to change behaviour and attitudes so that it can be a long term change.'

This long-term change is achieved through the EJF's working relationships with NGOs and grass roots organisations in the developing countries that are affected, as well as affiliations with the UN (United Nations) whilst also campaigning at a political level at the EU (European Union). However, the EJF's involvement transcends humanitarian establishments.

Working with the relevant industries and retailers is critical in the EJF's efforts to effect change. 'We've had great success with our cotton campaign, now forty of the biggest brands in the world including the Arcadia Group, Gap and Nike have all committed to a ban on Uzbekistan cotton until human rights abuses and environmental abuses cease. Because the problem we took to industry was massive, we began by asking where their cotton came from and the first response was nobody really knew, they just bought their cotton from a trader, so we demanded accountability from where the cotton had come from as a first step. It was a really big deal for these retailers when you think about the number of products they sell.'

Yet, the foundation of the crisis is not always at the level of manufacture, but the fields where the cotton is grown and picked that sees children taken out of school to help their families financially. The EJF took the position of informing brands that buying their cotton from countries such as Uzbekistan is fuelling a horrific regime, all to benefit an elite. Clark asserts: 'We believe consumers should have the knowledge to decide which product they want to buy. Our message to these brands was quite simply "is that what you want your shoppers to spend their money on?" and within two years there was a huge response from industry to try and understand the supply chain of cotton … We believe in a safe, natural environment that can provide for people; where people have access to food and water and can earn their livelihoods under humane conditions, we believe that that is a basic human right.'

T-shirts: 'Save The Future' and 'No More Fashion Victims' both designed by Katharine Hamnett for EJF • T-shirts kindly supplied by the Environmental Justice Foundation in conjunction with their cotton campaign 'Pick your cotton carefully' • Model:: Amy Thompson

Shumon Basar

The slogan T-shirt as a political tool

www.yourheadisthewholeworld.wordpress.com

'The brevity of slogans is Twitter culture. We need terseness. But not at the expense of informed tracts and detailed reflection.'

In 2000 social theorist James Slevin claimed that new computer technologies, such as the Internet, were opening up opportunities for new forms of human association. Fast-forward to over a decade later and it is self-evident that the Internet, replete with its vast reservoir of choices, offers users new kinds of social experience. The scale of social dissemination multiplies vigorously as online subjects negotiate electronic social space, in some cases leisurely and casually, and in other instances shrewdly and strategically.

It seems inconceivable that not so long ago computers were elite machines associated with the sciences. A generous decade later and technological space has metamorphosed into social space. This shift has increased the facility to obtain insights into proliferating individualised social and political spheres and their accompanying codified worlds. Naturally there are prohibitive exceptions, mainly pivoted around political and economic constraints. Subsequently, the idea of a singular and generic 'universal' Internet space has been contested as being generalised and deterministic given that technologised space operates as a multiplex of networked sources, each emblematic of

respective geographies and mobility patterns, which are nourished by particular cultural, social, political and economic dynamics. Nonetheless, web-based practices are actively appropriated to create the kind of personalised, mediated experiences users desire, operating as a conduit that enables social agency.

A pivotal shift has seen textual *and* visual representation, as exercised by the new wave of social utility networks and mobile devices, stimulating new practices of identity management in which to engage a potentially, panoramic audience: ditto slogan T-shirts. If we consider the slogan T-shirt as a sartorial agent that has the ability to give exposure to political biases and social beliefs, then the sentiments of cross-traversing electronic networks can be applied to the notion of *cross-traversing* tangible networks sporting one's own one-line manifesto.

'A lot is being said about how social networking sites have contributed to populations reaching critical mass and then tipping point,' states Shumon Basar, whose work as a highly revered cultural commentator, an art critic and an editor at *Tank* Magazine sees him regularly globetrotting between four continents. 'Perhaps the most important aspect, to me anyway, is

'Donald Rumsfeld was the Wittgenstein of the War on Terror', notes Shumon Basar

Model: Albert Kang

how technology allows the circumnavigation of other repressed circuits of technology. Therefore, if your dictator runs the entire national media, there is no image of public dissent. I have to say I haven't counted how many slogan T-shirts appeared in Tahrir Square or Tunisia or in Bahrain. Placards, yes. Home-made posters, definitely. T-shirts? I'd have to re-watch Al Jazeera footage and keep an eye out for them. They haven't featured as a talking point. Either this is because they're not there or they're so ubiquitous as to not be of newsworthy interest. I just don't know,' asserts Basar.

Basar looks to slogan politics as a democratic and transparent counter-cultural tool that endeavours to combat a hegemonic language that is often both duplicitous and esoteric. Accordingly, popular culture and political culture are inseparable, the culture of irony being both political and apolitical whilst indifference to politics is categorically a form of political agency. Basar articulates his point with precision: 'Mostly apathy emerges when you feel there is nothing at stake anymore or when your freedom, on a base level, doesn't require you to fight for your rights unlike in oppressed countries ... the ultimate ironical end point of political freedom is the freedom not to care about politics and use your time, energy and money in any which way that you want such as pop culture artefacts, but I would argue that that freedom is still political.' With this in mind one could consider consumerist pursuits and boasts about them as expressed on slogan T-shirts such as 'I Love Dior' or 'I Love Boys,

Bags and Shoes' fitting into the late capitalist culture and political lethargy remit that Basar so eloquently elucidates.

Basar illustrates this position further: 'I visited Occupy Wall Street a couple of days after it began [17 September 2011] to see the anti-capitalist demonstrations. I wanted to go because I have ended up in places where there have been occupations and demonstrations and volatile situations; spaces of protest, often economic protest, and the speed of the merchandising is astonishing. One of the interesting things about Wall Street were the placards, the inventiveness of people's one liners ... people have become amateur professional copywriters in their own right; one of my favourites was "Finally An Occupation That Jews Can Support". A number of people were wearing T-shirts but I gave it just a day or two before the conceptual rhetoric proliferating the Liberation Plaza would be immediately turned into T-shirts. Incongruously, it was right next to Starbucks, I saw someone protesting against the venal nature of the finance world chomping on a Pret A Manger sandwich, so the contradiction is palpable ... The whole phenomena of protesting against capitalism is so deeply riddled with contradictions, it's not to negate it, but for me all it does is reiterates the depths to which we are all implicated. One of the questions I thought about whilst there, is "what would it mean to depose capital?". This is what this type of protest should in essence really tackle, but it's a very difficult thing to tackle because it's somewhat abstract. It's like

an asymmetrical warfare and so I think there is something very interesting about the parallels in which capitalism proliferates through our lives throughout the world as a modern form of terrorism and for me the slogan T-shirt is the obligation to express your concerns, even if ultimately you know your expression is impotent. But what can you do? One of the only options is to manifest disaffection and frustration and maybe for some that is through wearing a slogan T-shirt.'

This is also characterised by dichotomised factors that both empower and disempower in equal measure, principally because in Western society most of us have full command of our bodies; adorning them and expressing them as we desire, as Basar postulates, 'We have to remind ourselves that a third of the world don't really own their bodies.'

According to Basar the affected power of these protest movements and protest gestures, which may include wearing a sloganised T-shirt, are close to zero as there is a fundamental misconception where power resides today: 'I believe in the right to express whatever you want to express and the power that it might give you back or act as a catalyst for a community of likeminded people, but I am highly skeptical about it being accepted in any greater scheme and of course they are all context specific ... I think there is a potency for the individual who wishes to demonstrate, express and inhabit the world through the means of their verbal expression but, for me, in the world today, the vast discrepancy in individual agency and actual political or economic power is evident.'

Basar concludes on a decisive note: 'There probably are some things in the known universe that exist as incontestables, precisely why we don't see T-shirts for them, but I'm prissy ... I want my discourse to be constantly calibrated and plastic. Which is not to say that equates to being evasive. I hope not. Yes, maybe I'd like to see relativist T-shirt slogans, in that fraught Derridean way, where every statement put forth is quickly and anxiously qualified by all its attendant, epistemological caveats. One of my favourite slogan-ish quotes comes from Factory Records mogul Tony Wilson, who was citing New Order lead singer Barney Sumner, when describing the transformation from punk to post-punk: "For a couple of years all we needed to say was 'fuck you' but sooner or later someone would have to find a way to say 'I'm fucked' with all the intensity on earth."'

Howard Besser

Political slogan T-shirt collector

http://besser.tsoa.nyu.edu/T-shirts/

http://besser.tsoa.nyu.edu/T-shirts/AA96/

www.digitalpreservation.gov/partners/pioneers/detail_besser.html

http://web.archive.org/web/20000816010020/

http://www.academicinfo.net/usmodlibrary.html

'The fact is that T-shirts are some way of indicating in public your belief in something, and so to find a group of people in one place, like in a demonstration, and have them go back to their communities with the protest T-shirt that they acquired at the demonstration is a fairly effective tool.'

'With maybe twenty or thrity of my T-shirts you have people who will misread the reason why I am wearing them', begins Howard Besser, professor of Cinema Studies and director of New York University's Moving Image Archiving and Preservation Program *and* owner of over 2,500 politically-led T-shirts. 'For example, during the election when Bush was running against Gore, my T-shirt read 'Bush Gore in 2000'. So there I was in Washington DC at a Republican event and people were saying to me "great Bush" they would just see the name Bush and applaud me for what they [wrongly] thought was my support of him; the same thing happened with Gore supporters at a Democrat rally I attended. Neither party saw that the point of the T-shirt was that there wasn't a lot of difference between Bush and Gore,' Besser asserts wryly.

All forms of cultural messaging feature in Besser's impressive T-shirt portfolio. However, a particular collection development policy has ensured that his T-shirts signal what is most compelling to him: 'I collect aggressively in the area of very radical politics: anarchist, anti-authoritarian, anti-capitalist ... I also collect very aggressively in radical environmentalism,

the more radical the critique that is going on in the T-shirt, the more I collect. I also collect media-related T-shirts such as anything to do with television, video and computers, as well as T-shirts related to Dada, Surrealsim and also postmodern art, which were primarily critiques of media and communication, basically the kind of art that really was challenging the traditions that came before it. But T-shirts with just the representation of artworks on them are less interesting to me.'

Besser explains that he started acquiring T-shirts as 'a collector' in the late 1980s, but his enthusiasm for slogan T-shirts began earlier when he was living in a collective anarchist household in San Francisco (between 1980–84). Besser's residence was one of a dozen collective anarchist compounds in his neighbourhood: 'In a way we were all trying to outdo each other with our political pursuits. All these things were very creative because even though they were politically motivated they had an artistic nature to them. So what happened was that one group started making and distributing T-shirts and then the next group started making and distributing T-shirts and so there

was this kind of almost competitive thing going on ... but the T-shirts were all really interesting and politically poignant.'

Ever engaging, Besser tells an anecdote about the time someone had thrown a rock through the window of the first chichi bar in his San Franciscan neighbourhood of the 'Haight' long before it became respectable: 'The next day the newspaper [*The San Francisco Examiner*] came out with a front page headline "Mindless Thugs Terrorize the Haight". Within a week, more than a dozen different groups took on the name Mindless Thugs, producing lots of leaflets and T-shirts to promote the group. We all knew that there was no such group as the Mindless Thugs, it was a figment of the press hysteria over one broken window;

though perhaps they were astute to know that residents of the neighborhood really felt that the whole issue revolved around the symbolism of a battle against gentrification. So we all used the press hysteria name in an ironic way. Some of the designs honoured the Mindless Thugs as heroes, but most just claimed something in the name of the Mindless Thugs. And I'd say that the quick proliferation of leaflets and T-shirts around this incident was probably what started me collecting T-shirts and leaflets.'

According to Besser the onslaught and waves of a slogan T-shirt's popularity fluctuates: 'Something that happens when there is interest in a subject, is that people start thinking of ways to get more people

interested in that subject ... often they hit upon the T-shirt, usually because they want to generate fairly quick interest ... For instance, a war starts in some country and people are opposed to the war, so they are thinking "how do we disseminate our resistance to it?". Well, you can write all the articles you want and it's not going to have a big effect because most people are not even going to read the headlines. You can also hold demonstrations and make leaflets, but that will have a limited effect, so one of the options people choose is to make and wear T-shirts. Usually they are distributed at a demonstration and then those who are at the demonstration go back to their own communities wearing that T-shirt which ideally gets them into conversations

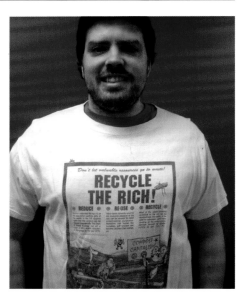
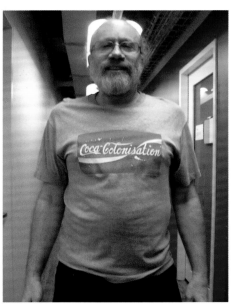
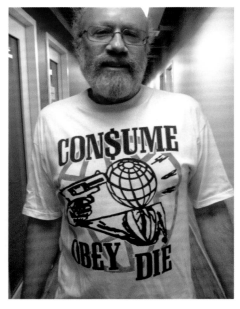
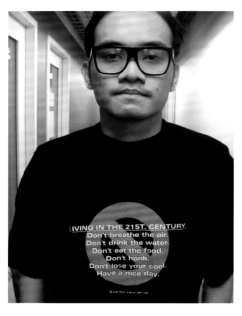

with others, so as a tactic it tends to emerge at a fast moving social pace. We tend to see a lot of waves of this type of activity when there is political conflict, but it doesn't start out to make a wave, it starts out as a very functional thing i.e. the war in Iraq, the war in Afghanistan ... and maybe someone sees a T-shirt that has a political slogan that is along the same line of what they were thinking, or perhaps there are sectarian differences so they make a T-shirt that has their own individuated message on it and so on.'

Besser reasons that often when politically charged events transpire, the first surge of protest T-shirts take their time to surface, but then rapidly they emerge in abundance as an effort to get their 'voice' heard over all the other voices. Because even within a community that is challenging the media's or government's own voice, the diversity of nuanced perspectives are competing with each other. Besser's observation that the messaging tactics of a T-shirt organically grow into a wave seems to achieve even more value when he notes that T-shirts, 'are constructed from the bottom up not the top down ... no one sets out to do a T-shirt that's popular, they just want to get their own message out there and in some cases those T-shirts then become a phenomenon.'

The last two decades have seen Besser engaged in creating an online database that indexes his T-shirt collection. In 1995, whilst teaching at the University of Michigan, Besser proposed the introduction of a class in image databases to his department, the School of Library and Information Science now known as the School of Information. 'It was undoubtedly the first image database class in a university,' says Besser. 'As part of the coursework for the class we developed metadata and standards for a T-shirt database and the students scanned about 550 of my T-shirts. One student even made off with one of my T-shirts and held it for ransom!' Besser shares with good humour.

In essence, the project involved assigning metadata records to each T-shirt, then

A selection of T-shirts from Howard Besser's archive as modelled by Besser and his students at NYU: 'Yes, that was a group of students meeting with me last night ... we were archiving all the videos made for 'Occupy Wall Street'. They had a lot of fun choosing which T-shirts to model (fighting over some). And special thanks are due to Zack Lischer-Katz for taking the photos of me modelling near our media department, and Walter Forsberg for the photos of me modelling in the library. I also included a picture of where I store all my hard-copy data relating to my T-shirt collection [above]', says Besser.

cataloguing the T-shirt images and creating rules for those categories. This also served the purpose of collective decision making and creating a 'data dictionary' alongside a pioneering vocabulary.

The mid-90s was an era when the cost of a scanner prohibited personal purchase, but Besser's university had a number of flatbed versions. However, it took a number of scans to accommodate the larger T-shirts, in which the images were then pieced together: 'At the time there weren't very many images out there on the Internet, this was a couple of years after the first web browser came out, and we put it up on the web as a database.'

Nowadays Besser's interests revolve around digital preservation. 'A few years later [in 1999] I returned to this image database class with my students at UCLA, but on this occasion we started asking questions about what you can say about a T-shirt and what exactly we should record. There's size and markings of course, but also we asked questions as to their iconic value and things like "do we transcribe all the words on the T-shirt or should we limit the amount?" and so on. So now the database contains descriptive information about each T-shirt, background and inscription colour, neck-style, fabric type, artist, etc., as well as subjects – anarchism, environmental activism,

postmodern art, copyright, technology, media, libraries, museums and so forth.'

Currently, Besser has 1,200 of his T-shirts fully catalogued in two databases. Half are in an online searchable database, whilst the remainder are in a counterpart database. The plan is to merge the two. In the meantime, Besser's extraordinary history and enthusiasm is stored safely both digitally and physically. Besser's T-shirt collection is so extensive that it inhabits three homes: Rio de Janeiro in Brazil, Berkeley in California and New York: 'When I took the NYU job, I actually asked them to build an extra closet for my T-shirts in the housing they provided for me!'

Dr Matt Cook

The slogan T-shirt's relationship to queer culture

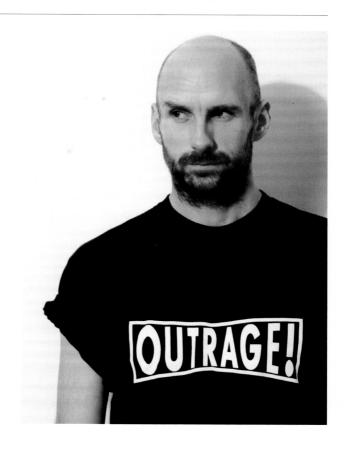

'I suppose you could use the slogan T-shirt as a marker of visibility in a way that starts to mark shifts in queer culture and in what people want to make visible.'

'I suppose what's interesting about slogan T-shirts, in the context of the history of homosexuality, is the way in which, as much as slogan T-shirts have been in existence, clothes generally have always been important as indicators of a certain type of visibility and as signals of sexual difference. So, for instance, wearing suede shoes or colourful socks or shirts, were the kind of things that were cited in court by the police when they raided Soho clubs in the 1950s and 1960s; colourful socks and shirts were apparently tell-tale signs,' begins Dr Matt Cook, Senior Lecturer in History and Gender Studies at London's Birkbeck College. 'What is also interesting is that in old history interviews, men would talk about either avoiding those types of clothes because it would give them away or deliberately wear them so that other people could recognise them. It was a kind of code, and I think it reflects the customs of queer cultures where there was both a tacit acknowledgement of their existence and a visibility, but also a kind of secrecy associated with that and a "saying but not quite saying" of one's sexual orientation.'

Cook notes that it was the endorsement of badge wearing rather than slogan T-shirts that

initially propelled the activity of asserting an explicit voice, and likewise an explicit visibility, especially through the activism of the civil rights movement in the US, including Second-wave feminism and the Gay Liberation Front (GLF) during the late 1960s–80s: 'I think the technology of T-shirt printing was yet to come. Although people did wear all kinds of apparel as signals, it was definitely all about badges. It seems a trivial thing now, since badges are deemed a minor fashion accessory, but at the time it was a very overt statement.' Cook traces the development of queer identity T-shirts from the act of badge-wearing, as they were often pinned onto T-shirts and often quite simply stated sexual orientation.

According to Cook, slogan T-shirts were worn most from the '70s onwards and especially during the nascence of the AIDS and HIV epidemic of the '80s and early '90s. The British government's inaction together with Clause 28 (a law that ruled that: local authority shall not (a) intentionally promote homosexuality or publish material with the intention of promoting homosexuality; (b) promote the teaching in any maintained school of the acceptability of homosexuality as a pretended family relationship), fuelled an anger

and grief which subsequently provoked a plethora of T-shirts in response to this suppressive and discriminating legislation. 'There was a real sense of embattlement during that period where actually marking a presence was important, and there was a real sense of community then too. This happens when there is a real activist impulse, and particular campaigns provoke shifts involving T-shirts and sloganeering', Cook says.

The presence of the now iconic 'Queer as Fuck' T-shirt caused two opposed forms of controversy during the 1990s. In 1992 British style magazine *The Face* published a picture of teenage pop heart-throb Jason Donovan wearing a superimposed 'Queer as Fuck' T-shirt, alleging that he was gay. This prompted Donovan to launch a successful libel action against the magazine (for suggesting that he'd been lying to his fans); costing the publishers £200,000 in damages and £100,000 in costs – it was widely reported that an agreement was settled out of court.

Several years later the political campaigner Peter Tatchell, famously (and proudly) wore the

T-shirt during the protest rallies organised by OutRage! (the world's longest surviving queer rights direct action group). Incidentally, in 2008 Tatchell was photographed wearing the rather clever slogan 'I Can See Queerly Now'. As Tatchell explains: 'Put into context, this ['Queer as Fuck' T-shirt] was one of several T-shirts produced by OutRage! in the early 1990s as part of our visual campaigning, the other T-shirts were 'Queer To Eternity', 'Dyke With Attitude' and 'This Faggot's Not For Burning'. The slogans were a collective effort and are still in circulation ... They were at times witty, at times provocative, and an affirmation of queer identity during a homophobic era when there was widespread prejudice and discrimination against lesbian, gay, bisexual and transgender people.'

As Cook suggests, another approach that has employed the use of slogans on T-shirts is the expression of identity politics versus queer politics. Cook elucidates: 'Queer politics doesn't just indicate being gay or lesbian, but submits a different perspective on the binary

division of sexuality as in gay versus straight, so I suppose the slogan T-shirt has been useful in those type of terms ... As for identity politics you are not talking so much about an attitude or an idea regarding a fluid sexuality, but rather the idea of a sexuality attached to an individual's particular identity, which has been crucial in pushing particular campaigns and movements.'

In recent years Cook has seen the slogan T-shirt move away from campaigning – nowadays it operates as a more neo-liberal story of sexual identity and consumerism. Cook cites American fashion retailer Abercrombie & Fitch's branded name on its T-shirts as being as much as an explicit gay marker as the confrontational 'Queer as Fuck' T-shirt. 'I think in general, the pertinence of making an obvious stand by your visibility is less important because we have visibility in all sorts of fields; also I think being recognisably queer might now be as much to do with having a beard or wearing a tight Abercrombie & Fitch T-shirt – we're back to those indicative fashion codes ...

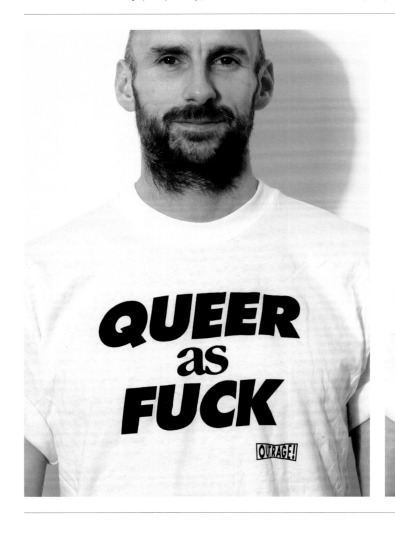
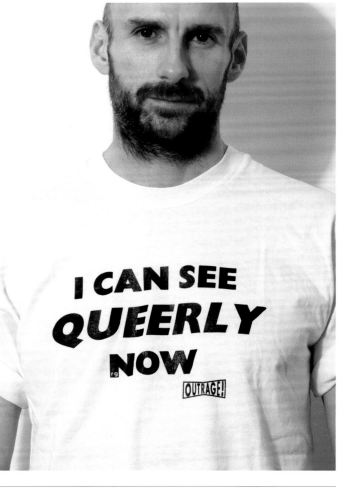

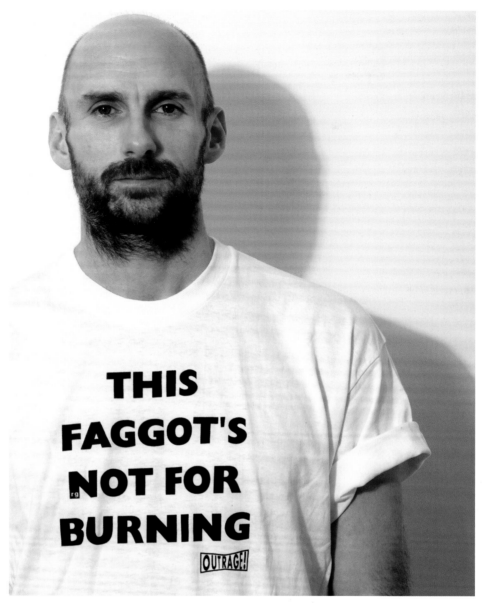

T-shirts kindly supplied by OutRage!; www.outrage.org.uk • Model: Scott Maddux

The gay community now is much more diffused … Some battles have been won so I think for a lot of gay men and women activism isn't so acute anymore.'

However, although slogan T-shirts no longer manifest as the dominant clothing of choice during events such as protests and gay pride festivals, their presence is still active: 'What you get now are witty T-shirts such as the famous Banksy two policemen kissing type of visual.' Cook continues: 'Also, you see groups of people affiliating themselves with particular factions within the gay movement, so they mark themselves out for the day with a T-shirt that expresses membership to a football club or a reading group.' Thus, not only do these types of T-shirt markers have importance both as implicit and explicit protest statements but also function as markers of group identity and the idea of community. Conclusively, what is transmitted through the display of these T-shirts is the duality of the individual's sexuality and their leisure pastimes *as* an individual; straddling both a wider audience (as in the context of the gay community) and the audience within (as in the context of both the gay community and the individual's personal interests).

On a personal level, the play on words on slogan T-shirts is an asset for Cook, he captivates with his closing comment: 'There has always been a tradition in queer politics from way back to the 1910s and 1920s to use a disarming wit and also for the use of camp, not just for its notion of fun, but also being a way of undercutting and giving a tongue lashing … Often camp relies on taking a cultural object, word or a phrase or a mainstream idea and giving it a twist, and that is exactly what the Gay Liberation Front did, they said "We're part of this culture too and we can fuck about with it". One of my favourites is the OutRage! T-shirt, it operates on two levels, the "Out" component and then the outrage of being overlooked. I think it's great; inspiring because it was, and is, uncompromising.'

Dr Clare Rose

The morals of language on slogan T-shirts

www.clarerosehistory.com

'I am not happy about the use of the word "bitch" on visible clothing as it degrades the common social space and legitimises the use of a word that is still an insult. In private social settings I am less concerned.'

Derogatory language has become somewhat sanitised in recent years. The reasons for this are many, but one possible explanation is its ubiquity on items such as T-shirts, which has caused people to become visually acclimatised to the presence of contentious words. But what does an aggressive slogan T-shirt mean to the wearer? What are their motives? What does it say about the wearer when their T-shirt is adorned with the words 'I am a whore' when clearly they are anything but? Do the visual characteristics of the text influence one's motives to wear a slogan T-shirt? If a slogan T-shirt is fashionable and covetable does this override the connotations attached to the slogan on the T-shirt? Is the choice of T-shirt slogan simply for one's own insubordinate reasons or used as a strategy to connect with or impress others through its display of textual transgression? Do people need to be validated by their T-shirt choice by wearing like-minded T-shirts as their peers? What are the implications and consequences of wearing a seemingly provocative or offensive T-shirt? Does the wearer even care, as long as they are seen wearing the T-shirt *du jour*? Whilst image and carriage typically contribute to

impression, the personal investment between one's own intention and designated projection is often discrepant to external reception. So by raising these questions we have to some degree provided an acknowledgement that all these possibilities may qualify ...

During the 1990s there was a slogan T-shirt that pervaded London's sartorially sober landscape; the T-shirt under discussion divided opinion as to its nuanced currency. Although for some people the slogan T-shirt is a low-risk form of communication, when the T-shirt is adorned with the words 'Barbie is a Bitch' can the gesture be as innocuous or cavalier as has been implied? The reactions to this particular T-shirt ranged from 'intolerable', 'vulgar', 'tacky' and 'scandalous' to 'it's just a T-shirt, it's harmless'. And although there are far more disturbing T-shirts in circulation, this T-shirt has been subject to discussion throughout this entire book project, primarily as its rhetoric cross-references many stratas of discourse including feminist ownership, which of course raises in itself the nature of what it means to be a feminist today. Another line of argument has suggested the statement of 'Barbie is a Bitch' as a form of cultural

subversion in which reclaiming the word 'bitch' empowers its demeaning denotation. Nonetheless, whether used as a protest tool or worn for its 'cool factor' associations, it is interesting that toxic or belittling language is principally upon T-shirts that dress or address females (incidentally, often those T-shirts that address females distastefully are usually worn by men). The male T-shirt counterparts may ridicule their gendered status in a comedic fashion but most lack the fervent overtones that underscore 'controversial' terminology.

According to fashion historian Dr Clare Rose, an exhibition researcher at The Women's Library and lecturer at the V&A Museum, the word bitch 'has a very, very long history as an insult and will take some time before it can be reclaimed with a sense of irony.' Rose explains: 'Because spoken language is so context-dependent, once you take it out of its spoken format and put that word not only onto paper but also onto a garment, it is no longer context-dependent, it is on the wearer's body and the wearer [and the body] creates the context. So I would say then that that undermines its claim to be ironic, as you can no longer say what the context is, because the status of words on T-shirts is very different from the same words used orally. It is important to reassert the context-specific damage that a single word can do, but spoken language can really change when those words are then written on T-shirts and should really be used with enormous care.'

For Rose, the morals of language on slogan T-shirts beyond quintessential meaning is contingent on the context-specificity of their application and physical situation. Naturally, the variable objectives that drive the use of a word like 'bitch' will connote different things to different people in accordance with the person's age, parental status, social background et al. More so, given that language is both a cultural and social construct. Rose elaborates: 'What you wear is loaded when you are in a public space. So I ask myself firstly, what it does to public discourse when you put "bitch" on a T-shirt and secondly, the repercussions to the wearer, because if we object to men having bitch on a T-shirt, then how does it change when as women we appropriate it ourselves ... I'd say it is crossing a line, but not because it is shocking. I wouldn't defend those people who attack what others are wearing, but if you are wearing a T-shirt like that ['Barbie is a Bitch'] and are provoking people, then you should be ready for whatever that provocation leads to. Also, it may not occur to the people who wear this type of T-shirt but what does it do to public space? For instance, if someone has a rude T-shirt on and there are kids around, and these kids are at an age where they are

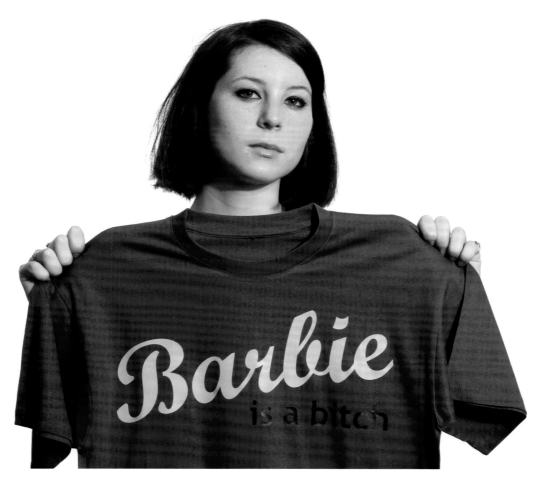

Model: Amy Thompson

beginning to tune into language and decipher letters, and they read the words on a person's chest that are an obscenity, you are polluting public space with those words.'

Therefore it is not so much the actual isolated word itself that vexes Rose but *where* it is worn, although she adds: 'If the language is offensive and legible to outsiders, I see it as unacceptable. If it's illegible, for example in graffiti script or in non-European typeface, less offensive but still not good.' Furthermore, should the wearer (of a questionable T-shirt) be in the company of friends or within a peer group it is more acceptable, but if the wearer is in a public space inhabited by strangers it is less so, principally because for Rose explicit language coarsens public space and likewise arouses negative attention.

Rose characterises three distinct types of public space. On a primary level it is an environment where access is not controlled i.e. public transport, a high street, a library; its secondary level manifests as a controlled space where access is limited i.e. an educational institution, a place of work, a music venue 'and where you can to some extent predict the people who are going to be there'; finally a tertiary level entails a personal or private space i.e. one's home in which you invite the people you know over its threshold.

Rose's academic interests revolve around the history of childhood and the history of children's clothing, so it is unsurprising that the issues of slogans and branding relating to adulthood but adopted by adolescents and pre-adolescents is a concern: 'Throughout history there has been culturally accepted age demarcations, as in terms of what is deemed to be acceptable for different age groups, and although you could say it is very repressive in a way, these age demarcations mark out safe spaces for the types of clothes that are going to be worn by these different age groups. Because by wearing a graphic T-shirt it implies you know what you are doing, it also marks the wearer's body as being someone who is ready to engage in sexual behaviour and if that body is pre-teen then I think it is extremely worrying. For instance, if a pre-teen is walking around wearing a slogan they don't understand it is concerning, and just as concerning is a pre-teen walking around wearing something on their body that they *do* understand ... why this rush to turn pre-teens into adolescents? You could say to some extent it's coming from the children themselves, but usually the people who are buying the T-shirt are the parents, so in that case it's got to be endorsed by the parents ... and in some ways there now seems to be this culture of mothers and daughters dressing alike.'

According to Rose, the plethora of contexts one can attribute language use in response to its delivery include the stylistic context and the bodily context: 'Unfortunately the aesthetic evaluation of people is so deeply seated, so it would be natural to have a reaction to the T-shirt depending on the physical attractiveness of the person who was wearing it. Perhaps someone not conventionally attractive may suggest that "Yes, Barbie *is* a Bitch" because of Barbie's physical standards and then conversely someone whose appearance is similar to that of actress Pamela Anderson, for instance, may ironise the statement by side-stepping the sentiment of attractiveness ... Also I think *how* the T-shirt is worn influences its insinuations; you could have ten people wearing it and it might evoke ten different reactions.' Thus, the T-shirt's 'personal styling' signifies different sets of values according to its adoption, i.e. worn nonchalantly with a pair of jeans and sneakers sends out an alternative message from those who choose to glamorise it by partnering it with a skirt and heels. Rose continues: 'Bodies change meanings. For example, a 'Barbie Rules' or 'Disney Princess' T-shirt would have different meanings if worn by the intended market (eleven-year-old girls) and by ironic users (twenty-year-old women with grunge or Riot Grrrl styling). Location gives another layer of meaning, as slogans are often about identifying group allegiances, the meaning changes when the garment is worn in places associated with the group, or not. For example, a twenty-year-old in a 'Disney Princess' T-shirt at Disneyland would be understood to be endorsing the intended message as in Disney Princesses as role models. The same T-shirt on the same body at a feminist march would be understood ironically as a comment on the limited role models presented to women, though I suppose you could claim Mulan as a feminist model ...' Rose offers thoughtfully.

Since the positions and takes on the morals of language on slogan T-shirts vary considerably, one's conclusion can only occupy a subjective position. The word 'bitch' alongside many of its lexical cohorts is so multi-faceted in its appropriation that a definitive conclusion remains elusive, interestingly its absence in the many dictionaries we checked spoke volumes.

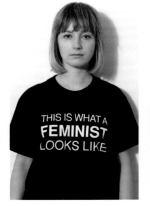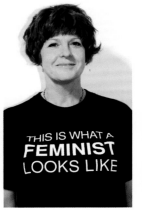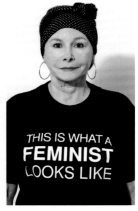

'Since at least 1850 feminists have been stigmatised as ugly, masculine women and weak, effeminate men, or as abnormal in other ways. The 'This is What a Feminist Looks Like' T-shirt, worn by women (and men), is a powerful way of combating this stereotype', notes Dr Clare Rose. • Model: Amy Thompson, Annick Talbot, Lindsay Freeman, Liz Thompson and Silvia Ricci.

Fiona Cartledge

The presence of female empowerment on slogan T-shirts during the '90s

www.doubledice.co.uk

www.signofthetimes.org.uk

'Slogan T-shirts are excellent for challenging stereotypes.'

Vibrant, eclectic and idiosyncratic, cultural commentator and youth trends expert Fiona Cartledge's retail emporium Sign of the Times, located in central London's Covent Garden, was at the vanguard of promoting emerging designers during the 1990s, many of whom are prolific today. To cross the Sign of the Times threshold was to enter a one-stop experience where one could amass flyers for club nights, buy tickets for clandestine parties (including those organsied by Cartledge), peruse offbeat fanzines that documented the music, fashions and characters customary in those club scenes and, of course, buy apparel for that evening's revelry. Within its dazzling yellow walls were several T-shirt designers who reflected the flamboyant and hedonistic club culture that the Sign of the Times crew heralded and were an intrinsic part of.

If one considers that the early to mid-'90s suffered from recession fatigue, individuals favoured wearing their disillusionment visibly. Unsurprisingly, sartorial ideas sourced inspiration from their cultural surroundings rather than under the influence of mainstream consumer-centred cultures. As a consequence T-shirt declarations such as 'My Drug Hell' and 'My Booze Shame', as coined by part-time sales assistant turned 2004 Turner Prize winner Jeremy Deller, were best-sellers. 'In a recession people need to connect,' explains Cartledge, who considers times of political uncertainty as a perfect example of how slogan T-shirts can encapsulate a collective consensus. 'I think in difficult times individuals question things and want to convey things they are feeling ... T-shirts got really big for us back then, chiefly because slogans are far from empty, they capture the mood. Slogans *can* be overdone, especially when the high street churn them out, but there are times like now, where society feels another cycle of change is emerging, and it feels completely right for slogan T-shirts to take charge.'

For Cartledge, whose teenage years were rooted in the punk circuit of the late '70s, slogans are an extension of punk's social vocabulary that not only transgressed dominant ideology, but also publicised fury at a declining economic climate and rising unemployment figures. 'T-shirts are always good communicators of change and commentary, but more so in times of protest and when times are challenging,' explains Cartledge. It is befitting, then, that

her decision to name her enterprise Sign of the Times reflected the change in atmosphere that was so prevalent in the late '80s, notably since the acid house scene had a central presence in Cartledge's social orbit.

It was in 1988 that Cartledge ventured into the clothing trade with a stall at Camden Market selling vintage apparel. However, the popularity of her merchandise, which had started to include original clothing and accessories, soon necessitated larger premises. The following year Cartledge set up shop in a unit at Kensington Market – celebrated for its fashion-alternative and music-oriented bias. Wallpapered with Bacofoil, the bijou space saw every available surface embellished with eccentric paraphernalia such as oversized plastic trolls, fluorescent flowers, smiley merchandise, kitsch key-rings and cartoon badges. In essence the shop was fashioned to reflect the colourful raves and warehouse parties that Cartledge and her customers frequented: 'If you consider that the acid house movement had been a retaliation to '80s materialism, and once that had died down the recession hit and people started to become quite cynical after a period of feeling uplifted, so it was important for me to have a "feel good" shop interior to combat the gloominess of the recession ... and retailing slogan T-shirts fitted into that perfectly.' Ironically, it was as a result of the recession, in 1993, that Cartledge's business acumen captalised on the deflated, commercial rental market and she negotiated a deal in London's West End. Sign of the Times part three was to make its mark on the British fashion industry.

By this time Cartledge had already established herself as a pioneer of young fashion talent: 'It was always very ad hoc, designers would just turn up unannounced and show me what they had designed, sometimes I would spot people in clubs wearing amazing T-shirts they had made themselves and commission them to supply the shop. I also started going to graduate shows which was really fertile ground for burgeoning talent and at that time not many companies took interest in these shows, so I was able to get exclusives with great new designers.'

Sign of the Times' illustrious reputation continued to impress the high fashion and innovative music scenes, not only in the UK but worldwide too. Whilst Sign of the Times' DJ sets ranked famed club luminaries such as Mark Moore (S-Express), Terry Farley (Boys Own), Darren Emerson (Underworld), Danny Rampling and the Chemical Brothers, the likes of Bjork, Pulp, Naomi Campbell, Courtney Love, Jean-Paul Gaultier and Alexander McQueen were regular patrons of both her boutique and her club nights. Even British *Vogue*'s fashion doyenne, the late Isabella Blow, made an impromptu visit to WC2 to book T-shirts for a shoot with Steven Meisel. Conclusively, the

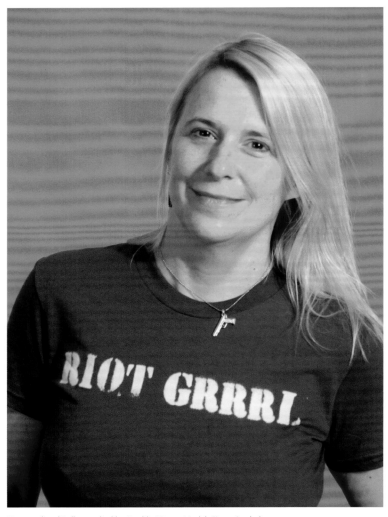

Gun pendant kindly supplied by Double Dice • Model: Fiona Cartledge

 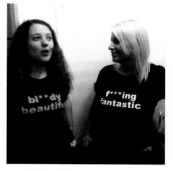

Karen Savage and Fiona Cartledge modelling Savage's T-shirts in 2012. 'I've always loved Karen's tees, they exude positivity with attitude!' notes Fiona Cartledge, while Savage reveals: 'As soon as I met Fiona [in1992] I realised I had found an important piece of my life as a young, independent designer. She was the best you could wish to meet. Her knowledge and passion for street culture, art and fashion inspired many designers, including me. Her generosity in sharing and mentoring others is legendary.'

Sign of the Times world was an all-inclusive enclave – everyone was welcome; on any given day drag queens, skate kids, pop stars and secretaries inhabited the Sign of the Times space exchanging news and offering advice as to each other's future purchases.

Once again a cultural shift was emerging with the arrival of 'Cool Britannia'; an era that championed left-field music, entertainment, art et al. 'Lad' culture, as endorsed by the likes of bands such as Oasis and their cohorts, was now being matched by their female counterparts in terms of behaviour and language. Thus, 'Ladette' culture, as it became known, saw 'a new projection of femininity' that ironised anachronistic portrayals of female passivity. Cartledge accounts numerous factors for this feisty sentiment: 'Women were keen to assert a certain type of toughness that subverted typecasting ... it was a reaction to all the "nice" girly stuff that was around at the time.' Cartledge, always one step ahead, stocked T-shirts *du jour* such as Karen Savage's dichotomised Baby/Bitch amongst others: 'We sold loads of really strong female slogans, some were angry but they all communicated positive images of women that probably weren't being featured in the media at the time.'

Cartledge recalls this period vividly: 'We used to accept a lot of sale-or-return items in the shop, so in theory anyone could pop in and show us their T-shirt collections and if we liked them we'd sell them, so we had a really good variety of slogan T-shirts. Because of this approach small alternative movements would often appear in the shop almost organically, and one of the things that seemed to be happening around that time was the British end of the Riot Grrrl movement. It had started in America in the late '80s as a reaction to the fact that so

many bands were male dominated and there were lots of girls frustrated with this.'

According to Cartledge the Riot Grrrl scene was a natural step on from the punk scene. Often credited as an underground post-punk feminist movement, the Riot Grrrls' DIY values and punk philosophy was often associated with third-wave feminism which embraced diverse female identities and contradictions in those identities, such as the choice to be feminine, thus revising the rules of what it meant to be a feminist. Cartledge continues: 'The Riot Grrrls' fanzines, which had then arrived in Britain were inspiring as were British bands such as the Voodoo Queens, which I particularly liked because their take had humour ... they did this one song about Keanu Reeves called Kenuwee Head, it was very funny ... I wasn't actually immersed in the scene personally but what I could gauge from the merchandise we had in the store, and the Riot Grrrl fans who used to hang out on the shop floor, was that the original Riot Grrrl scene was more hardcore in its feminist principles, whereas this side of the Atlantic added a dose of satire. It was just great to see women not being just decorative on stage, but giving it some and playing instruments, and of course the music was incredible.' Cartedge's interest in this particular milieu pivoted around females critiquing traditional assumptions associated with women and carving a cultural space that enabled them to be as irreverent as their male consociates without shame or apology. Furthermore, Riot Grrrl culture was very much a feature of the Generation X culture due to its rejection of conventionality and its questioning of social norms and the establishment's hegemony. Much of this activity manifested as empowerment slogans on T-shirts, with the Riot Grrrl name, alone, proudly adorned across

chests nationwide.

As a result of unemployment and the absence of capital people took it upon themselves to form their own enterprises; hence the flurry of independent fanzines, bands and clubs. Cartledge recounts: 'The vibe generally was about being rebellious, and that included women being as rebellious as the men ... in terms of music on a more commercial level, the Spice Girls were really making waves, and their thing was all about strong female imagery and attitude more than anything else, and then there was the pop band Shampoo. Although they were at the more pop end of Riot Grrrl, they definitely belonged to that era with their female-based lyrics and sassy look. They used to play at our parties and attended our shop launches, actually Sign of the Times got quite well known in Japan through Shampoo as they were considered pop royalty over there.'

As the mid '90s started to flourish, a new-found optimism altered economic conditions. This, alongside a shrewd high street culture that was quick to adopt fashion trends, affected small businesses, such as Cartledge's. 'As the recession stated to fade the rents in Covent Garden shot up dramatically forcing many shops to close, including my own. This paved the way for the big brands that now dominate the area.'

Nonetheless, Sign of the Times' legacy is still fervent with tickets for reunion parties selling out within days of their release: 'I often see people in the streets wearing the slogan T-shirts we stocked at the shop, not only those who bought them first time round but also the younger generation who have somehow "inherited" them ... because slogan T-shirts have impact I can't see them ever becoming obsolete.'

Daniel Pemberton

The presence of dance music on slogan T-shirts during the '90s

www.danielpemberton.com

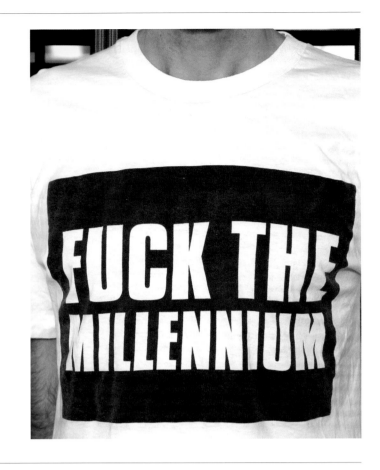

'The problem with slogan T-shirts is that they tire very quickly, but that is also one of their joys – they are a snap of a moment in time, a bit like a pop song.'

Before Daniel Pemberton became a prolific music composer scoring soundtracks for films, TV shows and video games, his talents straddled journalism (including a role as *i-D*'s technology editor) and for a short period, T-shirt design. Whilst still at school, Pemberton designed his first T-shirt in response to the late '80s acid house scene that he frequented. T-shirts were the ideal sartorial accompaniment for rave culture. The velocity of the music and speed of the substances necessitated loose, breathable clothing to allow the energetic movement that the atmosphere encouraged.

'There's a whole T-shirt phase that came out of the rave scene that was based around drug culture with labels capitalising on crude cartoon characters or large symbols that very much played on cannabis usage. Also, printed T-shirts featuring packaging such as Vicks VapoRub became really popular, as were colourful graphic prints and big slogans. These T-shirts were everywhere, not just at raves, you saw them at school and on the streets, it was like a uniform for kids wanting to be rebellious.'

Pemberton remarks upon the entrepreneurial spirit that emerged out of the acid house scene and in turn boosted its growth. Cottage industries throughout Britain operated on the fringes of the law, covertly making and selling slogan T-shirts; inevitably big corporations seized the market, repackaged it and sold a youth culture, which had materialised organically, to a lifestyle-hungry adult market.

The nature and culture of nostalgia, usually authenticated at least two decades after an era's inception, has seen a new generation adopt the sounds, artefacts and values of the '90s rave scene as their leitmotif. But as Pemberton muses: 'First time round was exciting, more so as you could only really find these types of subcultural T-shirts at markets such as Camden or Portobello, now with the Internet you can get everything straight away, which is great because you have access to all this stuff, but at the same time it removes that feeling of discovering something special. For better or for worse online shopping has seen an end to these more cult things because everyone has the same type of T-shirts and accessories.'

Following on from the acid house movement, British dance music exploded exponentially, subsequently T-shirt designers further developed the trend for licensing trademarks and recognisable visuals. Cartoon character Dennis the Menace and his compatriots from

the comic strip *The Beano* prompted the fashion for bold prints that took up almost the entire surface of a T-shirt's front. Pemberton recalls that slogan T-shirts had a prolific presence during this period, but a creative shift marked a period of individuals making their own T-shirts in an attempt to separate themselves from the clothing conglomerates who were exploiting the mania for dance music-related merchandise: 'Suddenly you could feel a sense of independent businesses producing their own T-shirt lines and setting themselves up as professional enterprises. The quality of designs varied, but they were definitely more interesting than those manufactured by massive sportswear companies.'

Pemberton has always been at the vanguard of the hybridist culture of fashion, music and clubs, but it was the graphic appeal and laid-back attitude of urban streetwear brands, such as Stüssy, and their affiliations with sporting activities such as skateboarding, BMXing and surf culture as well as inherent links with the worlds of hip hop and graffiti art, that received his sartorial endorsement.

Pemberton reflects upon graffiti's own relationship with slogan use: 'Graffiti is effective because so many people read it, but the difference is that because it appears on a wall it is no longer associated with the individual, whereas the drawback of slogan T-shirts is that often they are co-opting someone else's idea ... there's something more subtle and intriguing about graffiti, somehow it makes you think a little bit more.'

Slogan T-shirts are a contentious issue for Pemberton who has, as has been established,

been at the forefront of subcultural style for the last two decades: 'Slogans always have an effect on people, you just have to look at the power of advertising and how it impacts people's perceptions of things ... we live in a world where corporisation forces its ideas onto audiences all the time.' Pemberton reasons that slogan T-shirts, as mobile forms of advertising, commodify individuals by making explicit their brand allegiances. It is also the discrepancy between the slogan itself and the wearer of that slogan that concerns Pemberton because the way sentiments are received are often contextualised within a colloquial framework. Pemberton elaborates: 'For instance, if a city banker was to wear a 'down with Third World debt' T-shirt beneath his suit you may think it jars a little with his formal appearance and his principles, but should a student wear it, somehow it seems more appropriate, so if you don't like the look of that person [i.e the city banker] you almost instantly lose the idea of that thought.'

Pemberton continues: 'The problem I have with slogan T-shirts is you are very much projecting opinions, and being a mass-produced item is a little like saying that basically you don't have any individual thoughts; that you have to adhere to someone else's thought patterns ... I've always preferred to be more ambiguous, mainly because I think it is very difficult to encapsulate any kind of argument in one slogan, but I think if you can achieve that, then I suppose it can be very compelling ... Personally to wear a T-shirt with someone else's idea on it is problematic for me, I suppose there is still a choice of what slogan one chooses, but someone else's viewpoint is not necessarily my own and wearing a slogan T-shirt

suddenly bonds you with other people wearing that very same T-shirt, removing this idea of choice of who you affiliate with.'

Pemberton does argue favourably for the slogan T-shirt's ability as a device to engage in conversation, although this isn't without its hazards: 'Recently I've noticed really explicit slogan T-shirts for women that refer to their chest, they're pretty horrendous, but I guess these type of T-shirts are used as conversation starters ... I think they have often been used for that reason ... encouraging the entire world to interact with you may suit some, but personally doesn't sit well with me.'

Pemberton's only foray into the slogan T-shirt landscape surfaced in 1997 at a Barbican gig for techno band KLF. 'Every member of the audience was given a 'Fuck the Millennium' T-shirt, but I saved that T-shirt for the Millennium festivities and to this day I have worn it only once." Pemberton expands: 'I wore it as a one-joke gag for the girl I was going out with during that period. She woke up with me wearing it in bed; I'd held onto to it for three years purely for that one moment, but because I am a huge KLF fan I'll always keep that T-shirt. I love how they were one of the last great independent bands and they *were* independent, as they weren't signed to any label and for that reason they could do whatever they wanted. Nowadays it's unheard of to have worldwide success like theirs and not embrace corporate mainstream ideology. I think they are still very underrated for what they achieved even from a business point of view as well as an artistic one ... If anyone knew the power of a slogan, it was KLF.'

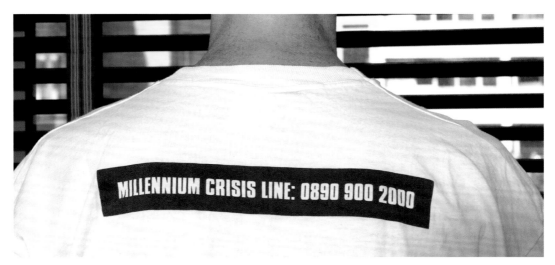

T-shirt kindly supplied by Daniel Pemberton • Model: Scott Maddux

Philip de Mesquita

T-shirt entrepreneur and former Camden Market vendor

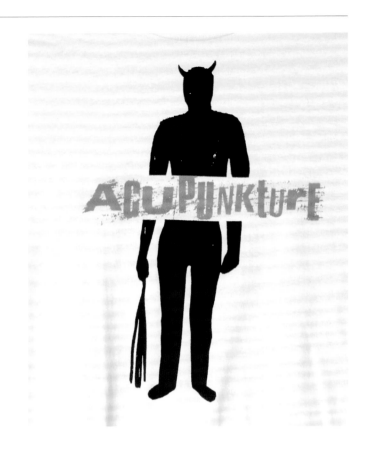

'In the late eighties there were very few merchandisers specialising in slogan T-shirts, but it was apparent that the demand was there, especially sports-related ones.'

There is an ongoing debate whether sportswear brand logos can be considered slogans. Although contestable, slogans are often distinguished as transparent forms of affiliation and self-expression, thus seen in these terms and given the nature of branded merchandise as symbolic devices, perhaps one can contextualise the omnipresent nature of brand names as worthy of the status of slogans.

Back in the mid to late 1980s sportswear logos were hugely coveted and their counterfeit counterparts were equally popular. During the years 1987–92 Philip De Mesquita was at the forefront of this trend, selling T-shirts adorned with the sports brand names *du jour* at London's Camden Market. Subsequently, sportswear has been a consistent theme in De Mesquita's orbit ever since. 'It was just pre-the acid house era, tracksuits and trainers were a staple, in fact people seemed to be obsessed with sportswear and also fanatical about sneakers, and part of that look was a matching T-shirt. It was all about head-to-toe sportswear, it was a really simple look but one that was everywhere. I'd go on buying trips to New York all the time because the stock was so sought-after. It's also worth remembering that at the time sportswear

was one of *the* main fashion trends,' says De Mesquita enthusiastically.

If one takes into account that American hip hop artists Run DMC and the Beastie Boys were style mavericks, defining an era with their Adidas-led attire, loose-fitting jeans and their parody of conspicuous consumption as exemplified by their outsized gold chains, it is unsurprising that sports labels were appropriated as fashion's latest parlance. More so when one considers the availability and accessibility of the apparel they sported.

De Mesquita's foray into T-shirt retail began during his years as a club promoter: 'My friend knew a theatre designer who hand-painted T-shirts, so I started selling them for her, I also sold DJ Goldie's T-shirts that had 'Spike' written across them in Nike's font. Back then Camden was the failsafe place to find T-shirts to go out clubbing in, it was mobbed at the weekends, people from around the country would come looking for a T-shirt to wear that evening to a rave. It really was phenomenal, we sold up to 8,000 T-shirts a week.'

De Mesquita's day would start at six in the morning, queuing on the off chance that someone wouldn't turn up, in which case their

pitch would be offered to vendors on a first come, first served basis. 'To begin with I was a casual trader at Camden but after a year or so, when a permanent unit became available, I was given the opportunity to buy a pitch. I was also fly pitching at the same time, as in setting up on the street with a couple of garment rails. Times were really different back then, you could secure stalls at all the major markets, like Portobello and Kensington and in effect you had a chain of retail units ... you couldn't do that now, but in the late '80s and early '90s you could be enterprising and it was lucrative,' he adds.

And it didn't stop there. Demand was high. The weekends began on a Friday whilst during the week De Mesquita would travel up and down the country selling his T-shirts to retailers, who by the time he made his weekly reappearance had sold out of his merchandise: 'Monday I'd be in my car driving up the M4, Tuesday would be the M1 ... week in, week out, I'd have my routine of Bristol, Birmingham, Northampton and so forth.' However, as De Mesquita explains, in around 1991 sports brands became savvy to the imitation goods that were profiting from their name: 'They would literally seize merchandise, up until then I'd only had one warning. But *actually* a lot of the sportswear companies really liked counterfeits as it gave popularity to their brand. Anyway, by the time

it became problematic for my business I'd already started producing my own T-shirt range with Barnzley [Armitage], in the early '90s, and this soon expanded to include a store in Soho called Acupuncture.'

When Acupuncture launched in 1993, it was unlike any other boutique in London. Hidden in an alleyway in the hub of Soho, the store was not for the fainthearted nor timid on account of its proximity to the peep shows that lined the facing passage. The store's dimensions were so petite that bathroom facilities were provided by the X-rated cinema that the store was an appendage of. Based on the concept of fashion shops in Tokyo that retailed handpicked items, Acupuncture spearheaded the idea of an eclectic space with its array of vintage Vivienne Westwood regalia, MA1 jackets, retro sneakers and rails packed with graphic and slogan-based T-shirts. Acupuncture's transition from sneaker and T-shirt boutique to sneaker and T-shirt brand happened by default: 'When the supply chain of sneakers ran out we started customising Adidas trainers and this led to us designing sneakers with our own logo. Before long, we started getting orders from all over the world and then the buyers began enquiring as to when our next collection would be ready and so that's when slogan T-shirts fitted in with what we were doing. And remember brands like Nike and Adidas disclaimed that they were

fashion items as they were only interested in being seen as sportswear labels ... so we did the opposite and made our sneakers fashion sneakers, this was before the likes of Diesel etc. There was a five-year period before I sold the company, a few years ago, when we'd sold a million sneakers in forty countries and slogan T-shirts were also best sellers for us too.' Nowadays, De Mesquita works with his wife the illustrious fashion designer Roksanda Ilincic and exercises his impressive business acumen through an assortment of projects.

According to De Mesquita's experiences in the trade: 'Slogan T-shirts always work in a trend.' He cites a trajectory that had sportswear T-shirts being replaced by record label embellished T-shirts, such as those by Tommy Boy and Reinforced Records, which in turn was supplanted by cartoon characters, especially Bart Simpson, and then concluded with the plethora of indie bands whose sound and style was loose-fitting.

As the '90s approached its close, generic branding was at the receiving end of a backlash and luxury branded goods became its replacement. As De Mesquita notes: 'Slogans are all about belonging, but as with all things, they have their day and then years later, as with the acid house resurgence, they come back into fashion. It's really as straightforward as that.'

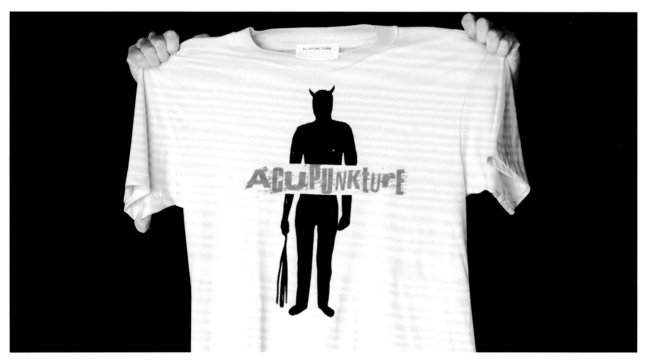

T-shirt: 'Acupunkture' (designed by Barnzley Armitage, circa 1993), kindly supplied by Roger Burton at Contemporary Wardrobe; www.contemporarywardrobe.com

**Robin Bennett
at A-non Brand**

The slogan T-shirt's presence on the festival circuit

www.a-non.co.uk

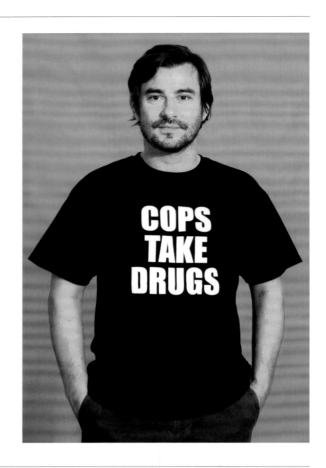

'The T-shirt is a no-thought garment … it can take one slogan to propel your business.'

'It's always been T-shirts — only T-shirts and slogan T-shirts *sell*,' asserts Robin Bennett, whose T-shirt business A-non Brand officially launched circa 2000. Like many T-shirt retailers Bennett's career started as a stall-holder at Camden Market in 1989, before establishing himself as one of the premier T-shirt vendors on the festival circuit as well as co-owning a vibrant T-shirt shop in London's Brick Lane.

It is apt that Bennett christened his enterprise A-non Brand. Like his T-shirts, the name plays on dual meaning, 'A-non Brand' being discordant with the very essence of branded merchandise and cemented through a recognisable insignia. 'Anon', which Bennett's business name is often shortened to, alludes to namelessness, which of course is an anathema to branding strategies and the nature of slogan T-shirts.

Bennett resisted the festival circuit for many years; it was only in 1997 that he decided to test out his stock, his chosen venue was the grandaddy of festivals — Glastonbury. 'I put off doing festivals for years, people used to say "your gear would really sell at festivals" but I couldn't think of anything worse. My first time at Glasto was a real eye-opener, it rained for a week and all the T-shirts got wet, but you could

see the potential as they sold out.' The following year Bennett attended all the festivals, yet along the years he has been more selective. 'I still do Glasto, and I also do V and Leeds and a couple in Europe but the pound is so weak at the moment and that affects business.'

You'd expect the popularity of what slogan T-shirts people are buying to be reflected in what slogan T-shirts people are wearing. However, it is always surprising to hear that sales of 'explicit' T-shirts are high, because their visibility in daily life seems to be absent. Yet at festivals, according to Bennett, the more blatant T-shirts actually tend to be amongst the most popular, especially drug-related T-shirts: 'Slogans such as 'I Take Drugs' are very basic statements, I guess the wearer thinks it suits the mood of the environment. You do see some that are very low, like last year 'Psycho Bitch' was everywhere, but we do have a line we wouldn't cross, you just use your own ethics as to what that line is. I guess these types of T-shirts are mostly bought by tourists who take them back home to their respective countries, but to be honest it's all about the here and now at festivals; people buy them there and there, wear them there and there, it's a "Here I am" thing.

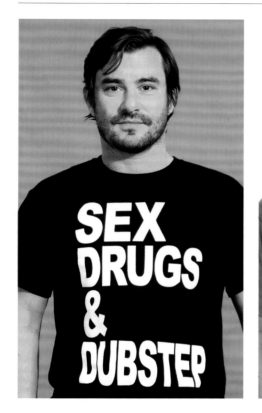

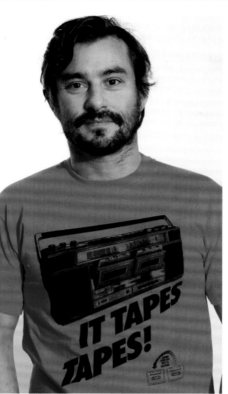

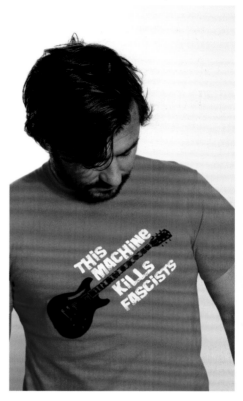

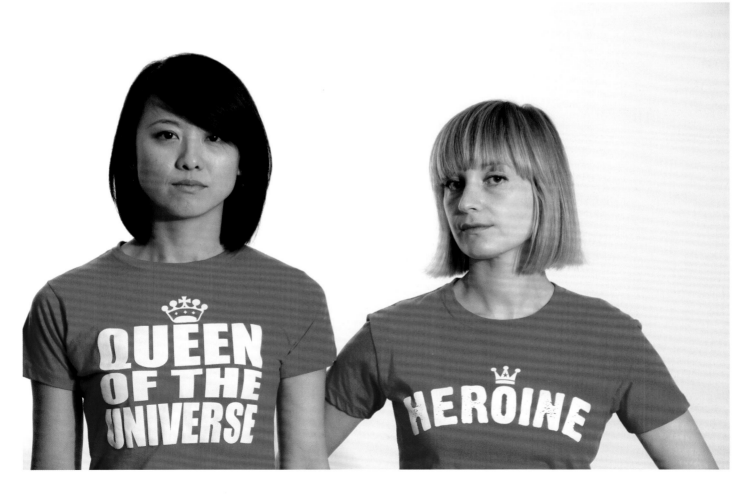

And of course, there is the slogan T-shirt's shock value, which in that context isn't shocking at all, because everyone is wearing a similar style of slogan.' Bennett recalls how back in the '70s Hugh Cornwall from The Stranglers was arrested for wearing a T-shirt simply adorned with the word 'Fuck'. Conversely these days people are so accustomed to profane language that they have almost become anesthetised to it.

Bennett's customer base ranges from age 14–60; many are regular festival goers, and he reveals that both the younger age bracket and the more mature generation seem to enjoy the shock factor the most, despite the fact that their ages sit outside what is customarily conventional for their demographic to be seen wearing.

In the last few years Bennett has noticed the trend for parents, who have refused to give up their riotous lifestyle, buying questionable T-shirts for their children who accompany them to the festivals: 'I've seen six-year-old girls wearing T-shirts with 'Future Porn Star' written on them ... it's immoral,' he confides flatly. 'Nowadays certain festivals won't allow you to sell T-shirts with specific words or phrases on them. To be honest they are embarrassing to sell and embarrassing to wear and wrong on every level.' Considering that festivals are spaces tolerant of extreme behaviour, it is not so scandalous to learn that individuals exhibit extreme suggestions upon their T-shirts. To get into the mindset of the wearer is to acknowledge that the availability of alcohol and substances come with the territory of festival culture and the atmosphere itself generates a sentiment of feeling emancipated from the world outside it.

Bennett shares the story behind one of his top-selling slogan T-shirts. 'Years ago you could do whatever you wanted at festivals, police tolerated everything, and then one year it was evident that everything changed and it turned into zero tolerance. I remember it was on a Wednesday before a festival was due to start, there were these kids driving to a venue and the police stopped them. One of the kids had a joint so the police searched the car from top to bottom but they couldn't find anything incriminating in terms of volume. Later that day they relayed to me what had happened and so we did a T-shirt 'Cops Take Drugs'. We printed 200, took them up to Leeds festival and by the end of the day they had sold out.' Bennett has now moved on from drug-related T-shirts, but continues to produce this one on account of its play on words, lending itself perfectly as a tongue-firmly-placed-in-cheek twist.

A large component of festival slogan T-shirts is the appropriation of brands, often reinterpreted to include drug or salacious connotations. Given the obscenity law (companies are liable to prosecution under the Indecent Displays [Control] Act, 1981 and the obscene publications Act, 1959) and copyright regulations, it's curious how businesses selling these types of slogan T-shirts seem to evade capture, especially since the seeming absence of enforced censorship results in *anything* being printed upon T-shirts.

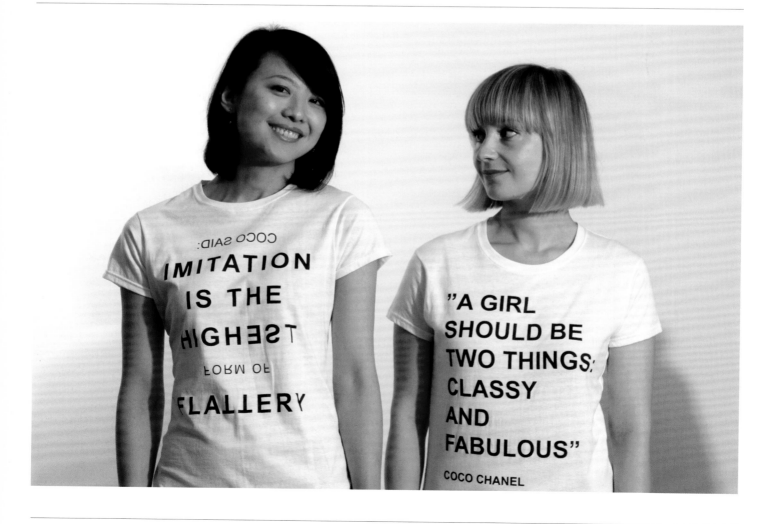

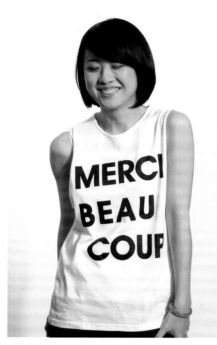

T-shirts kindly supplied by A-non Brand • Models: Silvia Ricci, Yu Ling Huang and Zach Pulman

Bennett explains: 'You can never get round the copyright issue, although if you make six/seven significant changes it exonerates you from any copyright infringement, but eventually you don't get away with it ... people do it for as long as they can and then there comes a point they have to remove the T-shirt from sale. What happens is the law comes to you with a cease and desist (an official instruction to halt an activity [cease] and terminate it permanently [desist] or else face legal action). In ten years I have had the trading standards onto me only once, it was at a festival, stock was confiscated but they brought it back the next day because it was legit, but I lost a day's trade.' He adds: 'It was all a lot easier in the '90s, people could pretty much do what they wanted. The irony is that I never did drugs and so many of the connotations I didn't get, but they were an easy sell. It's also worth bearing in mind that if one stall has a particular slogan T-shirt, very quickly they all do, the competition never subsides. So what sets you apart is the site of your pitch; the location of your pitch affects your business dramatically, for better or for worse.'

Nowadays, over 90 per cent of Bennett's merchandise is designed in-house with original artwork. 'The Internet has changed things for us, online sales are huge, but the direct sell on concrete, whether that is at festivals or in our shop still produces profitable trade.' Bennett eloquently concludes: 'Festivals used to be our main market but they have become too middle class, it used to be more rough-and-ready and rough and ready wore slogan T-shirts more than the middle-class punters.'

Mark Wigan

The slogan T-shirt's relationship to club culture

www.wigansworld.com

www.museumofclubculture.com

T-shirt kindly supplied by Mark Wigan from his 'Snap, Crackle and Neo Pop' Collection

'T-shirts always have a presence in clubs. I think they always will …'

Between 1984 and 1992 artist, club promoter and now director of the Museum of Club Culture in Hull, Mark Wigan was employed by *i-D* magazine to photograph the club culture of not only London but other vibrant cities such as New York and Tokyo. Wigan adeptly captured a plethora of club milieu on Polaroid format: 'I have lots of image of T-shirts because that was what people were wearing back then,' he establishes enthusiastically.

Soon after graduating from Hull's School of Art and Design, Wigan moved to London to make the most of his new-found graphic design and 16mm filmmaking skills. Recognising his talents, *The Face* art director Neville Brody recommended Wigan for a design role at *i-D* magazine. It was the early days of *i-D* and as so often happens with many start-up publishing ventures, the ability to multi-task provided the opportunity to diversify; illustration and writing assignments ensued, as well as being *i-D's* in-house club photographer and columnist.

'When I arrived in London my first way to show my work was on T-shirts. I used to screenprint them myself and sell them at Camden Market', Wigan says. However, more than just being a profitable enterprise, his

T-shirts also functioned as a promotional tool for his art exhibitions. Wigan continues: 'I used to wander around Camden wearing my T-shirts to advertise my visual language. Around the same time I was also designing flyers for nightclubs and painting murals on club walls in London, New York and Tokyo, combining my illustrations with handwritten text and speech bubbles, so whatever artwork I was doing at the time I would put onto T-shirts too.' It is this triumvirate of design, clubs and T-shirts that propelled Wigan's reputation as one of London's leading creative figures.

Wigan's first self-produced slogan T-shirt, at the age of fifteen, featured furry transfer letters spelling out 'Wigan's Casino Heart Of Soul' as a tribute to the '60s soul music club he frequented as a teenager. As a result of his uncle owning a discotheque Wigan's fluency with nightclub culture developed at an early age. In 1985 he organised warehouse parties in London, cementing his name as a key fixture on the scene. A few years later in 1989 he was employed, alongside fellow club maverick Sean McLusky, to organise the nights at London's highly-celebrated Brain club in Soho, attracting an eclectic crowd of

creative luminaries, superstar DJs, Hollywood A-listers and well-known club faces that went on to become prolific names in the industries of music, publishing and fashion. 'The '80s was a very eclectic time and at the same time it was a very self-contained era. T-shirts were hugely popular. Influences drew from hip hop culture and the whole B-boy look with slogans like 'Yo Baby Yo' as well as bootlegged copies of brands like Chanel and Louis Vuitton, all of which were appropriated and absorbed into the hip hop look. And then the rave era suddenly exploded which assimilated to some extent with that New York rapper culture and so you would have the likes of smiley T-shirts and rave slogans such as 'Where's the acid house' worn with Kangol hats and chunky chains etc. It was all about mixing and matching ideas, I guess it

reflected the kind of tribalism of the times.'

Wigan recalls that the T-shirt's ubiquity stretched over a generous ten-year period from the mid-80s onwards on account of the house and techno music scene requiring a fluid, casual fashion that was conducive to hours of non-stop dancing. Wigan notes: 'The indie music scene, which had its roots in Manchester, evolved out of the rave era. The whole "Madchester" movement was so influential, it really centred on being proud of one's Northern heritage, and baggy T-shirts were once again embellished with words that communicated what it meant to be Northern, 'And On The Sixth Day God Created Manchester' was a notorious one.'

By the late '80s Wigan's eminence had reached to such a fanatical level in Japan that his T-shirt designs were bootlegged all over the

country: 'They were actually very good quality bootlegs, I remember Keith Haring had a similar problem because the bootlegs were better quality than the T-shirts he made himself, in fact he wasn't able to launch his Pop Shop in Tokyo *because* of the bootleg situation. I actually love the unusual slogan T-shirts that you get in Japan, the English translations are great, I even used to collect them.' Wigan shares that it was flattery he felt when he saw a slogan T-shirt mistake his moniker 'Wigan' for 'Logan'. Following on from his success Wigan secured licensing deals that saw his designs reprinted onto all manner of merchandise including futon covers, pyjamas, beach towels and even interior sets for television programs. Wigan concludes: 'Every year I produce a limited edition of T-shirts; recycling images from past eras as well as new designs ... they always sell out.'

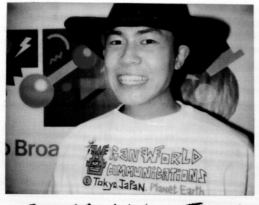

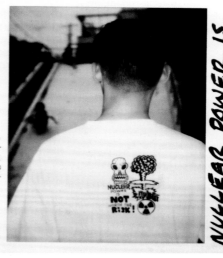
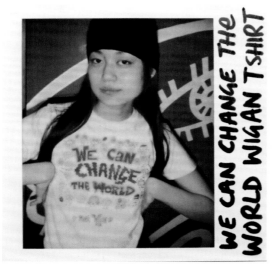

A selection of Mark Wigan's Polaroids kindly supplied by Mark Wigan at the Museum of Club Culture.

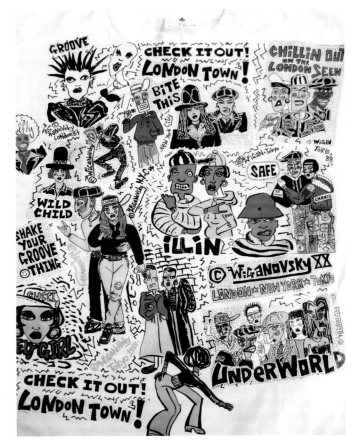

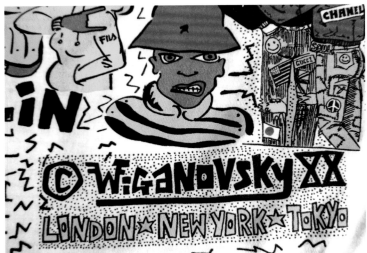

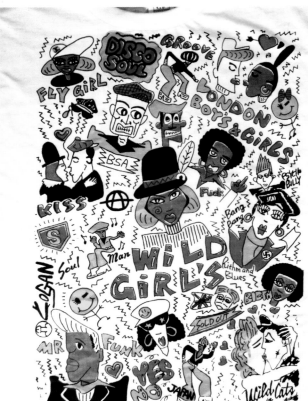

'This is a bootleg version of one of my T-shirts. They signed it off as "Logan" instead of "Wigan,"' notes Mark Wigan (see signature along left edge).

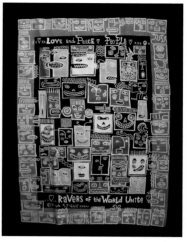

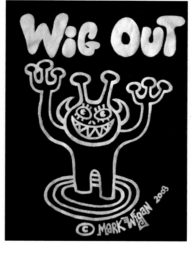

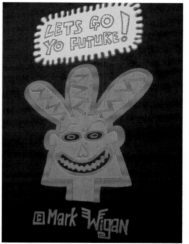

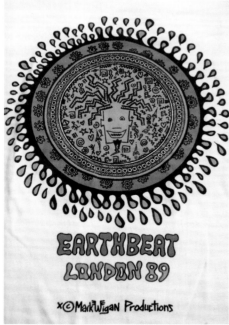

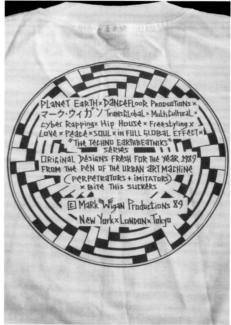

T-shirts kindly supplied by Mark Wigan

Roger Burton at Contemporary Wardrobe

The vintage value of the slogan T-shirt

www.contemporarywardrobe.com

'Something I really like about T-shirts is that they weren't really built to last, so the fact that they lasted twenty, thirty years plus makes them even more desirable in a way.'

Reduced to simple terms, there are numerous reasons why fashion has embraced the phenomenon of vintage clothing: the quest for individuality against a homogenised branded fashionscape; a reaction to the globalisation of fashion conglomerates; a symptom of people's concerns surrounding excessive consumer culture, especially relating to environmental sustainability; the lived experiences and legacy of retro apparel; resuscitating memories of one's own past identities and the activity that pivoted around them; the individuated meanings and associations implied by a historical past; the increasing interest in the revival of historically based subcultural groups (i.e. punk, mods et al.); postmodernism's fashion framework that includes recombining and cross-referencing a panoply of genres alongside introducing modern fashions; the currency of refashioning vintage as a contemporary trend and the connoisseurship affiliated with its adoption; the monetary and symbolic value of vintage as collectables and the fundamental aesthetic experience of vintage fashion – its visible history and the role of fantasy that figures in clothing identities. Ditto the function of the vintage slogan T-shirt.

As costume designer and proprietor of Contemporary Wardrobe, one of the leading specialist fashion hire companies in the UK since its launch in 1978, Roger Burton nimbly suggests the culture of nostalgia and the value of vintage T-shirts is often quite simply, 'the obvious link of associating youth with rebellion, but also I think there is an attraction to finding a T-shirt that one saw or heard about but didn't own first time round and now wants.'

Specialising in vintage street fashion and couture, Contemporary Wardrobe supplies the film, TV and fashion industries with a cornucopia of cult items, pop fashions and sartorial trends that have epitomised youth movements and subcultures from 1945 to the present day. Inevitably, slogan T-shirts feature prominently within Burton's eclectic and beguiling central London premises. However, he reveals that it is the field of fashion editorials rather than the domain of TV or film that borrows his branded T-shirts the most, on account of copyright legislations prohibiting trade names or logos to be broadcast without clearance and the necessary fee being agreed – accordingly, screen-endorsed T-shirts tend to be of a generic

variety or patterned. Unsurprisingly, given that sartorial nostalgia is also cultural nostalgia, band T-shirts, particularly punk, rock 'n' roll, and heavy metal bands from the '70s and '80s, maintain their popularity with the fashion crowd. 'In one form or another or another, T-shirts have always been popular items,' Burton remarks.

Many of the slogan T-shirts that form Burton's impressive collection were purchased at the time of their production, but have since become historic items: 'When I was wearing punk T-shirts in the '70s you never thought that one day they would be collectable. At the time they were a sort of disposable art form and so now to get museums calling in a certain type of T-shirt is quite extraordinary.' Amongst Burton's T-shirt archive is a high volume of McLaren and Westwood slogan T-shirts that continue to be highly sought-after. A long-standing relationship with COMME des GARÇONS (CDG) in Japan recently saw fifty of Burton's McLaren and Westwood T-shirts displayed in cabinets, in their quasi-museum retail store in Tokyo, to coincide with a CDG collection that had been inspired by them.

The definition of 'vintage' clothing is elastic as there are huge variations as to how the notion of vintage is deployed. Traditionally vintage fashions are garments that originate from a previous era with a time scale that extends beyond 20–25 years from the year they were in production, whereas antique clothing is usually cited as clothing produced before the 1920s. But even vintage garments are subject to the vagaries of fashion, as are the hierarchies of its various genres.

In recent years vintage apparel has surfaced as highly commodified, mainstream and at times quite sanitised with stores and high street retailers profiting from this trend, thus negating one of its former attractions; low cost and differing from the masses. Furthermore, the authenticity and vanity of being there 'first time round' is questioned since the availability of vintage is cavalier. Nonetheless, clothing relationships are a dynamic process and introducing vintage into one's ensembles allows a connection to a renegotiated past appropriated in the present. The present being operative as many devotees of vintage fashions lack interest in revisiting, for any length of time, the relative lifestyles those fashions were fastened to.

Through his work Burton travels extensively, but rather than actively sourcing additions to his sizeable collection often he comes across slogan T-shirts when perusing miscellaneous merchandise at vintage stores and fairs; typically eBay is also a valuable resource for locating the random and the idiosyncratic. 'Being an ex-mod, I still love to find the really most obscure T-shirt that nobody would know anything about, more so because usually I know all about its origins and that's really what I am about.' Burton's own T-shirt preferences favours the ephemera of 1940s drag racing and hot rod sporting activities. However, he adds that his personal collection and archival collection are paramount in their importance.

Part of the appeal of vintage slogan T-shirts, as worn items of clothing, is how the T-shirt itself, as a material item, along with the printed matter upon it, relaxes with age and wear, whilst the memories are figuratively knitted into the T-shirt's fabric. Burton expands on this topic: 'I think there are a number of reasons why vintage T-shirts have become popular in recent years. Firstly, the nostalgia for a time or a place the wearer once related to either on an emotional level, or at a high point in their lives. Linked to this is a T-shirt's short-lived quality, the fact that very few were made to last has made even mass produced T-shirts highly desirable in certain circles. And then there are certain groups of people who want to show others their credibility by wearing a printed T-shirt of a cult, movement, band or organisation that they may, or may not, have once belonged to ... I think that people enjoy fashion nostalgia because wearing vintage clothes allows them the freedom of a mix and match individuality, sadly lacking in much of today's fashion design.'

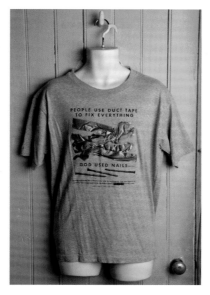

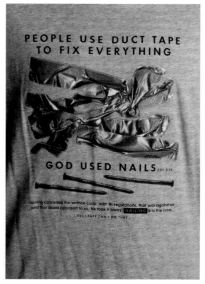

T-shirts kindly supplied by Roger Burton and photographed at Contemporary Wardrobe

Michael Kopelman at Gimme 5

Stüssy
T-shirts

www.stussy.com

'Many of the brands
I've worked with use words
on their T-shirts but it depends
how you define slogans.
I suppose if the word is on a
T-shirt, then yes it's a slogan.'

For over three decades clothing label Stüssy has been the sartorial barometer of streetwear clothing, transcending its original association with surf, skateboarding and graffiti culture and emerging as a cross-generational leitmotif for urban style. In the early 1980s Californian surfboard designer Shawn Stüssy printed his eponymous tag on T-shirts not yet knowing that his insignia would become as iconic as it was profitable. To some extent it is the inimitable Stüssy logo, alongside its alliances with hip hop culture and street subcultures, that has defined and augmented the brand's covetable status.

Since the late 1980s Michael Kopelman, founder of fashion distribution agency Gimme 5, has been at the vanguard of representing and supplying retail outlets in the UK and in Europe with some of the most cult clothing labels in street culture including Japanese brands Bathing Ape and Hysteric Glamour, Dutch brand Rockwell, American brand Supreme and the much fêted Stüssy, whose global reach has been historicised on its 'World Tribe' T-shirt series (aka 'World Tour' T-shirts that reference diverse cities). But what sets Kopelman's fashion stable apart from the multitude of street brands that have surfaced since he

founded Gimme 5 is that his studio operates as a site for clothing labels that inhabit a position outside of mainstream fashion consumer culture: 'It is not fashion as such that interests me,' imparts Kopelman, 'but more utility wear like workwear or branded goods... my strength lies in those areas.'

A central factor to streetwear consumer culture is not only the social importance assigned to the designated brands and their imbued meanings, but the criteria attached to the idea of group membership and the interplay between one's own unique sense of identity and a registered social identity that aligns itself with a set of cultural values.

In the case of Stüssy those values revolve around lifestyle and music culture as demonstrated by its droll slogan 'I Get Goose Bumps When The Bass Line Thumps' and the more cadential 'No Music No Life'. The absence of political content in Stüssy's output has been a conscious decision since the brand's birth, preferring to champion the notion of social belonging though an 'attitude' as exemplified by one of its infamous slogans 'It's Not Where You're From, It's Where You're At.' The operative word in this statement being an intangible, yet

authentic, 'at'; a seemingly inconsequential preposition that speaks volumes to those conversant with Stüssy's 'insider language'.

The consistent success of the Stüssy brand and the loyalty of its fan base is even more remarkable when one considers the cyclical nature of fashion and brand identification. Kopelman elucidates: 'Stüssy has quite a broad catchment as it has a foot in many realms and different followings in different countries.' As Kopelman shares, now that Stüssy is thirty years old its market appeal extends beyond surf, skate and fashion stores and includes heritage outlets to accommodate the Stüssy customer that may favour its additional status as modern vintage apparel.

Since clothing, especially T-shirts, are physical reminders of the past or can be used as props to 're-imagine' the past, it is unsurprising that mainstay labels such as Stüssy have increased their market appeal thanks to both their current youth customer base and the youths from 'first time round' who have now matured. The histories attached to kept and archived clothing, such as Stüssy's encoded T-shirts, evoke memories just through their very presence; furthermore, vintage and rare Stüssy is especially prestigious, once again alluding to the notion of 'first time round' as a marker of being *au fait* with Stüssy's established reputation.

Stüssy's use of words on its T-shirts has been a core design feature throughout the decades but as Kopelman verifies it is the 'World Tour' T-shirts that have had a continued presence over the years. Presently, it is the slogan 'If You're Feelin' The Vibe, Then Get Down With The Stüssy Tribe!!!' that adorns the T-shirts of Stüssy aficionados worldwide who value the collective sentiment of the memorable turn of phrase.

'Stüssy's slogan T-shirts vary in their longevity, some are more popular than others and that is obviously because they mean different things to different people, I think one of the reasons the streetwear community is so attracted to the T-shirt is that it's affordable or certainly it should be affordable,' Kopelman posits thoughtfully.

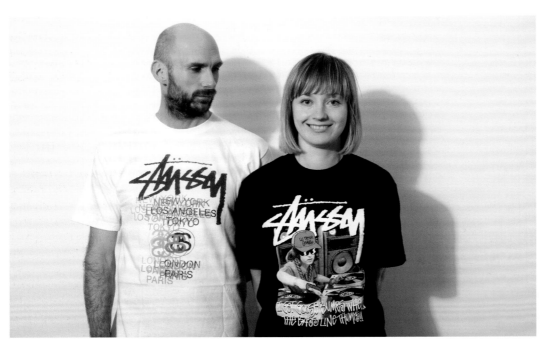

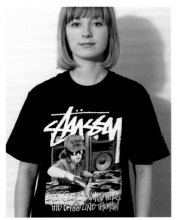
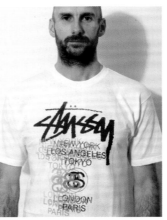
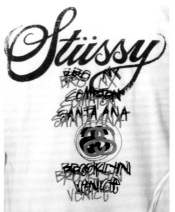
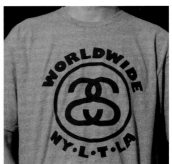

A selection of Stüssy T-shirts kindly supplied by Michael Kopelman at Gimme 5 • Models: Scott Maddux and Silvia Ricci

Namalee Bolle
at SUPERSUPER!
BOY
T-shirts

www.thesupersuper.com

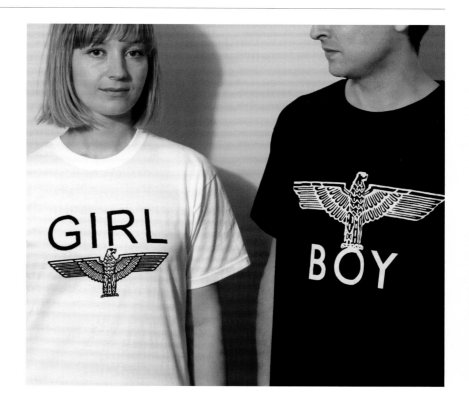

'I really like how it's a three-letter word that is easy to relate to visually *and* it fits nicely on a T-shirt.'

'I'd say that symbols are the slogans of our time,' launches Namalee Bolle, a polymath of talent and one of London's fashion and music trailblazers. In 2006 after years working as a journalist, Bolle co-founded the fashion 'n' music magazine *SUPERSUPER!* Nowadays she is its fashion director alongside working as a fashion stylist and fronting a rock band. Bolle elaborates: 'In 2008 these two young upstarts, that came from the club scene, started this small T-shirt label called LONG Clothing. They took the aesthetic of long T-shirts and printed very simple, linear graphics such as triangles and quasi-witchcraft and Celtic signs upon them – they completely made the long T-shirt their own. The "LONG" boys are absolutely what we're about at *SUPERSUPER!* they're just doing their own thing, working really hard and building their label up...'

Securing its place as *the* cult T-shirt label *du jour*, it is unsurprising that LONG Clothing has recently collaborated with another cult T-shirt label (BOY) that has seen numerous revivals since its inception in 1976. Assimilating BOY's trademark typographic visual into LONG Clothing's *own* distinctive visual concept has mutually fortified both companies' iconic

status. Rhys Dawney and Gareth Emmett of LONG clothing elucidate: 'The collaboration between LONG and BOY was an obvious one for us. The brands have so many parallels between them and a similar following so it just made sense. After the success of the initial LONG and BOY collaboration we sat down with Stephane [Stephane Raynor, the original creator and co-founder of BOY] and discussed giving BOY London a proper re-launch. We all felt like the brand deserved it and more importantly that it was the right time. BOY still resonates with people because it's real. Through all its transformations it has somehow managed to keep it's true edge and people recognise and respond to that."

Engineered by Raynor (and John Krevine); both formerly of Acme Attractions the legendary punk clothing boutique in London's King's Road, BOY has been a sartorial leitmotif for countless youth movements since it began. Its consistent graphic language has been at the receiving end of much imitation, yet authentic BOY T-shirts have been fetishised regardless of whether they are in production or not. According to Bolle, BOY meets the criteria of being a slogan because it 'relates to the current

youth generation.' As with LONG clothing its gendered ambiguity and unisex values play on the sexual climate of androgyny and pansexuality. Bolle explains: 'I'd say BOY is a very *SUPERSUPER!* brand. It reflects what our readership is about and that is an aesthetic that celebrates the idea of genders playing with each other's sexual characteristics ... so you have girls looking like boys and boys looking like girls ... because my generation is very comfortable about sexual identity, they don't feel the need to go on marches, for them it's just who they are, and BOY is a statement of that gender mix-up thing – even the models in the BOY ads, and we do a lot of advertising and promotions with BOY in the magazine, look neither specifically male or female. And of course there's a real love of all things '90s at *SUPERSUPER!* and BOY, although having a presence in the '80s, are very associated with the '90s.'

The cultural referencing of the 1990s nourishes the *SUPERSUPER!* ethos. However, Bolle and her team's creative prowess have seen its '90s retro elements processed through computerised and technological forms as a means to not only bring it up to date but to coat it with a futuristic visual cohesion. 'We're not at all a '90s magazine, it's just that it's the era we grew up in, so things like films such as *Clueless* and clothing such as Buffalo Boots, which so many people think are ugly, to us are great,' says Bolle.

As Bolle explains, *SUPERSUPER!'s* audience mainly comprises of 16- to 25-year-olds and although it maintains a strong web *and* print presence, its audience mainly accesses information through electronic forms of communication: 'When I started the magazine years ago it wasn't online, but basically all of the new stuff is online and so is our audience. It's all moved so fast, everything has gone much more underground and I'd say the underground is now online. The artwork that is coming out of it is really incredible, it's really technical and Giffy [GIF: an image format that is hyper-coloured and animated] and flashy and I think that's where the most interesting stuff is ... I think people are staying in on their own so you can't really see them but they are there working away online, so it's much more geeky in that way.' Astutely, Bolle regards the speeding-up of information as being symbolic of a much faster media-led culture (i.e. flipping TV channels incessantly and quick-cut advertising) which generates not only an inevitable diminished attention span but also an image-led form of exchange: 'Nobody writes whole sentences anymore. I'd say that the current youth generation is not about speaking directly with words so much, because online they communicate with visuals, that generation is visually clever, they *read* visuals, it just seems to be the way the consensus went.

It doesn't mean they're not intelligent, it's just a different type of intelligence.'

Bolle expands further on how the underground online movements are shaping new approaches towards creative production: 'There are loads of DIY bands at the moment and people hijacking popular culture, such as hijacking boy bands and doing their own interpretations of their poppy, commercial aesthetic and it's quite punk how they do it; the thing is, it's not an attack on boy bands – they take their gloss and their rules and make it their own by absorbing it into their own language. It's like all the kids who wear band T-shirts and they don't know who they are, and older people say they *should* know who they are, but that's not what they have grown up with, because what they do is they read pictures so it doesn't matter, because for them it's more about how it looks or what they want to evoke. Remember they've grown up in a styling generation, everything is styled now and they are all stylists themselves. Personally, I'm somebody who grew up loving words but I became more visual and I think that may be one of the reasons I formed a band is because I needed the words.' Bolle muses rather poetically.

Bolle's styling credits include working with Katharine Hamnett, for whom she has also modelled: 'One thing I love about Katharine is that she's using the T-shirt to say something

about her place in the world and what she cares about, and by wearing her T-shirt it shows that it's something you care about too — it's a mutual thing. She's very much like that as a person and I really love that integrity ... and her slogan T-shirts aren't about trends so they stand the test of time.'

Bolle reveals how her approach to fashion styling has been influenced by her position growing up in an overt, consumer-driven landscape that saw branded fashions using its logos as its design feature: 'When I started styling and took consumerism on, people were like, "Oh my God, that's so garish how you could wear huge sportswear logos." But I think it's a generational thing, we grew up loving those brands and the newer generation completely accepts it but also they never really had the chance to fight against it and in my own way I was fighting against it but also appropriated it. So with *SUPERSUPER!* it was always very colourful and loud and very Disney looking.'

The 'Disneyfied' look that Bolle refers to is truly exquisite, more so when you consider that its presence has been adopted out of love for its imagery and not for the purpose of irony, as Bolle clearly asserts: 'There's never been any irony, I just think if you like something say you like it, don't pretend otherwise, I just think it's a bit pointless really. With *SUPERSUPER!* I've kept this joy of things that I really love, that's what we're all about.'

Bolle and her coterie at *SUPERSUPER!* were championed as the figureheads of the Nu Rave movement (a music scene that amalgamated elements of electro, new wave, indie and hardcore breakbeats) but as she illuminates it was a label that the media had coined rather than a self-appointed tag: 'I don't like the idea of labelling myself anyway, for me it's always been about the ideas. Really it was a mash-up and clashing together of lots of different styles; a very bold style, it was such a new aesthetic. So what happened was that Nu Rave was

taken on by a wider media, because our media is obviously very small, and the media gave it a name, which was fair enough because we didn't know what it was either at the time, and then it became something that was reduced and sold on by the mainstream. Actually, the only thing the media were interested in were the colourful trainers, which we did wear, but there was so much more to it than that. And yes there was appropriation from the '90s rave scene, but it was only a part of it, and it wasn't even the most important part. But that was sad to me because there was a genuine concept behind it, such as unity and creative expression and being unafraid, and that wasn't developed properly. I think what happened was the high street made these slogan T-shirts to coincide with the time, but to be honest I don't remember anyone wearing them in our group of people... whatever is picked up on by the media never represents how it actually was anyway.'

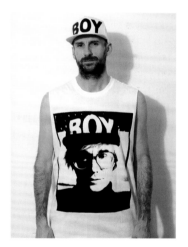

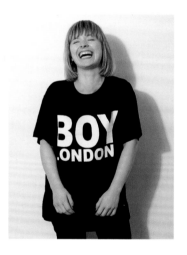
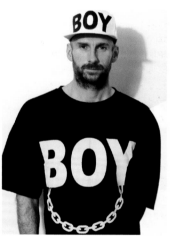
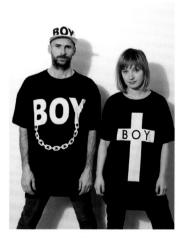
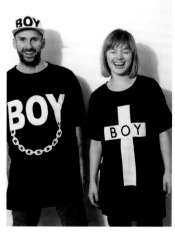
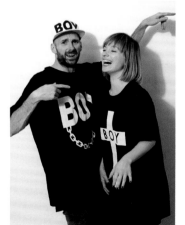

T-shirts kindly supplied by LONG clothing; www.longclothing.com and www.leavetheboyalone.com; BOY T-shirts featuring 'Andy Warhol' and the words 'GIRL' and 'BOY' (p.89) both kindly supplied by Urban Outfitters; www.urbanoutfitters.co.uk • Models: Scott Maddux and Silvia Ricci

Navaz Batiwalla
at Disneyrollergirl

Martin Margiela T-shirts

www.disneyrollergirl.net

'There are some slogan
T-shirts that are able to captivate
people's imaginations, not
just the slogans but the look
of the actual T-shirt too.'

The culture of disclosure and sharing one's everyday experiences has reached paramount levels. It is now common practice to broadcast one's tastes, insights and opinions on modern life, professing authority on themes of one's choosing. Blogs, especially, have brought the 'I' back into writing in a momentous way; virtual narrator-talks-to-audience communication. What is truly captivating about blog culture is the scope in which individuals can chronicle their daily insights and align themselves with related worlds through the construct of technological mediation. Propelled by the online culture of the soundbite and the capacity in which individuals can socially brand themselves courtesy of Twitter et al., many sources are now referring to the slogan T-shirt as an offline Twitter or blog post. Given their pithy nature, soundbites can be used effectively as codes for identification, whilst colloquial language or trivial subject matter is a bi-product of trends and topical issues and therefore interwoven in everyday life. The possibility to form soundbites from trivia is seductive, whilst their capacity for 'connectedness' is addictive.

Social media and slogan T-shirts are not only intoxicating platforms on which to disclose textual and visual information, but significantly, they are an uncensored and undiluted form of self-expression; whilst both function as not only a communicating tool but also a unifying one.

Navaz Batiwalla's Disneyrollergirl blog has captivated a worldwide audience with her erudite fashion knowledge and perceptive musings. According to Batiwalla, the need to wear a slogan T-shirt to *convey* opinions has been compromised as a result of the proliferation of online exchange: 'It's interesting that before the digital age the slogan T-shirt could say a lot about you, fashion does that naturally ... but now that everyone is interacting so much digitally, especially young people who appear to be very open and outspoken, I wonder if wearing a slogan T-shirt tells anything extra since it's probably quicker to do it through Twitter anyway. On the other hand, I'm saying that now, but as I am thinking of it, the flipside could be going back to the old school way of connecting with others which was through a slogan T-shirt or even bringing out a fanzine ... those alternative ways of communication.'

Once again correlating the explicit nature

of the slogan T-shirt with the autonomy of social media brings the subject of self-censorship to the forefront, Batiwalla gives this some consideration: 'I do ask myself to what extent is sharing your views publicly a good or bad thing, because at heart I'm quite private and shy, so having a blog, for instance, means that you can talk about things without having that face-to-face contact with people ... so what it has actually done is make you more confident in your opinions because people do respond to them and you realise they are valid. I think for a lot of people who use online media there's a fear of being judged, but if you are just being yourself I can't see a problem to it, that's where I've come to with it. I'm aware of what I'm doing, I put myself out there to be judged, and luckily I haven't had any negative feedback ... after all, we are supposed to have freedom of speech in this country and I think that's necessary for media such as Twitter and Facebook.'

As characterised by Batiwalla, whose blog has been immensely influential since its nascence in 2007, young people are possibly more conversant with technological forms having grown up with Internet technologies. 'I think blogging and social networks lend themselves to anything that is hyped, because those types of channels go viral very quickly these days'. Batiwalla continues: 'So if you have, for example, text on a piece of clothing and review it online, it can travel that much further. That's what I see the digital side of things doing. I think from my point of view, in the last two years I've noticed how fast things move, so I think if you are trying to get a message across and you wear it on a T-shirt, you can expedite it through exhibiting it via these viral channels.' This idea of concurrent, dual dissemination is not only potent but also reciprocal if one considers that the sloganised T-shirt mirrors the concept of the soundbite prevalent on blogs, Twitter, Facebook etc.

Likewise, the soundbite nature of social networks is transposed to the medium of the T-shirt, which in itself is further propagated by online conduits.

Batiwalla's own preference of slogan T-shirts are those designed by fashion provocateur Martin Margiela that he created in support of AIDS awareness in 1994 and have been a staple of his collections ever since. The seemingly esoteric text reads; 'There is more action to fight AIDS than to wear this T-shirt but it's a good start.' Batiwalla elucidates: 'It's the slogan T-shirts that I have a connection with from the past that I really like. The Margiela T-shirt is a classic and it'll always be worth keeping, even if I don't wear it ... it's almost like there is a bit of a secret code that you are going to recognise other people wearing them, so for that reason it's also becomes a bit of a cult thing too.' Although there is an ealier generation which was more conscious of the urgency of AIDS activism *and* its partnership with the fashion industry, this is not the principal

reason Batiwalla holds Margiela's AIDS T-shirts in such high regard, despite her support for the cause. 'For me, a T-shirt's use of words and its graphics always go hand in hand, as does the actual cut of the T-shirt, so even if I liked the words but didn't like the graphics I wouldn't wear it. Margiela's type is a bit like a stencil, which I love, and I also like how you can't read the text properly unless if it's lying flat, it really is a coded message. Each season they bring out new colour combinations … I think the whole concept of it was really clever, but at the time I probably wasn't thinking of those things consciously, it just appealed to me. And then when you do break it down, I think it's the combination of *all* those elements. For me, a T-shirt is an emotional reminder of a time,' Batiwalla reflects before adding, 'some slogan T-shirts do date in as much as they represent a certain period in time because they can be evocative through their non-verbal communication of places you've been and where you were at emotionally … As for the Margiela T-shirt, to me it's timeless in so many ways.'

The Martin Margiela T-shirt incited an emotional response from many of the contributors in this book. Adam Thorpe of Vexed Generation (interviewed with his business partner Joe Hunter on p.120–4) kindly emailed a paean to its value: *'Margiela came up with this T in 93/94 and has been doing it every year since. The first I saw of it was a friend Nic Jones wearing one around this time. The fact that the "message" was obscured made me notice it more and pay more attention to what it said. There was lots of neckline tugging to see where the text goes. The design appeared to follow a deconstructionist approach to the construction of a slogan T – both in terms of how it was made (the finished garment with a screenprint; without separating front from back) and how it "worked". Deconstructionism is a philosophy based on uncovering contradictory meaning and therefore destabilising the idea of universal truth. It is widely associated with the philosopher Jacques Derrida, who first proposed it as a way of thinking in the late 1960s. I don't know about destabilising universal truth, unless it's the one that says slogans should be readable, but there is contradiction here – the contradiction is between an important message held within a slogan and the fact that the slogan is obscured by the person wearing it; its impact on me was to make me pay more attention to it than I might of done otherwise.'*

T-shirts kindly supplied by Navaz Batiwalla (women's T-shirts) and Sam Bully (men's T-shirts) • Models: Albert Kang and Silvia Ricci

Alex Fury
and
Paul Hetherington
at SHOWstudio

The downloadable T-shirt project

www.showstudio.com

'I think of the slogan T-shirt as a sartorial item that has become a cultural artefact.'

Paul Hetherington

Borrowing its title from the global vernacular of the tourist T-shirt, SHOWstudio's ingenious 'And All I Got Was This Lousy T-shirt' project democratised the availability of the designer T-shirt by creating free downloadable designs that any of its online patrons could access, print and then iron on to a T-shirt of their choosing.

Although many of the initial fourteen contributors who submitted T-shirt designs were established fashion designers, the project relocated the T-shirt from being a fashion timepiece to one that saw illustrators, graphic designers, stylists and photographers also interpreting the open brief.

The maverick behind the concept was SHOWstudio's creative director between 2000 and 2009, and art director, Paul Hetherington: 'It was an active project between late 2001 to early 2002. The idea was a simple one plus one equals two. I saw that fabric transfer paper with which to make homemade T-shirts was available, and since colour printers were becoming relatively cheap, the plan was that each week a new design would be added to the existing T-shirt designs which people could download as a PDF ... virtually everyone we asked responded with a design made

especially for us.'

Hetherington shares how he had been inspired by an article he'd read about T-shirt culture in South America. The account had described how T-shirts operated as media spaces in which messaging benefited from a rapid turnover through the production of new short-lived slogans being printed up on a weekly basis, thus reflecting the news bulletins of that particular week. Hetherington elaborates: 'I thought the idea of an ultra-short-term T-shirt that took on a different meaning, via political or socio-political statements, was an interesting concept. The notion that you might wear the T-shirt for a day and then replace it with another the next day motivated the idea of commissioning one new T-shirt per week, however from an ecologically political perspective the T-shirt needn't be disposable.'

SHOWstudio's current fashion director Alex Fury continues the dialogue: 'We also offered the opportunity for people to take pictures of themselves wearing the T-shirts which we then posted on the site, it was always interesting to see how people made the T-shirts their own.' This cycle of an initiative originating from web-

based premises with the results returning to its web pages demonstrates a reciprocity that is integral to SHOWstudio's principle objective of being a collaborative platform.

When SHOWstudio launched in November 2000, the idea of an online space devoted to the culture of fashion was relatively novel. Hetherington had been part of the brainstorming team that established the concept of SHOWstudio, alongside its founder and director the acclaimed photographer Nick Knight: 'SHOWstudio began as an experimental project, so we were looking at all conceivable mediums to work with, always with the intention of posting new ideas on a weekly basis, bearing in mind at the time that blogs and social media, as we know it, had as yet to emerge.' Fury adds: 'The site is founded on three principles: process, performance and

participation; the 'And All I Got Was This Lousy T-shirt' project fell into participation. At SHOWstudio we focus on the process and performance of fashion contexts, opening the medium up as a two-way communication, everything we do is about engaging with the audience. The concept of SHOWstudio is in the name, "show in the studio"; studio being a place where artists and designers work and therefore showing a window into their world.' On a personal note Fury considers the slogan T-shirt as possessing capital when political or social intent drives the meaning of the text, words as a decorative feature hold little interest to SHOWstudio's style maven, 'Just the presence of words alone doesn't mean it's a slogan,' he remarks.

SHOWstudio continues to be at the vanguard of creative experimentation, a series of other

downloadable projects include the downloadable pattern which saw fashion luminaries such as Martin Margiela, Junya Watanabe, John Galliano, Alexander McQueen, Yohji Yamamoto and Gareth Pugh creating, as the name suggests, downloadable garment patterns, and likewise the downloadable poster which enabled online users to download the album covers Nick Knight had photographed for Lady Gaga's *Born This Way*, Bjork's *Volta* and Gwen Stefani's *Love, Angel, Music, Baby*. Since both projects were colossal in terms of actual downloadable time and their physical size, SHOWstudio viewers were required to assemble them as segments not dissimilar to a jigsaw puzzle in grid form.

Conversely, the 'And All I Got Was This Lousy T-shirt' downloadable T-shirt was far more straightforward in terms of scale and lack of complexity. In autumn 2009, a select few of the

'And All I Got Was This Lousy T-shirt' designs were reissued for the 'SHOWstudio: Fashion Revolution' retrospective at London's Somerset House. The T-shirt artwork of fashion designer Jens Laugesen, illustrator Julie Verhoeven and graphic designer Peter Saville amongst others were not only exhibited but also for sale. According to Hetherington, the slogan T-shirt has the capacity to express an exhaustive range of viewpoints including personal or political positions, yet it was only the work of London-based stylist and accessories designer Judy Blame who politicised his donation. His design 'Zero Tolerance' saw the words 'Pollution, Corruption, Ammunition, Isolation' embedded in and configured by the iconic image of the United States' flag. Upon first glance the T-shirt visually seduces, but it is the explicit nature of the T-shirt's rhetoric that expresses a duplicity associated with governmental politics; more poignant given the timing of events. Blame's design contribution epitomised how a T-shirt is so much more than *just* a T-shirt and masterfully SHOWstudio's visionary team recognised that.

T-shirts: 'Pollution, Corruption, Ammunition, Isolation' designed by fashion stylist Judy Blame (p.94), 'Mum's Boyfriend Sprung My Tag So Go Out' designed by illustrator Jodie Barton (p.96) and 'Stupid Fucking Printed T-shirt' designed by artist Peter Davies (above) all kindly supplied by SHOWstudio • Model: Yu Ling Huang

Zachary Pulman

The tourist T-shirt

www.zacharypulman.com

'We didn't have to "sell" them… they sold themselves.'

The quintessential tourist T-shirt 'My Mum went to London and all I got was this lousy T-shirt' transcends national borders through the revision of two operative words; the title of the donor and the name of the country. Although visually generic and available worldwide, it is the symbolic value of destination; 'London', Dubai', 'Shanghai' et al. that prompts purchase either as proof of travel, as a future trigger for memories, as a token acquisition or perhaps as architect and one-time tourist retail assistant Zachary Pulman suggests: 'It is the the tourist T-shirt's quality of "convenience", that impels the sheer quantity that are sold'. Remarkable, then, that their visibility as worn items of clothing is negligible, if at all. And not only are there 'London' T-shirts worn in London, but, say, 'London' T-shirts worn in Dubai or 'Dubai' T-shirts worn in Shanghai or Dubai citizens wearing a 'Shanghai' T-shirt in London.

The tourist T-shirt has always been a simple artefact that commemorates a vacation or functions as a souvenir, so maybe *wearing* the tourist T-shirt isn't really the point, maybe its worth is purely as memorabilia: 'I can't remember the last time I've seen someone wear a tourist tee; I guess because those who

buy tourist T-shirts are mainly from abroad and return home with them, so you wouldn't necessarily see them wearing them anyway, but I've travelled a lot and now that I am thinking about it, I have *never* seen anyone wearing one' shares Pulman thoughtfully.

During the late 1980s Pulman worked weekend shifts at a tourist retail chain to support himself through art college: 'We sold all types of merchandise in our shop: postcards, batteries, camera film, postage stamps, but slogan T-shirts were the best-sellers and being the highest priced items in the store they were the most lucrative. The older the customer, the more they had to spend and so they were the ones who would buy armfuls of them, literally sometimes they would come to the counter clutching loads of them, people seemed to absolutely love them… we never asked who they were buying them for, but I guess for the most part they were given as gifts to family and friends. Back then, they were a blanket price of £5.50 each which was a lot at the time.' Pulman continues: 'The shop I worked in was right opposite Big Ben, so at least we had a great view, but to be honest it was always

so busy that the day passed quickly. We had lots of wealthy Japanese customers, quite a few couldn't speak English ... There was one occasion when one guy didn't understand the currency and was paying for ten postcards at 5p each, so he hands over a £50 note and by the time we'd returned from the back of the shop to get change, he'd gone, so we thought that's a good tip!'

Being an architect, it is unsurprising that Pulman comments on the T-shirts' visual presentation in the store: 'I recall one side of the shop was a floor-to-ceiling wall of T-shirts, the racking system was as a grid and since the T-shirts were all wrapped in cellophane they looked like wallpaper.'

Pulman also remarks how the branch he worked at only sold London memorabilia; novelty T-shirts and brand-appropriated T-shirts were conspicuously absent. Nowadays the majority of tourist outlets also sell T-shirts with obscene graphics and text, and also worded T-shirts in fonts that are intrinsically associated with particular brands. In Britain the display of indecent material on items such as T-shirts is liable to prosecution under the Indecent Displays (Control) Act, 1981 and the Obscene Publications Act, 1959, so it is curious how tourist shops, which are located in premium sites, display and sell a range of T-shirts which use inappropriate language and appropriated visuals, *and so*

publicly, avoid prosecution. 'I've spoken to my friend's brother who currently works in a tourist shop in Piccadilly about this issue and no one seems to know how these shops get away with it. I guess it's a grey area but apparently they sell like hot cakes yet I've never seen anyone wear those types of tees either!'

Pulman concludes wittily: 'I do think there is an age limit regarding wearing a T-shirt that is anything other than a plain colour. But then again I don't like any form of branding on T-shirts, it's just free advertising for that company. If I had to choose between the two I would prefer to wear a tourist T-shirt – at least you're advertising you've been on holiday!'

**Matt Snow,
Independent Screenprinter
based in Dalston,
East London**

A visual chronicle of the screenprinting process

Do ALL THAT YOU CAN, WITH ALL THAT
YOU HAVE, IN THE TIME THAT YOU HAVE,
IN THE PLACE WHERE YOU ARE.

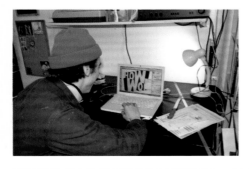

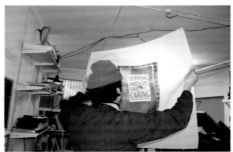

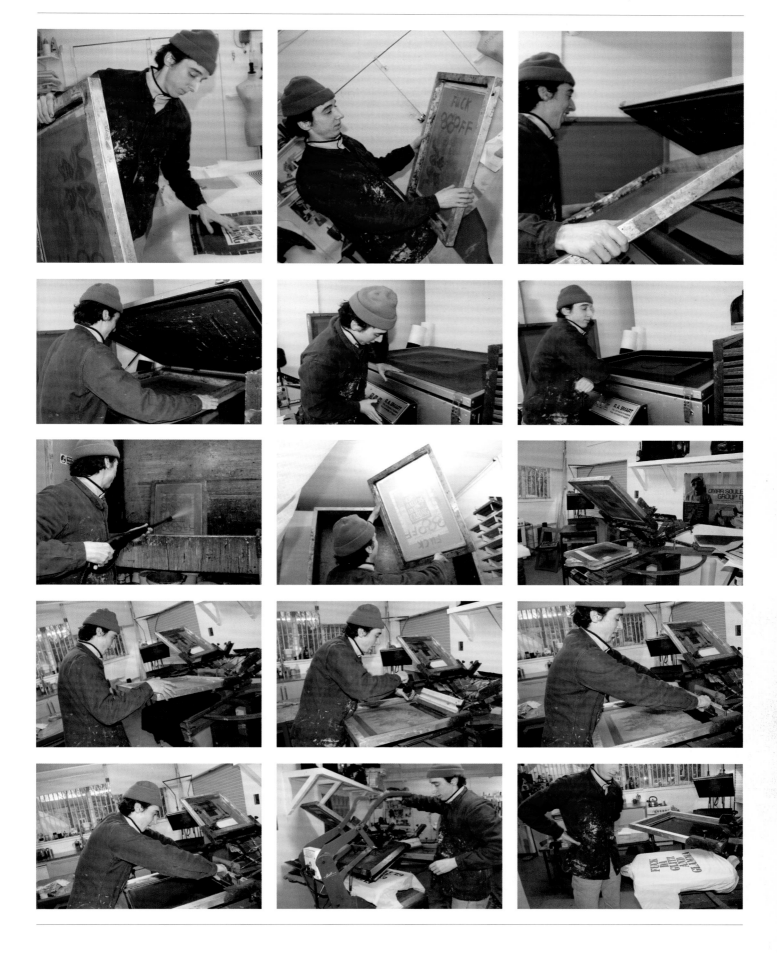

I want!
I WANT!
I WANT!

a sweet boyfriend
money
supper cute clothes
hugs and kisses
candy
shopping sprees
the sun to always shine

pretty shoes
yummy food
a cute puppy
peace
nice car
a day of
happiness

I ♥
ATT
ENT
ION

I ♥
LOVE

HOLLY
WOOD
♥'S
ME

L♥VE
L♥VE
ME
DO! ♥

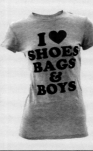

I ♥
SHOES
BAGS
& BOYS

AVAILABLE FOR
ONE
NIGHT
ONLY!

BORN TO SHOP

I like to sleep all day & party all night

I like to sleep all day & party all night

THIS GUYS A
GENIUS

THIS GIRLS A
GENIUS

YES
IT'S REALLY ME

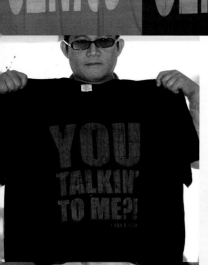

YOU TALKIN' TO ME?!

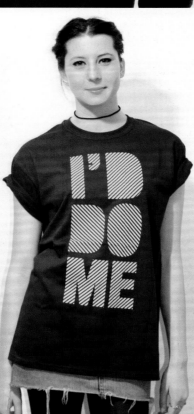

I'D DO ME

What ever

WHO ARE
YOU
AND WHY ARE YOU
READING MY T-SHIRT

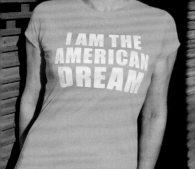

I AM THE
AMERICAN
DREAM

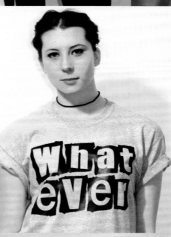

Living THE SHEEN DREAM

PALE
IS THE NEW
TAN

I ♥ ME

I ♥ GEEKS

I ♥ GOSSIP

I ♥ LA

BAR WARS
MAY THE BOOZE BE WITH YOU

STAR WHORES

I ♥ PUB

Drugs are my Life
HOLLYWOOD HILLS UNIVERSITY SCHOOL OF PHARMACY

This Guy Needs A Beer

The Ladies Love This Guy

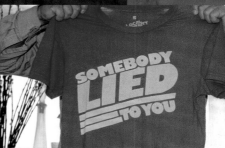
SOMEBODY LIED TO YOU

The Gendered

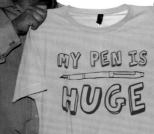
MY PEN IS HUGE

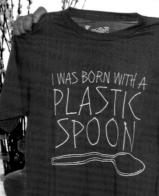
I WAS BORN WITH A PLASTIC SPOON

LETS START A SCANDAL

DON'T BE JEALOUS

100% SILICONE FREE

NO PICTURES

BORN TO BE BAD

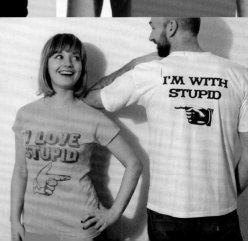
I LOVE STUPID
I'M WITH STUPID

NO I AM NOT ON F*!#ING FACEBOOK

If all else fails, Ctrl Alt Del

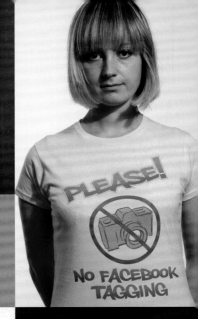
PLEASE! NO FACEBOOK TAGGING

The Technological

London
UK

Big Ben Tower Bridge Piccadilly Windsor **more »**

England |

Search ▷ I Love London

Search: ⦿ the web ○ pages from the UK *esc*®

Fuck Googl
Ask Me!

poke me

I ♥ Friend Requests

Feed Me

500,000 Views

I don't need 140 characters to say
fuck you

twatter

lol.

WTF? OMG LOL!

OMG WTF

I facebooked your mum

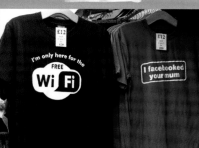

I'm only here for the FREE Wi Fi

I facebooked your mum

Your Mum
94 people like this.

I Like This

I'm only here for the FREE Wi Fi

Wiirdo

I know what I'm doing this Wii-kend

hacker inside

blog to dif fer. I blog to differ. I blog differ. I blog to differ. I blog to dif fer

Give me a

textually active ;)

fwd: out of office

OMG WTF

OMG WTF

PROBLEM SOLVED

STUDENT

SUPER SKUNK

adihash
Gives you speed!

ENJOY
Cocaine

STARSUCKS COFFEE

STARSUCKS COFFEE
DRINK OUR COFFEE OR WE'LL BREAK YOUR LEGS

STAR WARS COFFEE
May the froth be with you

STAR WARS COFFEE
May the froth be with you

I THINK
HE'S GAY

The Questionable

COMA

COMA

I can only please
one person each day.

TODAY IS NOT YOUR DAY

Tomorrow doesn't look good either.

I can only please
one person each day.

TODAY IS NOT YOUR DAY

Tomorrow doesn't look good either

JUST DO IT
TOMORROW

I DON'T
NEED SEX
THE
GOVERNMENT
F*CKS ME
EVERY DAY

KEEP
CALM
AND
CARRY
ON

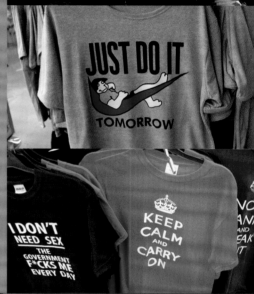

SexDrugs
&Sausage
Rolls.
@twistedsoul

AVAILABLE
FOR HIRE
MOST
NIGHTS!
@twistedsoul

WHAT THE F**K WOULD
Scooby Do?
XPLICIT INDUSTRIES RAP TO THE CORE

SexDrugs
&Sausage
Rolls.
@twistedsoul

HANGOVER
T-SHIRT

YOU BUY EM
'LL DRINK EM!
@twistedsoul

IF FOUND
PLEASE
RETURN
TO
THE PUB!

THIS IS MY
DRINKING
TEE SHIRT
I WEAR IT EVERY DAY
XPLICIT INDUSTRIES RAP TO THE CORE

I ♥
LAger
PISSED UP STATE

Do I Look Like a
F**king
People Person

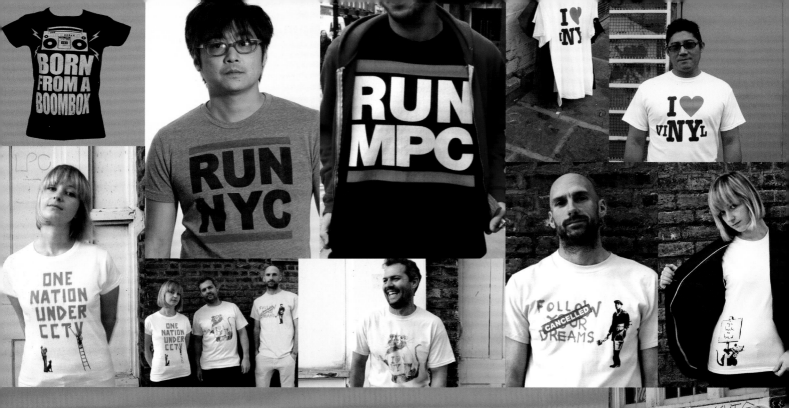

The Marvellous 'n' The Miscellaneous

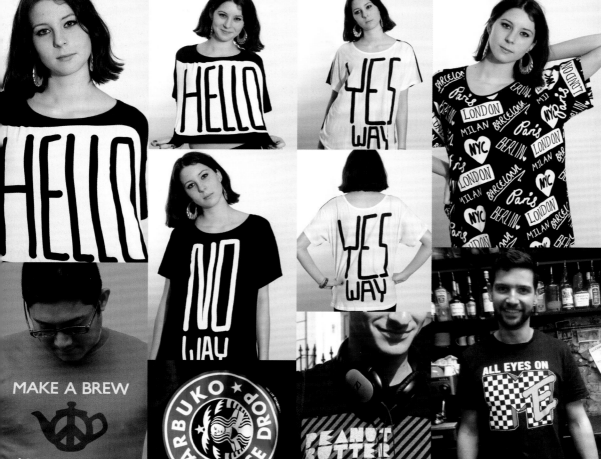

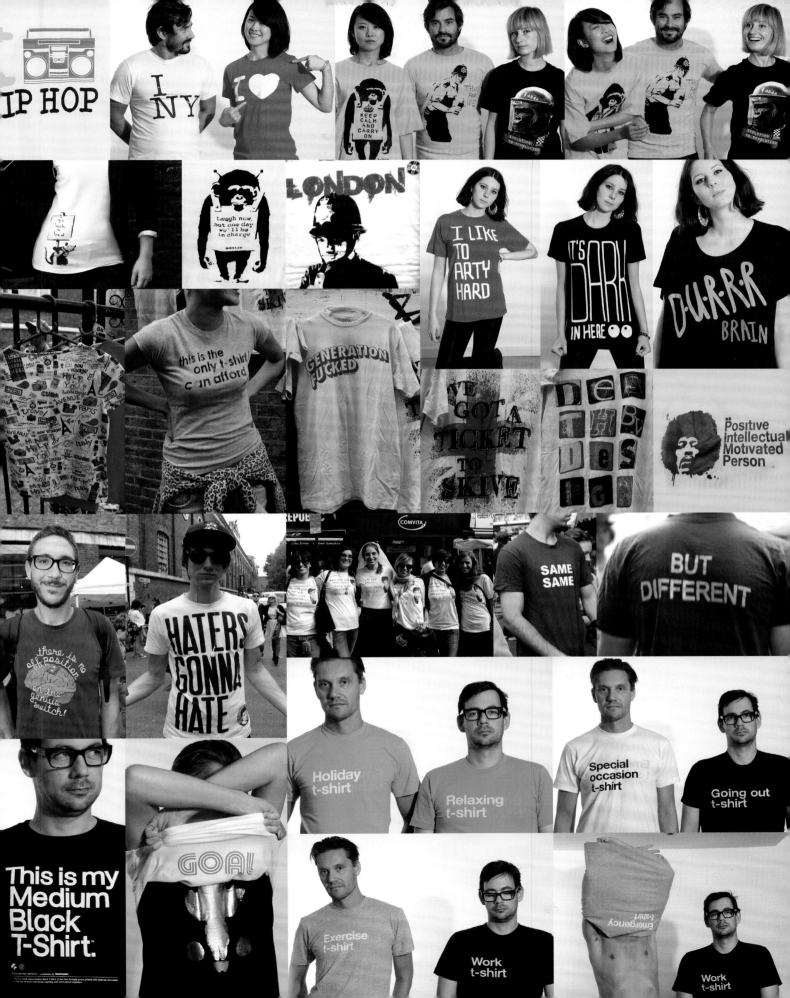

BEEN THERE, DONE THAT, BOUGHT THE T-SHIRT

BEEN THERE, DONE THAT, TWEETED ALL ABOUT IT

I SHOT JR!

I shoot people!

I DON'T NEED A WEAPON I AM ONE

DON'T HASSEL THE HOFF

19 72

made in the 80's

BIG NEON LETTERS

GET YER FREAK ON GILES DEACON

DO ME DAILY CHRISTOPHER BAILEY

I LIKE TO MOVE IT! MOVE IT!

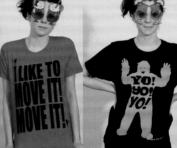
YO! YO! YO!

WHOOP WHOOP!

HELL YES

BPM

OCD

A BCD EFGH IJKL MNOP QRST UVW XY Z...

I never finish anythi

WE ARE THE CODE

TOP BRO

Its a Black thing you wouldn't understand Me

It takes up to 40 dumb animals to make a fur coat. But only one to wear it.

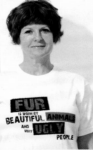
FUR IS WORN BY BEAUTIFUL ANIMALS AND very UGLY PEOPLE

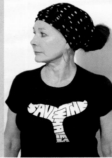
SAVE THE

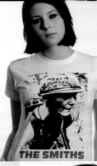
MEAT IS MURDER THE SMITHS

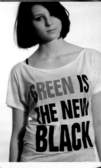
GREEN IS THE NEW BLACK

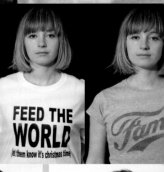
FEED THE WORLD (let them know it's christmas time)

Fam

NATURAL BORN SLACKER

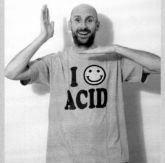
I ACID

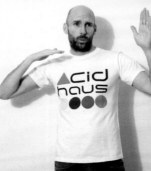
Acid haus

BAUHAUS

BAUHAUS Typography Dept.

i shot the serif.

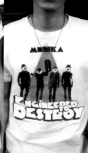

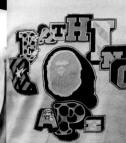

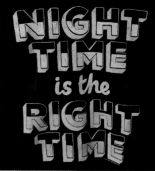

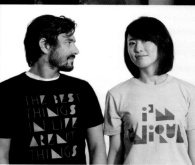

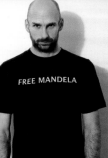

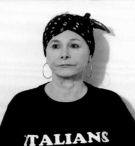

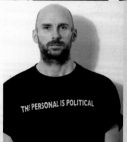

The Marvellous 'n' The Miscellaneous

Part Two

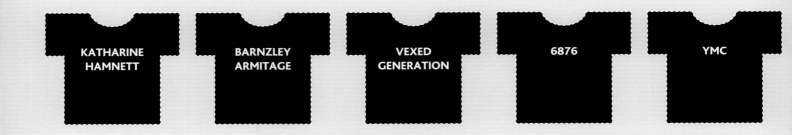

KATHARINE HAMNETT

BARNZLEY ARMITAGE

VEXED GENERATION

6876

YMC

JEREMY DELLER

SCOTT KING

GERARD SAINT AT BIG ACTIVE

EXPERIMENTAL JETSET

2K BY GINGHAM

IAIN R WEBB

ANTONI & ALISON

TOBY MOTT

KAREN SAVAGE

I LOVE BOXIE

CASSETTE PLAYA

DR NOKI

IAN WARNER AND OLIVER MILLER AT SLAB MAGAZINE

DELAY NO MORE

TOPSHOP

Katharine Hamnett

www.katharinehamnett.com

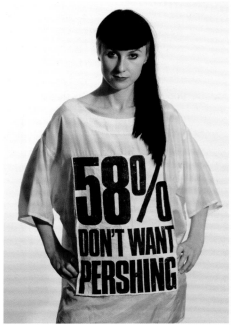
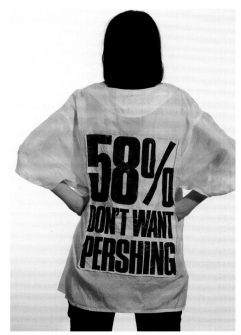

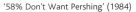
'58% Don't Want Pershing' (1984)

'There's a lot of textual art that says a lot less interesting things than 'JAIL TONY' or 'NO MORE FASHION VICTIMS'. To paraphrase Duchamp: "I am an artist so if I say it's art, it's art". They are art.'

The year that fashion provocateur Katharine Hamnett was awarded Designer of the Year by the British Fashion Council was the same year that she captivated a worldwide audience with her encounter with then British prime minister Margaret Thatcher at a reception at Number 10 Downing Street (headquarters and official residence of Britain's prime minister). As Hamnett removed her coat, apparently only moments prior to meeting Thatcher, she revealed an oversized T-shirt declaring in outsized block lettering '58% DON'T WANT PERSHING'. Furthermore, not only did the size of the type confront, but Hamnett reinforced the public's opposition to Thatcher's purchase of US missiles by also printing the statistic on the T-shirt's back. Unnerved and unamused Thatcher was quick to ignore Hamnett's affront.

Hamnett's coup de grâce was even more remarkable given the fact that political action was initiated in a political setting that was not only a social occasion but a soirée to celebrate British Fashion Week, which made Hamnett's politicised gesture even more threatening and thus even more valiant. The year was 1984. It was the most syndicated image of that year and continues to be a benchmark of how an ethical and political position can be effectively partnered with fashion.

Hamnett's sartorial vigour has been consistent ever since; nineteen years later, in 2003, Hamnett's London catwalk collection saw models wearing T-shirts emblazoned with 'NO WAR, BLAIR OUT' and 'STOP WAR E-MAIL YOUR MP', a reference to the invasion of Iraq. Hamnett explains her unremitting commitment to the slogan T-shirt: 'Slogan T-shirts are a vehicle to print and are effective for things that need to be said or that we need to be reminded of in three words or four. Initially, I wanted to design something that would make me happy if it was copied because my designs were getting copied a lot and it was very irritating. I thought it would be amusing, if not delightful, if T-shirts with giant political and environmental messages on them, about the issues that I cared deeply about, became all the rage.'

Hamnett studied fashion at London's Central Saint Martins. Prior to launching her eponymous label in 1979, she spent a decade freelancing for various European companies. Soon after setting up her own label she began experimenting with slogan T-shirts: 'WORLDWIDE NUCLEAR BAN NOW' and

'SAVE THE WORLD' being amongst the first. Concurrent to her devotion to sustainable clothing and the urgency of the world's injustices, Hamnett has instigated fashion styles and trends that have shaped the relative zeitgeists.

Throughout her career Hamnett has adhered to ethical practices. Her use of organic cotton demonstrates how it needn't compromise the glamour of the garment, whilst her campaigns skillfully raise awareness of the virtues of organic cotton, such as healthier working conditions for the farmers and factory workers, and improved resources for the population. Using the slogan T-shirt as a device to disseminate message delivery, Hamnett has also adeptly used the media to draw attention to a range of social, political and environmental concerns: 'Slogan T-shirts give protest credibility. They were designed to sophisticate protests, to put its issues on the same perceived level as a newspaper headline. They are designed to be seminal; to make people think and hopefully act, because when

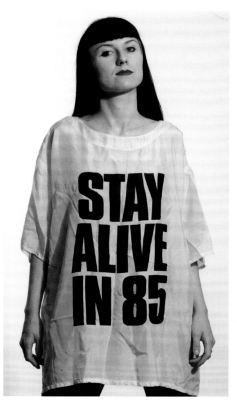

'Stay Alive In 85' (1985)

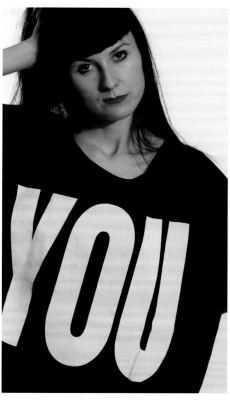

'Me/You' (1984)

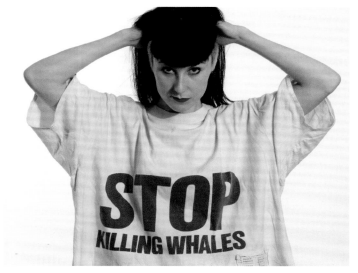

'Stop Killing Whales' (1983)

'Education Not Missiles' (1983)

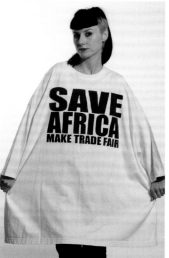

'Save Africa Make Trade Fair' (2003)

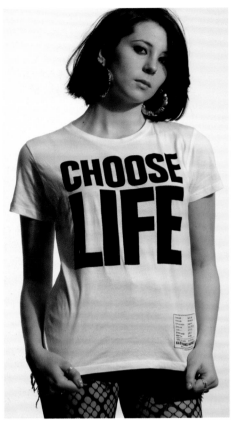

'Choose Life' (1983)

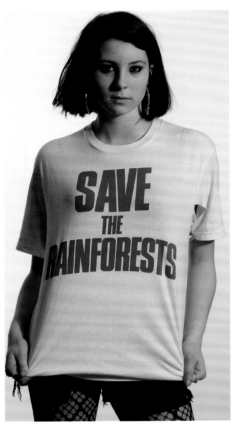

'Save The Rainforest' (1983)

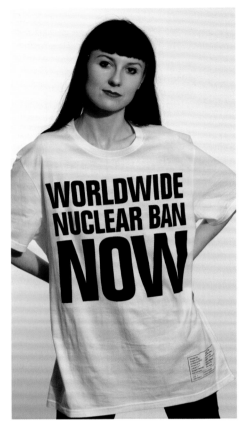

'Worldwide Nuclear Ban Now' (1983)

T-shirts kindly supplied by Katharine Hamnett from the studio's archive • Models: Amy Thompson and Karlie Shelley

you see one you can't help but read it.'

According to Hamnett the slogan T-shirt's appeal is also its aesthetic: 'They have to be something that you would want to wear ... The use of slogans on a T-shirt gives you a voice. You speak to anybody who sees you. They can be quite sexy. Wearing a T shirt that's says 'KNOWLEDGE IS POWER', for instance, makes you look like someone who has a brain, [someone who is] interesting, you would like to know more about them. You look as if you are part of a thinking elite. By wearing the slogan T-shirt, you use your body to put over a clear message. For instance, the 'STOP THE WAR COLLECTION' (2003) started as a follow up to some T-shirts we did as a reaction to Bush's call for a 'war on terror'. The 'NOT IN MY NAME' T-shirt was hugely visible in the enormous demonstrations held in London.' Always *au courant* with current affairs Hamnett continues: 'Article 13 of the British "Prevention of Terrorism Act"

says that it is illegal to wear a T-shirt with a politically contentious message. In theory you can be jailed for wearing a T-shirt that says 'FREE TIBET'.'

Hamnett's assertive and universally recognisable proclamations have been used as a blueprint for slogan T-shirts on a scale that is unparalleled, but as she remarks: 'Someone once said you should get worried when they stop copying you. High street copies are an endorsement; stupid slogans go nowhere. You can never really devalue a slogan that's says 'WORLDWIDE NUCLEAR BAN NOW' or 'SAVE THE RAINFOREST'. A contribution from sales of our T-shirts has been made to various charities over the years. We also donate slogan designs to charities to help raise awareness and funding. Sometimes people ask me to do some relating to a particular issue like AIDS awareness for H&M where I came up with 'STOP AND THINK, USE ONE' and 'PROTECT AND SURVIVE = use a condom'. We try to keep them pure,' adding;

'the 'FRANKIE SAYS RELAX' wasn't ours, they did it themselves.'

During the entire process of producing this book, one name has repeatedly been cited as a source of inspiration, regardless of the industry the contributors come from, and that is Katharine Hamnett. Moreover, in 2011 the Queen finally recognised Hamnett by awarding her a CBE (Commander of the Order of the British Empire: an official accolade given for services to the country or community) for 'services to the fashion industry'.

Hamnett continues to innovate with clothing designs that make her patrons' hearts palpitate, and erudite slogan T-shirts that likewise make government hearts palpitate: 'I think they have turned into a new medium; they don't seem to go away. The most popular ones are some of the first ones we ever did such as 'CHOOSE LIFE', 'SAVE THE SEA' and 'LOVE'. People carry on asking for them and I keep on making up new ones. They work.'

Barnzley
Armitage

www.achildofthejago.com

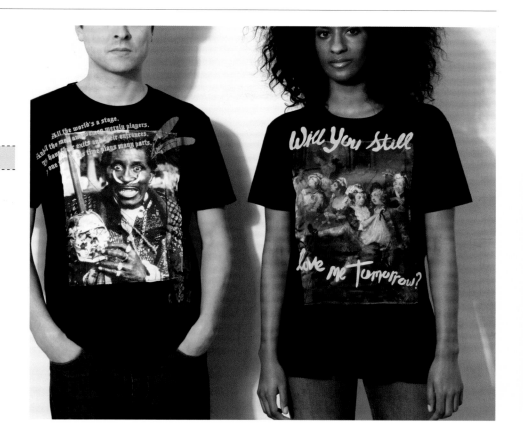

'I always see people
wearing my T-shirts, probably
because there have been
so many of them.'

Cultural agitator and co-founder of the inimitable fashion label A Child of the Jago, Simon 'Barnzley' Armitage's creative trajectory has nearly always involved the presence of T-shirts: 'Even as a kid I was making homemade T-shirts, everyone used to do that, it was standard punk rock practice.' Yet, what is palpable about any one of the independent T-shirt ventures that Barnzley has established since the 1980s is his ability to demote elitism through his transgressive tactics and irreverent vision that capsizes the cultural status quo.

During the latter part of the '80s a trend erupted that saw the appropriation of status-led logos such as Chanel and Gucci engaged with as street fashion, bringing an urban glamour to what was formerly regarded as bourgeois fashion. Inadvertently, this guerrilla gesture changed the fabric of designer labels as we knew them. By negating the exclusivity and fiscal inaccessibility of haute couture, these luxury brands no longer belonged merely to members of the affluent and privileged, deluxe fashion had crossed the threshold into pop fashion's colourful playground. The man responsible for this revolutionary T-shirt spectacle was Barnzley Armitage.

It was in the mid '80s whilst working at the headquarters of the iconic King's Road boutique BOY that Barnzley's entrepreneurial spirit was inaugurated: 'In the studio was a screenprinting table, and at night, once the manager had locked up, the guys who had the keys used to let us in and we'd mess around with ideas.' Inspired by the sartorial prowess of Japanese youths that used to frequent the King's Road, Barnzley recalls how they'd imported a trend that saw buttons removed from Chanel clothing and sewn onto the front of jeans. 'I remember seeing all these Japanese kids hanging around Worlds End [Vivienne Westwood's landmark boutique] with their video cameras, which at the time you sensed were going to be the next big thing after Walkmans. Anyway they seemed so futuristic with their gadgets and their customised clothes and quite suddenly there was this whole thing about bootleg designer clothes.'

This movement towards recontextualising designer motifs led Barnzley to cut out adverts from magazines and screenprint them onto muslin T-shirts: 'Chanel made this T-shirt just for their show and I saw it in a magazine and it was either *not* for sale or for sale at £300 or something

completely ludicrous, but I thought, "Fuck me, we've got a screenprinter at work, I'll copy them" and so I made a big bag's worth of these T-shirts and the next day I was walking along the King's Road wearing one and I had the bag with me, and by the time I got to Worlds End there were none left! All these posh kids had bought them. After that literally every time I walked out of the front door with a bag of these T-shirts I'd translate them into cash and I thought "this is handy", so I started doing a few other designs like Gucci and this went on for a few years. It started slowly and then it got quite ridiculous. By the time acid house kicked off, around 1987, I was the only person doing these bootlegs. But what happened was I went on holiday and when I came back I walked up to Camden to see what was going on and they had started selling counterfeit Chanel T-shirts themselves – and I was really pissed off because I thought I was the only guy who was allowed to do that. So I went to the owner of this one particular shop and said, "You can't bootleg my bootlegs", but before I knew it those types of T-shirts were everywhere, so then I thought now its time to move on and create the next thing.'

As Barnzley explains, this coincided with a time when rave culture saw people underdressing, but the trend for high fashion labels also maintained a prominence. Conversely, rather than adopting designer label culture as a symbol of prestige, street style culture parodied and claimed these extravagant artefacts as a leitmotif for a new type of style statement; one that undercut the snobbery attached to its unattainable values but also caricatured the logo's visual itself.

'We had always associated Chanel and Louis Vuitton as the enemies,' states Barnzley, 'and then suddenly what emerged were all these young Japanese kids wearing it, so by making those bootleg Chanel T-shirts I was making a mockery out of those who took it seriously; it was a type of "I'm going to steal your

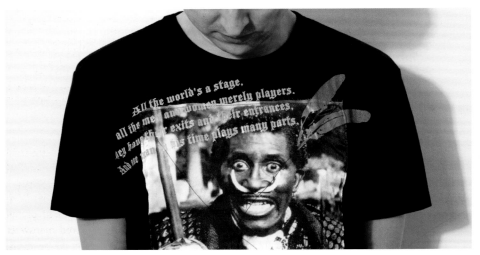

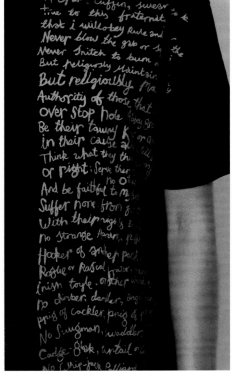
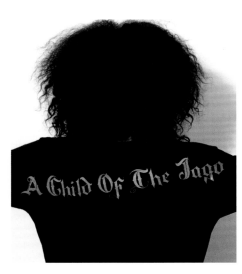

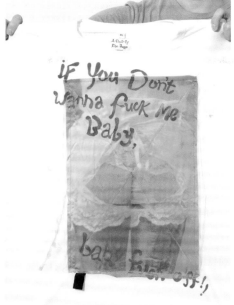
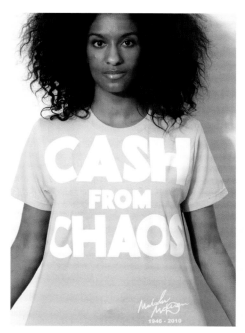

T-shirts kindly supplied by Karlie Shelley at A Child of the Jago • T-shirt: 'Cash from Chaos' also kindly supplied by Karlie Shelley at A Child of the Jago – 'Humanade have produced a commemorative Malcolm McLaren T-shirt with his famous 'Cash From Chaos' in homage to the one he wore during his famous performance of *You Need Hands* by Max Bygraves in the film *The Great Rock 'n' Roll Swindle* the scene was appropriately filmed in Highgate Cemetery, McLaren's resting place'; www.humanade.org.uk • Model: Lindsay Freeman

designer thing and make it my own" because when would you come into contact with Louis Vuitton luggage unless you were super rich? You just wouldn't. And then we got a cease and desist letter from Chanel and so I took that down to the printers and we were going to screenprint that onto a T-shirt, but for some reason we never got round to it.'

Always at the frontier of directing trends, Barnzley's venture was quickly followed by a foray into screenprinting smiley T-shirts, the emblem that heralded a rave generation's interest in dance, drugs and their deliverance. 'At first I couldn't sell them but then Danny Rampling [prolific DJ] bought one and put it on his Shoom flyer [the seminal London acid house club] and it became the biggest thing ever, so there I was Christmas 1987 not being able to sell a single one, thinking there goes all my Christmas money spent on these smiley T-shirts, and then by the end of January I had these mammoth orders and they were absolutely everywhere.'

Fast forward a decade's worth of virtuoso enterprises and Barnzley became co-proprietor of Zoltar the Magnificent (or to honour its full name; Zoltar The Magnificent's Lolly Dealing und Puppy Peddling Nonce Emporium), a small risqué fashion shop cum gallery space in the heart of Soho that designed its own range of audacious T-shirts such as 'Zoltar Says I Just Kicked Your Girlfriend's Door In' and 'I Am A Rampant Homosexual And I Must

Find My Way To Old Compton Street'. However, courting controversy was never an objective for the Zoltar crew as Barnzley explains: 'A lot of these ideas were kicked around from us sitting around and having a laugh ... the thing is a lot of people, especially at these trade shows we would visit, made really sensible clothes to guarantee sales, but from my experience 99 per cent of those designers do really conservative looking clothes that all look the same. So by doing unique things there really is only one place to get them from, and if it's you that's doing that unique thing then that's who they buy from.' In this instance the unique manifested as a layering of social meanings and cultural themes. For instance, the Zoltar team identified Arabic people as the new outsiders, and subsequently adorned T-shirts with Arabic slogans as a means to pass comment on the hysteria that surrounded post 9/11 suspicion towards the Arabic population. Other sartorial devices included distinguishing themselves from the homogenised, American sportswear culture that was ubiquitous at the time, by nuancing quintessentially English types of apparel and partnering them up with American classics. They also adopted the letter Z as their motif and patterned the entire surface of T-shirts, which at the time was the antithesis to branded T-shirts that sported a single trademark on their front. And since technology had become increasingly accessible, their turn around of printed T-shirts

was rapid which in turn gave their ideas an immediacy that was unlike other stores that adhered to the twice-yearly catwalk collections.

Since 2007, Barnzley's investment has been devoted to his clothing label A Child of the Jago which sees exquisite, tailored menswear rather than slogan T-shirts as its design focus: 'It was a conscious decision not to do T-shirts. I mean we could just churn out lots of slogan T-shirts if we wanted to, it would be a really easy thing to do, but then everyone does that, so we're now having a go at doing something that is completely original, there's no point in recreating something that has been done before, because it has already been done!'

Categorically Barnzley has been instrumental in reshaping T-shirt culture in not only London but also Tokyo, New York et al. 'My only advice to people who want to make T-shirts is not to do what most people think is going to be the most profitable, as in buying the cheapest T-shirt available and screenprinting a thousand of them. Because the quality is so cheap, you just get lumbered with a thousand T-shirts no one buys. I would suggest buying the most expensive T-shirt you can find, I really like these organic bamboo ones, and then you can sell them ... because it's not just the artwork people spend money on, it's the T-shirt itself. Even if it costs you a couple of quid more to buy, people will pay a higher price for quality.'

Vexed Generation

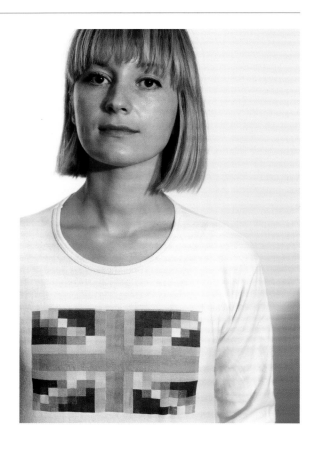

'The benefits of slogan T-shirts is that they have a physical presence that have the capacity to promote concerns.'

Being lateral thinkers, it's unsurprising that co-conspirators Joe Hunter and Adam Thorpe (a.k.a. Vexed Design, formerly Vexed Generation) have a unique definition of what a slogan T-shirt is: 'When you remove words from a framework, you have to try harder using visual language. An absence of words introduces ambiguity which makes it more interesting, which is why when we were designing Vexed Generation T-shirts we principally used iconic imagery which we subverted to convey messages.' Thorpe elaborates: 'Text needs to be funny or clever otherwise it can feel rather lacklustre, our slogans derived from images, because if the images are commonly recognisable, then they are automatically part of a vocabulary that work in the same way as words.'

Thorpe's background in bio-analytical science and Hunter's in graphics converged as an innovative partnership that inspired a socially-responsible clothing label which rapidly became the *dernier cri* in urban living. Politically motivated, culturally charged and producing garments that continue to be coveted by style mavens worldwide, Hunter and Thorpe's stylistic direction started in 1993 during the Criminal Justice Bill's gestation period, which saw the government

suppress civil liberties by restricting freedom of movement and large gatherings of people in response to a ubiquitous rave culture.

Early on Hunter and Thorpe devised concepts referencing 'urban utility' and 'urban mobility' which accommodated multi-modal lifestyles in conjunction with their interest in widening discussion about public surveillance, air pollution and the welfare of the environment. Additionally, their garments endorsed the notion of longevity, making a statement about fashion's ephemeral nature.

Imbued with seditious and iconoclastic overtones, their socially responsive collections – whilst supremely stylish – acknowledged the essence of urban safety as demonstrated by their celebrated parkas, which zipped up to one's eyeline as 'armour' against police riots and the proliferation of CCTV and its adverse consequences. Likewise, their industrial-strength backpacks that strapped across the body and were sufficiently capacious to accommodate a night's worth of vinyl, a pocket for one's mobile and another for a pack of twenty (nicotine and/or prophylactics) alluded to the clubbing generation that they originated from. Accordingly, analogous

themes, pivoted around self- and social-identity, as well as personal protection, inspired Vexed Generation's slogan T-shirt messages. For Hunter and Thorpe the slogan T-shirt has always been a mechanism by which to raise awareness and discussion. Take their iconic, long-sleeved T-shirt that featured a pixelated Union Jack, it may have seduced customers with its graphic sensibility, but the immediately recognisable visual was underscored by a connotative association. It reassessed patriotism and its place in modern society as emphasized by the nuanced digitalisation of its ancestral inference; thus negating it.

According to Hunter, the slogan T-shirt became a catalyst with which to generate awareness of social issues, and also facilitated the combination of 'social imperatives with commercial imperatives in an attempt to harness consumerism to expedite positive social change'. Thorpe continues: 'To the wearer, the slogan T-shirt is a means by which an individual can exhibit their allegiances and can help verbalize their opinion, it can also describe an individual's perception of the society they live in. Being a commercially available and socially acceptable item, the slogan T-shirt enables us to articulate marginalised attitudes towards mainstream acceptance. The availability of a socially responsive product on the shelves and rails of the high street demonstrates to "the consumer" that the vision of society the product serves is possible and plausible.'

In keeping with their commitment to social consciousness and the dominance of corporate autocracy, Hunter and Thorpe's retail spaces adhered to a more opaque and obtuse way of organising shop interiors and facades. Windows were concealed; an anathema to the rules of attracting customers, conventional customer circulation patterns were subverted and archetypal store display was replaced by more ingenious methods in which to showcase merchandise. Furthermore, stock was minimal alluding to the excesses of consumer consumption. Despite visually arresting schemes, the stores were configured as a byproduct of the pair's dedication to confronting and promoting the social issues that, as their name suggested, vexed them.

However, towards the end of the 1990s increasing rents brought about an end to Hunter and Thorpe's retail enterprise. This led to a focused appetite to design slogan T-shirts and subsequently they joined forces with designer and art director Nic Jones (partner in creative studio Surface to Air in Paris) to form Broke, Bitter 'n' Twisted, a clothing label counterpart to Vexed Generation. Maintaining their enthusiasm for streetwear and stirred by news headlines, slogans exercised vitriol in response to controversies such as the Enron scandal, child labour and the first invasion of Iraq: 'We'd always been very anti-establishment and now we were very anti-America too; we felt that Britain was becoming America's 52nd state,' says Thorpe. He also reveals that they thought it pertinent that their T-shirts which commented on child labour were sold alongside T-shirts made at the hands of child labour: 'This juxtaposition made its point.'

Operating under Broke, Bitter 'n' Twisted, the slogan T-shirt once again provided opportunity for the duo to 'throw away antagonism'. 'Slogan T-shirts are a conduit for recontextualising issues and jolting people to question things,' Hunter and Thorpe concur. Similar to the Vexed Generation enterprise, Broke, Bitter 'n' Twisted's culturally-evocative slogan T-shirts resonated with customers across the globe with stockists worldwide reordering multiple times.

In recent years Hunter and Thorpe's design prowess has engaged with gallery-based environments; when asked whether their slogan T-shirt work can be framed as art, the answer is thoughtful. Hunter and Thorpe subscribe to the notion that whilst slogan T-shirts are propagandist, art captures humanity: 'Slogan T-shirts, for us, are about communication and design, and art is about spatial values and transcendental qualities.' Hunter adds: 'The question of art is never finished in terms of communication, for us slogan T-shirts are black and white whereas art occupies a grey area.' However Thorpe asserts: 'But we're not interested in telling people that slogan T-shirts can't be "art" Slogan T-shirts provide a direct meaning for the cultural moment and we believe that's true for the person who wears them too. Some may be apposite at the time, nevertheless a good slogan T-shirt can last over time.'

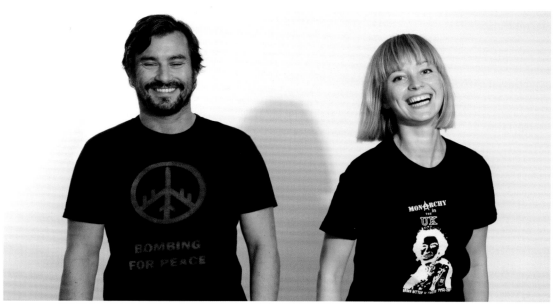

'Bombing for Peace' and 'Monarchy in the UK' Broke, Bitter 'n' Twisted. *Designed by A. Thorpe, J. Hunter and N. Jones*

Adam Thorpe and Joe Hunter explain the motives behind the following T-shirts:

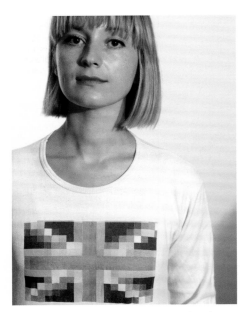

'Pixelated Union Jack' Vexed Generation (1994) *Designed by A. Thorpe and J. Hunter*

'Those With No Future' Broke, Bitter 'n' Twisted (2001) *Designed by: A. Thorpe, J. Hunter and N. Jones*

'Sigh' Vexed Generation (1999). *Designed by A. Thorpe and J. Hunter*

The Pixelated Union Jack was an attempt to 'take back' the union jack as an iconic graphic (and pop) image devoid of its negative nationalistic baggage. The design also references CCTV – an ongoing adversary of Vexed Generation who were concerned that CCTV encouraged people to 'devolve' power to a faceless state (a Big Brother) rather than take responsibility for monitoring and managing their neighbourhoods themselves. Also at the time, this design was made the Tory government would fund 50 per cent of any CCTV cameras in the UK – part of the reason we ended up with the highest per capita concentration of CCTV cameras in the world. Typically when images of a criminal where shown on television in the '90s it would be CCTV footage that would carry the image of the felon to the public. Others in the image, often those for whom a case was yet to be brought, would have their faces pixelated to maintain their privacy, afforded them as a consequence of their assumed innocence. It was with this in mind that Vexed pixelated the Union Jack – whilst the Union Jack was present in many nationalist scenarios, the nation itself or its flag was to blame for the actions of those who had taken it to represent their myopic, monocultural version of Britishness.

Vexed joined forces with old friend and collaborator Nic Jones, founder of the '90's UK label Shoplifter. Sharing a love and respect for Situationist communication strategies we decided to work together on a collection of street wear that would not try too hard. The idea was to 'knock out' one-liners that occurred to us as and when, and have a bit of a laugh doing so. From selling embroidered tees with stitches spelling out in childish font that 'these tiny stitches were sewn by tiny hands' on the rail in UK shops alongside some that possibly had been was considered a Situationist joke. The slogan 'Designed By Those With No Future For Those With No Clue' was a nihilist admission of Broke, Bitter 'n' Twisted's fast fashion game plan.

Two years into the rule of a Labour government we realised that nothing was going to change – the entrenched interests of globalised business would continue to be serviced over and above those of the public. Jaded and battle weary 'sigh' was a 'sigh of the times' – same shit different leaders – back to the barricades. Woodstock [the character in Charles M. Schulz's comic strip *Peanuts*] said it best so that's the one we used.

'The Truth About The World' Vexed Generation (1999). *Designed by A. Thorpe, and J. Hunter, in collaboration with B. De Lotz*

A tribute to Cormac McCarthy. The 'Truth About The World' from Blood Meridian is quite simply one of the most beautiful, optimistic, frank and dreadful pieces of text on a life. Ben De Lotz made the font that we used to silhouette the final scene from high noon – the showdown when opinion becomes fact and a truth is forged from the outcome.

T-shirts kindly supplied by Vexed Design Models: Silvia Ricci, Yu Ling Huang and Zach Pulman

Secret Member' Broke, Bitter 'n' Twisted (2001)
Designed by A. Thorpe, J. Hunter and N. Jones

Just stupid – a bit like that line in *The Life of Brian* where the reluctant Messiah addresses the townsfolk standing below his balcony: 'Go home, you are all individuals,' says Brian. 'Yes, we are all individuals,' the crowd responds in unison; then one lone voice calls out, 'I'm not!' Brilliant! I am a secret member of Broke, Bitter 'n' Twisted with the same stupid humour that we enjoy.

'Manufacturing Team' Broke, Bitter 'n' Twisted (2002)
Designed by A. Thorpe, J. Hunter and N. Jones

The 'manufacturing team' featured on the shirt is in fact a group of South American children who eek out a living from the refuse sites on which they live. Broke, Bitter 'n' Twisted wanted to confront shoppers with the possibility that their clothes may indeed be made by young children in terrible conditions.

'Broke of England' Broke, Bitter 'n' Twisted (2001)
Designed by A. Thorpe, J. Hunter and N. Jones

With the prospect of recession never far away Broke, Bitter 'n' Twisted engaged in a bit of word play to imagine a future where inflation meant your money was worthless along with the bank's promise to pay. It also paid homage to the beautiful etched graphics that adorn our national currency.

'Blue Labour' Broke, Bitter 'n' Twisted (2002)
Designed by A. Thorpe, J. Hunter and N. Jones

The Blue Labour graphic is a mash-up of Labour and Conservative Party logos. It suggested that New Labour was a chimera that had much in common with Conservatism. It was a comment on the lack of choice within mainstream UK politics/democracy

'Brokelads' Broke, Bitter 'n' Twisted (2001). *Designed by A. Thorpe, J. Hunter and N. Jones*

Brokelads is an anagram of Ladbrokes – the high street bookmakers and refuge of many a gambler ready to take a risk despite the knowledge that they are unlikely to come out on top. 'Odds On Losers' was a reference to one of our favourite movie lines – a line that is sampled at the start of the eponymously named Vexed Generation EP released in 1994. In the film *McVicar*, when told he must remove his Adidas trainers Daltrey (playing McVicar) refuses and replies to the screws as they rush into his cell, 'Alright, I know I'm gonna lose here but I'll be the best fuckkin' second you've ever seen'. Again, it's the honourable and optimistic nihilism that is appreciated.

6876

'T-shirts were a consequence of our interests, a sort of default.'

It is testimony to 6876's creative integrity that the T-shirts whic initially went into production when the company started in 1995, are still hugely in demand despite their run lasting only one season. Originally, the first T-shirt design appeared on a postcard that was sent out to the press to mark the launch of 6876. It featured a group of sheep alongside the words 'Retour A La Normale'. Taken directly from the May 1968 Situationist poster, 'Retour A La Normale' alludes to how a post-insurgence society returns to routine life and adheres to autocratic rules without further question.

Although an esoteric motto for many, 'Retour A La Normale' is still a well-known feature of the Situationists' history, but as Kenneth Mackenzie, 6876's mastermind, confirms: 'It had already been thirty years since that slogan had been published, so we were able to elude copyright laws, but to be honest we didn't really care anyway. Given the Situationists' rebellious nature, it would have been ironic had we been prosecuted, borrowing from the Situationists' manifestoes was keeping with the spirit of the Situationists themselves.' This innovative approach and irreverent undercurrent was to set the tone of 6876's unique vision that has been consistent to this day.

'We liked the idea of the label being British but not fixed as traditional British, and so the inclusion of French writing gave it a layer of difference,' explains Mackenzie. 'We knew we wanted to encapsulate modernity and a hard-edged sentiment, we also knew that we wanted numbers in the label's name, but we didn't want to use random numbers, they had to represent something we were genuinely into.'

Mackenzie's long-term enthusiasm for punk matched by a growing interest in the Situationists became the references for the name 6876; both being movements rooted in Marxism and their practices pivoted around socio-political agendas and anti-capitalist themes. And both famed for their radical aesthetic.

Culturally, 1968 and 1976 were seminal years, '68 being the year of the Paris riots, with its general strike almost causing the collapse of the French government, and '76 being the birth of punk. Mackenzie adds: 'At the time the Situationists hadn't really been cited. Now it has been fetishised too much, but back then it was really making a statement. I'd read Harold Jacob's book *The*

Weatherman and Christopher Gray's *Leaving the 20th Century*, for which Jamie Reid (widely-known for his graphics for the Sex Pistols) did the layout, and I also owned some of the Situationists' posters and was really into all their idealistic mentality, so all in all it was a perfect fit. As for incorporating punk, it came so naturally to me since it was an integral part of my growing up.'

Punk's vocabulary orbited around the refusal to conform; vandalising and defacing existing clothes with zips, safety pins and words was a means with which to challenge dominant culture. Even as a teenager Mackenzie introduced initiative into the way he chose to dress, customising his T-shirts with the names of his favourite bands such as The Clash and Joy Division: 'I'm from Dundee so if I couldn't find what I wanted I would make it myself ... I've always liked the idea of making your own

T-shirts and customising ideas to suit your beliefs.' Accordingly, a fashion label was the ideal medium for Mackenzie's set of values, as opposed to the usual reversed sequence of events whereby many designers seek material to inspire their label.

It is unsurprising that Mackenzie's work has such a strong graphic sensibility, since his background included a stint studying graphic design before completing a fashion degree in Preston. His first foray into fashion was so promising that before long he chose to work for himself. 'When people ask what I do, I just say that I design product, I don't see myself as a fashion designer, I see myself as someone who wants to get the nicest product possible made, it's part mentality and part necessity.' Necessity, of course, alludes to the financial component that drives a business, and mentality refers to Mackenzie's commitment to the ideologies

belonging to the Situationists and the punk crusade. 'It wasn't about manufacturing some slogan T-shirts that were a little left-wing, punk and Situationism represented an independent spirit which were central to the ideal of creating a non-corporate brand that promoted the idea of collectivism rather than the rarified and egocentric nature of most fashion. For me, both factions were like an explosion, and as is usual, things evolve out of those explosions. Through the 6876 label we are in a position to share what we love, and of course it's great to expose my influences to people. If customers "get" 6876 then great, but if someone turns round and just thinks that it looks interesting, then that is just as good as well.' Mackenzine illustrates further his lack of elitism: 'I've noticed lots of kids wearing Ramones T-shirts, they may not even have ever heard a Ramones record but they wear it because it's in fashion

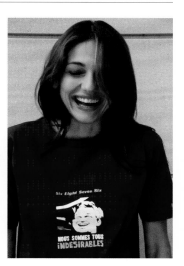
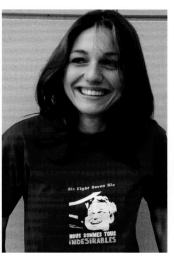
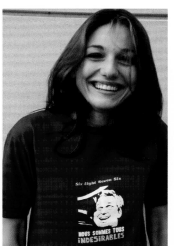

'Retour A La Normale' (1995) and 'Nous Sommes Indesirables' (1995), taken from original Paris '68 Situationist poster.

and I think that's OK. There are always different ways of looking at things and reasons for liking something, and Situationism is ideal for making that type of statement.'

Given that Situationism is so highly motivated by urban life and its relationship to politics, Mackenzie has never felt uncomfortable taking politicised references into fashion: 'Part of the Situationist thing was about taking art into everyday culture, it not being rarefied. I'm not interested in lionising what's topical, I recall a couple of years ago one of the luxury brands was using Pete Dogherty as their rebellious

muse and it just felt so sanitised and phony. If we use bleak, Marxist commentary on our tees, it's because we believe in what those words have to say.'

In 1998 Mackenzie reissued a few of 6876's T-shirt designs to coincide with the anniversary of the Situationists, however when the 2008 retrospective materialised Mackenzie felt distanced from any form of involvement: 'It actually felt quite fraudulent and I wasn't really keen on capitalising on it. Anyhow I'm more interested in doing new things. Of course at the time we loved taking these themes into a

different environment because it was brilliant to educate people about it, not in a dictatorial way, but just to share the graphics and what the movement was about.'

Having popular ideas that reach other people has importance in Mackenzie's vernacular: 'So much imagery and slogans are about branding. 6876 isn't about a branding mentality, it's always been first and foremost about product, but of course we want people to like what we design, the more people that wear your T-shirts the better... We found a medium for our interests, not the other way around.'

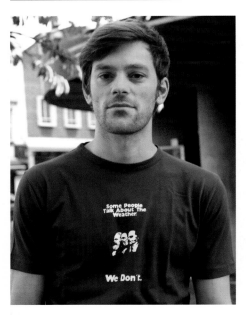 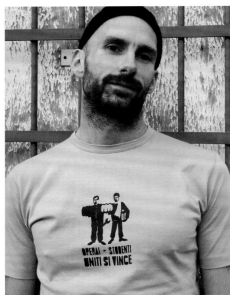 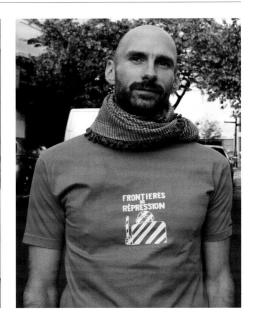

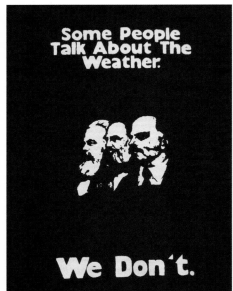

'Some People Talk About The Weather' (1998), taken from SDS (student) orginial German poster

'Operai – Uniti Si Vince' (2000), taken from original Italian Bologna 1969 poster

'Frontiers Répression' (1998), taken from original Paris 1968 Situationist poster

'Up Against The Wall Ruling Classes' (2001), 'New Left Notes Publication' (1969) • T-shirts kindly supplied by 6876 • Models: Gosia Cyganowska, Odilo Weiss, Scott Maddux, Silvia Ricci and Zach Pulman

YMC

'Good design is not an applied veneer.'

Raymond Loewy, date unknown

In 1995 when Fraser Moss co-founded (with Jimmy Collins) his quality-led fashion company YMC, the label's name and ideology alluded to pioneering industrial designer Raymond Loewy's germane quote: 'You must create your own design style'. Shortened to a pithy 'You Must Create' (YMC), the brand's name was used modestly both as a visual motif and design idiom on skillfully cut, text-based T-shirts that sold worldwide. As Moss remarks: 'When we began in the mid-90s, which is also reflective of fashion today, everything was very label and media focused, fashion had become almost identikit dressing with no real individuality. So really the decision to call our label YMC was a "call to arms" for like minds.'

YMC's continued sartorial allure is its emphasis on staple pieces that deviate from the seasonal and trend-oriented vagaries of fashion, and instead accentuate the idea of fashion possessing the capacity to be both contemporary and timeless in a single stroke of understated, utilitarian virtuosity. Even the simplicity and rhythm of the name YMC, as well as the extended You Must Create, serves as a straightforward rhetoric that connotes an individualistic space of reference. Designed in

a serif-free font, the acronym YMC features on their garment labels not only as reinforcements of the brand, but also as a guidance for a creative philosophy.

The T-shirt has featured consistently in YMC's repertoire, although in recent years its graphic-focused designs partnered with the YMC logo have had a sabbatical from its collections: 'I haven't used text on my T-shirts for years but funnily enough this seems to be becoming more relevant again in my work. Everything comes in cycles.' Moss elaborates: 'Originally slogan T-shirts were a powerful medium, especially if they were driven by politically sound motives. However over the years, the power of the high street has somewhat diluted this and they have mainly become just another ironic statement. The thing I dislike about slogan T-shirts is how they have almost become a lazy way of showing which tribe you "belong" to rather than making a valued statement.'

Raymond Loewy lived by his self-coined MAYA (Most Advanced Yet Acceptable) principle; in 1929 he was offered his first design commission by a British manufacturer to improve the appearance of the mimeograph machine (a quasi-prototype photocopying

machine), he attributed its execution as 'beauty through function and simplification'. Aptly both these slogans could pertain as other dictums for the YMC landscape, because for Moss, Loewy was a proto creative renegade: 'I think his "You Must Create" design ethos really struck a cord with postmodernism in the '90s,' he adds.

Moss' own eclectic and multi-referenced postmodern world is as likely to source design inspiration from the exactitude of American and British military wear and the ergonomics of uniform apparel through to esoteric vinyl sleeves found at car boot sales. However, as YMC's minimalist designs reveal, Moss and Collins adhere to the modernist tenet of form following function; their attention to detail remains covert as opposed to superfluous, whilst their silhouettes mimic the clean lines of modernism's candor.

Moss' (and Loewy's) precept of 'You Must Create' sees the slogan T-shirt as a tableau for embracing the need to locate and assert one's own style values, Moss reasons: 'Slogan T-shirts are ephemeral items of clothing, they reflect society as a whole so the slogan T-shirt will forever be changing'. Master of quotes Loewy once declared: 'The main goal is not to complicate the already difficult life of the consumer' — applicable to YMC's slogan and currently non-slogan T-shirts.

Jeremy Deller

www.jeremydeller.org

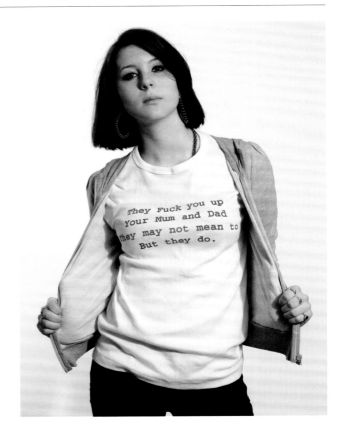

'Some people read
a lot of depth into their
T-shirts, but mine were
very uncomplicated.'

'Being a T-shirt designer is about volume; you have to sell thousands, but contemporary art is not about quantity it's about the one masterpiece and then after that it's about editions. It's a different economy.' Early on in artist and 2004 Turner Prize victor Jeremy Deller's illustrious career, he turned his hand to T-shirt design: 'It was a way to get ideas out into the open while earning money. A lot of people were making slogan T-shirts at that time and I thought, "Well, I could do this too", and since I worked in a shop [Sign of the Times] I already had an outlet for my designs.'

Sharing a similar pop cultural framework as his art, Deller conceived several T-shirt designs during 1992–93, two of which used a rhetoric that mimicked British tabloid headlines, not only in their pithy sentiments but also the typeface in which the sentiments were sensationalised. Consequently, Deller's 'My Drug Shame' and 'My Booze Hell' resonated with a youth that had grown up with front-page newspaper captions alluding to scandalous behaviour.

The irony and satirical value of wearing such declarative T-shirts was not lost on its proponents; for instance, disgraced Take That band member Robbie Williams wore 'My Booze Hell' upon his expulsion from the band. As Deller elaborates: 'Obviously you want your work out there so when someone wears your work publicly you've achieved what you had hoped.'

The genius of Deller's T-shirts was that their propensity was as self-explanatory as the tabloid language they derived from. Deller frankly shares that nothing deep was meant to be read into any of his T-shirts (other designs around this time included motifs such as targets and a defibrillated heartbeat scan). As he explains: 'You know what it means when you hear 'My Booze Hell' or 'My Drug Shame', they were very simple statements.' However, the transparency of the messaging on his T-shirts was adopted as the apogee of the dance club culture he was immersed in, although he is keen to point out that he 'didn't look to clubs as inspiration for my work.'

Deller followed these two cult hits with another T-shirt featuring text, this time borrowed from Philip Larkin's 1971 poem *This Be The Verse*. The T-shirt replicated the poem's first two lines 'They fuck you up/Your mum and dad/They may not mean to/But they do'. 'I thought it should be worn by everyone in the world purely because everyone understands it. I thought Larkin's words

were almost biblical in their conviction, the precision and truth of the way it is written has a sort of authority to it,' he illuminates.

Deller distributed this T-shirt to his friends' children — aptly they were made in children's sizes although this was not necessarily by choice, but principally because T-shirts were so popular at that time that the more well-known T-shirt designers had obtained a monopoly on the plain T-shirt market. Deller elucidates: 'All the other T-shirt makers were buying up whatever plain T-shirts were around and many had exclusive deals with suppliers, so it was actually really difficult to get the size and shape I wanted, which is why I ended up using children's T-shirts, purely because I couldn't get anything else.'

During his foray as a T-shirt designer, London-born Deller was working as an artist (he studied art history at London's Courtauld Institute) but as he modestly discloses: 'It was more in a low-level way, not what you'd call gallery-based work.' Still, the concept of public art has been a consistent insignia throughout Deller's career and this includes his T-shirts as forms of freely available artworks. 'My work takes many forms,' Deller affirms. Earlier projects favoured small-scale phenomena. Unsurprisingly, given Deller's interest in ephemera, many were paper-based.

Collaboration, participation and intervention are central to Deller's work. His broad range of formidable accomplishments spans the spectrum of filmic, photographic, event-led and performance-based works that frequently explore marginalised worlds as well as engaging with life's incongruity, or as Deller describes it, 'culture in general and life around us.'

The richness of Deller's oeuvre includes the reworking of acid house songs by a traditional brass band, a recreation of a battle between police and demonstrators during the 1980s miners' strike, a series of paintings based on the life of Keith Moon (the drummer of the English rock group The Who) exhibited unwittingly in his parents house whilst they vacationed, and the Turner Prize awarded *Memory Bucket: A film about Texas,* a video diary that documented the diversity of both supporters and opponents of the US president during his travels in Texas.

Returning to the subject of slogan T-shirts, Deller adds: 'Making T-shirts is actually a lot of work. You have to source the plain tees, silk screen them, distribute them, but I would do more T-shirts, if it thought I had a good idea. It may happen.'

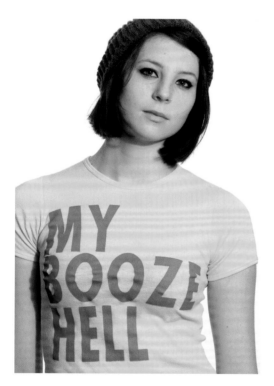

'My Booze Hell' (circa 1992–93)

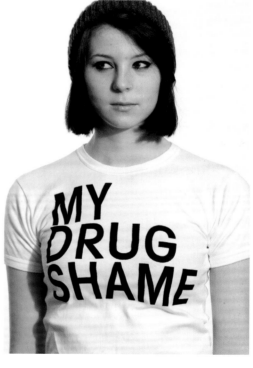

'My Drug Shame' (circa 1992–93)

T-shirts kindly supplied by Jeremy Deller • Model: Amy Thompson

Scott King

'My perspective on slogan T-shirts is as powerful or as powerless as the zeitgeist is really. I think if they tap into something relevant, then perhaps they have got some worth as a cultural tool.'

'It's always interesting how bands present themselves graphically,' ruminates graphic designer and artist Scott King, whose impressive portfolio of work spans roles as art director of *i-D* magazine and later *Sleazeation* to self-publishing cultural arts magazine *CRASH!* with political historian Matt Worley, followed by a plethora of creative projects including a number of commissions for bands.

Amongst King's favourite slogans is one he conceived for British indie rock band Earl Brutus, playing on an Oscar Wilde quote it professed: 'Pop Music Is Wasted On The Young'. In King's own words, quite simply a short quotation *is* a slogan and through an acerbic wit and perceptive insight he has created his own repertoire of fictitious quotations, attributing them to a wide range of popular heroes and villains and hapless characters from cultural history. These include artists such as Anish Kapoor, Antony Gormley, Jackson Pollock and Tracey Emin; philosophers Noam Chomsky, Ludwig Wittgenstein, Louis Althusser and Carl Jung; political figures Genrikh Yagoda and Henry Kissinger and a miscellany of writers and international idols such as Ernest Hemingway, Buzz Aldrin, Neil Armstrong and Nancy Spungen. Whilst most of King's

aphorisms are ironic, within that irony his ability to deflate or magnify the self-righteousness and self-importance of public figures or underscore the hypocrisy of politics and capitalism is achieved with a comedic overtone. Even the historical accuracy of time and place has been considered. The following is an example: 'The very idea of using another's words in order to authenticate one's own thoughts or position seems really quite repulsive to me. Recently, I scarcely seem to be able to open a novel or browse a museum catalogue without seeing my own words reprinted there: servile, meaningless and stripped of context. I appear to have become the principal propagandist for every imbecile that ever picked up a pen or paintbrush,' Walter Benjamin, Portbou, 24 September 1940. King notes: 'Personally, I'd love to print my quotations on T-shirts or mugs and have them sell at gallery gift shops, those fake quotes are meant to be confusing... I like the idea that they then become products in their own right with a certain omnipresence to them.'

However, it's King's work with the Pet Shop Boys that has disseminated his éclat to a wide and global audience. 'Famously the Pet Shop Boys work with designer Mark Farrow, but there

was a two-year period between 2001 and 2003 when I was given almost free rein and designed all their visuals for them.' This included five slogan T-shirts which King coined with the sayings: 'Quite Heavy Metal', 'Being Boring', 'Closet Homosexual', 'Blackpool Rock & Roll' and 'Sexy Northerner'. The T-shirts were produced for their 2002 *Release* tour. 'Chris Lowe and Neil Tennant [the Pet Shop Boys] were fantastic because they trusted me to just get on with it. They contributed lots of ideas and because there is a knowingness to their language, which is really smart, their audience also "gets" it. Once you have established a language or you are reliant on some association with someone else's language then the T-shirt doesn't have to be just a base medium, it can be a vehicle to really play with expression.' King continues: 'Typically, record companies will plaster the record sleeve visual on a T-shirt as it's an easy way to sell T-shirts, but I've always avoided going down that route.'

Conversely, King's creative method is driven by ideas and context: 'I've never been interested in designing something towards a commercial end or just doing decorative design. If I'm doing a music job I like to think of it in its final surroundings, for instance on the shelf of a music store and then I'll give thought as to what other albums may be displayed next to it, in that way I then try and make it stand out or jar with those considerations – things like that are conceptually interesting to me, so you work backwards towards that type of framework.'

According to King, the heritage of credible bands is interesting in terms of how individuals endeavour to authenticate themselves by wearing covetable T-shirts: 'Somehow it gives the impression that, as the wearer, you have done your research; they think it gives them a depth,' he suggests. This testifies as to how slogan T-shirts can offer the illusion of 'insider knowledge' when in fact often it's a superficial insider knowledge bought from eBay. King elaborates: 'If you imagine that all these T-shirts were a blank product once and then they become decorated with tragic heroes and words, in a way that's what slogan T-shirts are; they represent an easy affiliation for someone. Take Kurt Cobain, for instance. He wrote all the songs, did all the work, did all the drugs, did all the dying, and for just £9.99 people can obtain a piece of him. It's the easiest way to show your imagined credentials,' King illuminates further: 'And if you consider that people don't buy records as they used to, there's no physical three dimensional representation of music, no one is carrying around vinyl to display their allegiances, so the T-shirt becomes the current manifestation of an open declaration of your unity or your imagined unity to an artist.'

Central to King's work is the focus on the medium and the message, unsurprisingly then the cultural theorist Marshall McLuhan has been a source of inspiration to King: 'It's all in the title "the medium is the message". I was never interested in graphic design as a commercial enterprise, I had much more interest in the concept of words, and to me there's always this relationship between the three things of medium, context and subject, but rather than starting with the subject which is usually what happens in graphic design, I would always begin with the context and then I'd find the medium and then the subject. It's a reversal of thinking really, so it's all about the carrier of the message rather than the design of the message.'

King's innovative approach to his music-based work extends to his own personal work, which includes his aforementioned ongoing project that fictionalises sayings and ascribes them to cultural icons. This unique idea started in 1997 as a device for King's independent publishing venture with Matt Worley: '*CRASH!* was both a magazine and exhibition in London's King's Cross, that commented on pop commerce … As it so happens it has been a foundation for all the work I have been doing in recent years. So because myself and Matt couldn't find the quotes we wanted, we just thought it was easier to make them up, so we sat around and invented these incongruous slogans and to substantiate their weight we'd credit them to people like Guy Debord (the Situationists' figurehead) or Terry Wogan (British television presenter), a real mix of pop trash heroes and heavy weight thinkers; it was in the spirit of

T-shirts: 'Being Boring', 'Blackpool Rock & Roll' and 'Sexy Northener' T-shirts, all designed by Scott King for the Pet Shop Boys (2002)

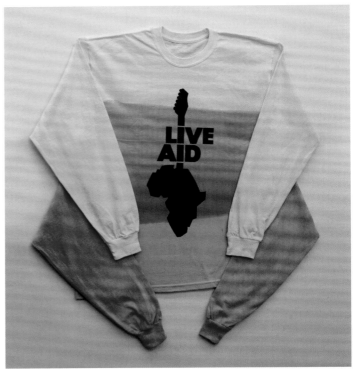

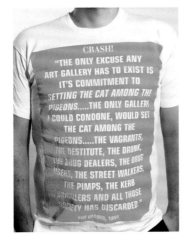

T-shirt: kindly permitted to photograph by Herald St Gallery; www.heraldst.com • Artists: Matt Darbyshire and Scott King • Title: Ways Of Sitting II • Edition: 1/10 • Year : 2011 • Courtesy of the artists and Herald St, London

T-shirts: 'Guy Debord, 1958' and 'Untitled' designed by Scott King and Matthew Worley (1997)

T-shirts kindly supplied by Scott King and Matthew Worley • Models: Ian Stallard and Patrik Fredrikson

what we were doing,'.

Recently King has revisited this idea of invented quotations through his work with artist Matt Darbyshire in another ongoing project called 'Ways of Sitting', although this time Darbyshire is responsible for the visual component and the textual element comes courtesy of King; reversing his role from image maker (as was the case during his collaborative work with Worley) to wordsmith. 'During my first collaboration [with Matt Darbyshire] we decided that instead of doing a press release for the show we would produce a little magazine ourselves, and this led to a discussion around our interest in mass production rather then gallery production ... so we got excited about the possibility of working together more and from that we decided to do more "Ways of Sitting" projects,' King enthuses.

One of their earlier art shows featured faux quotes alongside carefully selected visuals, with the quotes written on canvases — themselves operating as artworks. Darbyshire's art manifested

as shelves lining the gallery's walls adorned with different types of elephant objects, each one gazing at a fabricated quotation: 'The quotes were largely about the state of Britain today but some are semi-allegorical so include invented quotations by Jonathan Swift, William Blake etc.'

King and Darbyshire's follow-up exhibition explored the reappropriation of the classic 'Live Aid' T-shirt created in 1985 to raise funds for the relief of the Ethiopian famine. An additional pair of sleeves rendered the slogan T-shirt as an 'abstract and open artwork', as defined by King. For Darbyshire, the framed 'Live Aid' T-shirt was not so much about recontextualising fashion to a gallery environment or even lending fashion a specified status by freezing it beneath Perspex but rather about a socio-political position: 'The 'Live Aid' T-shirt is Scott's brainchild really. He'd been talking about doing one and then I suggested dip-dyeing it as I'd been using it quite a bit elsewhere in my work. Dip-dye for me came about after spotting that exact turquoise/yellow/magenta design on a Ralph Lauren polo shirt minutes

before seeing it on a crusty, new ager. The fact was that Ralph was extending it's ability to blur demographics further than ever before, beyond the already impressive rude boys vs. preppy jocks cramping each others' styles, to Sloane Rangers nicking their little trustafarian siblings' wardrobe too. Amazing on Ralph's part, but Scott had already highlighted all this a while ago of course with his "Never Trust a Hippie" posters. The Live Aid bit for me, apart from reflecting this weird '80s regression we're witnessing i.e. Tories back in, public sector striking, Duran Duran back on the radio, postmodern styles prevailing, Gaddafi back in the limelight etc. etc., was great because it calls to mind all those cultural elite tossers — Geldof, Bono, Sting et al. who a. I *love* reading about in *Viz* every month and b. epitomise the dilemma of today's impersonal, celeb-initiated protests rooted shamelessly in self-promotion and incentivised only by branding, subsequent merchandise and self-gain. There's something sort of dismal about it all when there's no such thing as alt, indie or punk, let alone a hippy!'

Gerard Saint
at Big Active

www.bigactive.com

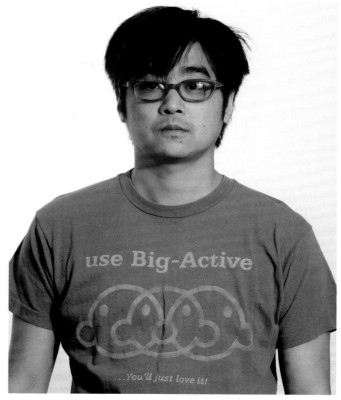

T-shirt: 'Use Big-Active – You'll Just Love It', designed by Paul Hetherington, Gerard Saint and Mark Watkins at Big Active • Model: Albert Kang

'Certainly, the slogan T-shirt is a ubiquitous and expressive canvas for the wearer to identify personally with a specific message or statement. How effective that all is depends on the context or intentions of the person choosing to wear it.'

In 1990 when art director Gerard Saint launched Big Active, one of the premier creative consultancies in Europe specialising in art direction and graphic design, he ingeniously employed the slogan T-shirt as a sartorial business card: 'The idea was to make a promotional T-shirt that looked more like it was for a sex aid rather than a design studio. We wanted to play with types of sales expressions and so coined "Use Big-Active" as a slogan that demonstrated how we weren't a company that took ourselves too seriously. I've always really liked those types of sales messages and also I like the idea of taking things out of context and then playing with the potential of their meaning. So by subverting a seemingly incongruous phrase through our choice of font, and the overall T-shirt design, was a really effective way to catch people's attention. As I remember it we only produced around 200 T-shirts in a variety of colour ways – mostly on white and black T-shirts – varying the fluorescent colours in the print itself. They were mostly given away as promotional gifts to clients and associates.'

The 'Use Big-Active' T-shirt's aesthetic language is indicative of the company's formidable design prowess. Whilst its visual rhythm begins with a self-explanatory statement followed by a linear graphic of the three faces that represented the founders of Big Active: Saint, Paul Hetherington and Mark Watkins, the tertiary component of '... You'll Just Love It!' lends a coquettish conclusion that is equally confident as it is unpretentious.

It is this technique of responsive design and visually nuanced graphic style that has seen Big Active responsible for artwork and creative direction for innovative music artists such as Mark Ronson & The Business Intl, Goldfrapp, Basement Jaxx and Beck, including Beck's 2006 album *The Information* that came with four sheets of stickers so that fans could customise the album's blank sleeve and controversially was disqualified from entering the UK album chart as it was deemed a sales gimmick.

'To some degree most projects involve developing T-shirts and merchandise, although many will simply feature the band's logo or a visual design related to the album sleeve we've developed as opposed to a "slogan" as such, although some might argue most good band names are pretty much slogans of intent in any case. One really cool series of T-shirts we developed was for the project surrounding the

work we did for Beck's album *The Information*. The album sleeve was all about encouraging fans to create their own DIY sleeve designs using a variety of stickers that we supplied with each album. We took this concept into the T-shirts available on the tour, so fans were able to make their own personalised T-shirts at the gigs using a range of iron-on transfers that were available at each show,' Saint discloses.

Saint's involvement in the music industry for more than two decades qualifies his knowledge of the slogan T-shirt's relationship to music artists: 'I think the beauty of the rock 'n' roll slogan is really about establishing lines of commitment. Formerly, bands were more anarchic and challenging and also independent insofar that

their music was made in conjunction with an ideology. Whereas nowadays slogans in music are usually part of a wider marketing campaign and the discussions with record companies play a part in that too. Also, perhaps it's not so relevant these days because kids cherry pick genres and maybe that is why brands are now playing with sloganeering more so than musicians.'

Big Active's impressive repertoire includes the brand identity of live music event Ibiza Rocks, magazine editorials (future trends magazine *Viewpoint* and the re-launch of 1960s seminal fashion magazine *Nova*) and books (David Bailey's *Chasing Rainbows*, 2001 and Rankin's *Destroy*, 2009), amongst others. Another of Big Active's compelling book projects documented

a selection of vintage US promotional T-shirts in the second half of the 20th century: 'I'd amassed quite a large collection of these during the '90s, before Topshop turned them into a classic high street trend! I chose these examples as they are a few of my personal favourites, I love the irony of the sentiments taken out of context, and I used to also wear them. The book's title *One Size Fits All* came from the idea that these type of slogan T-shirts were such a catch-all medium, and the title seemed to echo the rhetoric jargon of a typical slogan that might have been used for one of these businesses or organizations ... the areas that we were interested in covered everything from politics to religion – car spares to ice cream parlours and everything else for

A selection of images from Big Active's 'One Size Fits All' Project (designers unknown); kindly supplied from the personal collection of Gerard Saint

Ibiza Rocks event merchandise 2011, created by Big Active and Dawn Hindle. ''Fuck Dance Lets Rock' – Ibiza Rocks celebrates the spirit of rock and roll by being rock and roll,' notes Gerard Saint. Image kindly supplied by Gerard Saint

sale in between. We actually made up a T-shirt bearing the slogan 'One Size Fits All' which was to have been used as the book cover.'

Saint reveals that the design concepts Big Active generate for all their clients share the same foundations – 'to convey their own artistic message.' Saint explains the process: 'Branding addresses the visual identity of the product. From our perspective we always design with an integrity and depth, so when we work with a music artist, for instance, we look at how the fan may respond to the graphics and the text; ultimately we design so it actually feels like it's the work of the artist themselves. So we are in a way creating brand identities that they sort of have to live out, and I guess the way in which we put a message on a T-shirt is very

much informed by the visual language being developed around that brand or artist.'

According to Saint because bands are branded entities, their merchandising can often be framed as slogans in their own right, 'a lot of bands on a commercial level are focused on the marketing aspect of themselves *as a brand*, they're not necessarily trying to market an ideology or anything wider than that … and because subcultures and movements don't exist in the same way anymore, the common identity of belonging to a tribe is not so fervent.'

Technically, brand culture operates as a bisected cultural space which sees strategic brand identity concepts engineered with acute precision on the one hand and the consumer's interpretations on the other. Inevitably, the

art direction of the brand is typically visually motivated, but as Saint discloses, also has to perform on an emotive level too. So the message may manifest itself visually in accordance with the brand's objectives but likewise it invites the consumer to emotionally identify and engage with the given message. Saint continues: 'So the band's "name" or logo is very much what they are trying to push at that point and that poses the question as to what is the fan is buying; are they buying the band's music or image, or are they buying both? Or is it how the visuals tie up the emotional response to the name? We often ask these types of questions because if it wasn't for the band then the logo wouldn't exist. Personally, I think strong music design is when the two can't work without the other.'

Experimental Jetset

John&
Paul&
Ringo&
George.

'We really like the definition that Augusto de Campos once gave of Concrete Poetry: "The tension of thing-words in space/time". What we try to explore through our T-shirt designs is somewhat similar to that: the T-shirt as a "word-thing" existing in "time/space".'

It is ironic that the homage Dutch graphic design studio Experimental Jetset paid to bands such as The Beatles ('John & Paul & Ringo & George'), The Rolling Stones ('Keith & Mick & Bill & Charlie & Brian') and The Ramones ('Joey & DeeDee & Johnny & Tommy') on their simply stated T-shirts spawned a homage to the T-shirt design itself. Two years after its inception in 2001, images of random, self-produced variations of this now classic T-shirt landed in their inbox. To this day individuals worldwide continue to mimic the format with the names of their own coteries or allegiances. Furthermore, what started off as a design for Japanese T-shirt label 2K (by Gingham), which took a couple of years to propagate, has now seen high street versions such as 'Sex & Drugs & Sausage Rolls' and 'Shoes & Alcohol & Drugs & Boys' worn by all demographics.

As co-founders Marieke Stolk, Erwin Brinkers and Danny van den Dungen explain: 'Around 1999 we were asked by Yoshi Kawasaki, then director of 2K (by Gingham), now director of Publik whom we now design for, to contribute some T-shirt prints; many of them were about the subject of T-shirt prints themselves. We were also very interested in the whole concept

of "self-referentiality" as in graphic design referring to itself, or to its own context. So for instance, the 'John & Paul & Ringo & George' T-shirt was referring to a certain T-shirt genre, the idea of the archetypical band T-shirt, while the 'Anti' T-shirt (2000) [pictured as part of Scott Maddux's interview on p.50] was referring to the idea of the archetypical slogan T-shirt. In short, we were trying to follow the idea of the "archetype" to its logical conclusion.' According to the Experimental Jetset trio, the objective was to reduce 'the idea of a rock band to a list of four names in an attempt to reach the essence of the group.' Their T-shirt design played on abstraction, replacing the iconic imagery of one of the world's most legendary bands (incidentally one of their favourites) to the simplicity of their first names, which as a quartet are as identifiable as the name of the band itself: 'There's also an iconoclastic streak running through the T-shirt: the idea of puncturing through the world of images, by using text.'

The design profits from the egalitarian typeface Helvetica immediately followed by the ampersand (&) as a fixture between words with a full stop as its graceful conclusion. Apparently

the inclusion of the ampersand was used purely for formal reasons so that the sequence of names looked more even. Although their prototype featured white letters against a black T-shirt, various colour combinations have since been produced. The idea behind the following two editions; 'Keith & Mick & Bill & Charlie & Brian' and 'Joey & DeeDee & Johnny & Tommy' was to move away from the idea of the T-shirt design being about one particular band and emphasise instead the method of 'pop-cultural imagery "abstracted" through text.'

When it comes to the customised versions that have paid tribute to Experimental Jetset's design, it is a basic, blue T-shirt that has adorned on its surface only the ampersands (&&&) and full stop (the dot) without the presence of any names: 'We like it because it really shows the bare skeleton of the T-shirt; it emphasises the

fact that the composition is really a "format", that it can be filled in with any series of names.' Having been elevated to iconic status is rather befitting since all the elements present on Experimental Jetset's T-shirt design carry a certain iconic value themselves (i.e. the font, the grammar, the band members' names): 'But we never expected that the T-shirt itself would become an icon in its own right — that was never the plan ... it's always quite a surprise when it turns out that other people are enthusiastic about a certain piece and we never try to guess what will be popular or not. To us the popularity of the 'John & Paul & Ringo & George' format proves an important point: that a popular design doesn't have to be made with populist intentions.'

It is the pursuit of conceptual and visual integrity of the design itself that fuels

Experimental Jetset's work; 'trends', 'fashions' or 'target audiences' do not factor as part of their vocabulary: 'We basically only design things according to our own interests. Our way of designing is actually quite closed and hermetic, we always try to fully focus on the inner logic of the designed object. The phrase "but does it communicate?" is used in our studio only as a joke.' In recent years, Experimental Jetset has worked on projects for the Stedelijk Museum in Amsterdam, Centre Pompidou in Paris, Colette in Paris and the Royal Dutch Mail (currently known as TNT). In 2007, a large selection of work by Experimental Jetset was acquired by the Museum of Modern Art in New York, for inclusion in MoMA's permanent collection.

Experimental Jetset continue to innovate with their T-shirt designs. Describing graphic

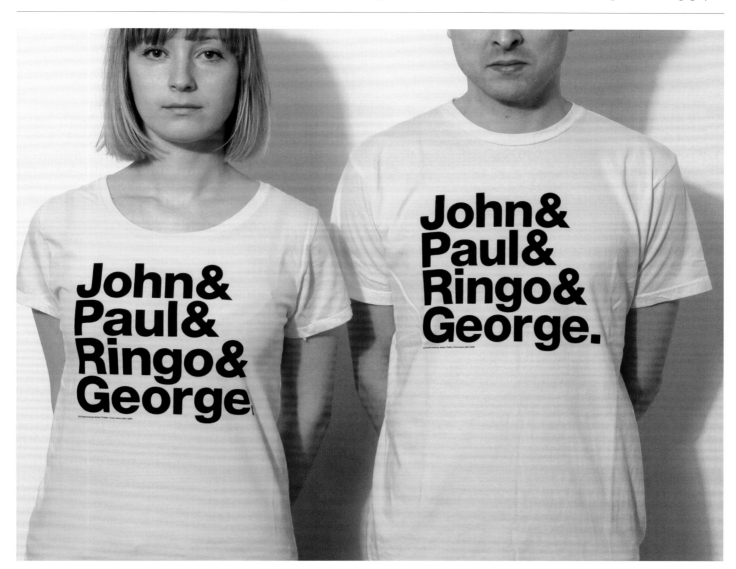

design as 'turning language into objects', Experimental Jetset's T-shirts nowadays focus more on the subject of language, such as short poems, found text, wordplay, quick thoughts and even the occasional joke. As they explain, it was objects such as the printed T-shirts that got them interested in graphic design in the first place. 'Being teenagers in the mid-80s, we were extremely interested in post-punk subcultures such as psychobilly, hardcore punk, two tone, mod, new wave, etc. And it was things such as record sleeves, mix-tapes, fanzines, badges and band T-shirts that made us aware of the medium of graphic design. So this gesture of designing a T-shirt print feels quite natural to us. But we have no idea of the appeal for the wearer. To sport a T-shirt featuring an outspoken slogan demands a certain personality: strong, even confrontational. Some slogans take quite some courage to carry; courage that we personally do

not always have. Sometimes you just want to stay low profile, walk around in the crowd as an observer rather than a messenger; in those cases, you don't necessarily want to display an outspoken slogan. We certainly don't wear our own T-shirts very often. But maybe that's mainly a case of designers not wanting to wear their own creations, which is quite typical we guess. It feels just too embarrassing,' they add modestly.

Experimental Jetset certify cultural value to the slogan T-shirt, citing T-shirt doyenne Katharine Hamnett as a heroic exemplar of how the humble T-shirt can effect political impact and social awareness: 'We always have to think of the fantastic photo of Katharine Hamnett shaking Thatcher's hand while wearing the '58% DON'T WANT PERSHING' T-shirt. In the case of the slogan shirt, we guess that, while the T-shirt itself may disintegrate and eventually

disappear, documentation of that T-shirt may always be around. Hamnett's 'Pershing' T-shirt was almost 30 years ago, and we are still talking about it. But the truth is most of the printed matter we design outlives the events that the printed matter announces. The catalogues we design outlive the actual exhibitions, the posters outlive the announced concerts etc. And while buildings get demolished, the books in which those buildings are described can always be found in libraries. In other words, we have a bit of an alternative view on the word "ephemeral", as it seems to be exactly the ephemera that survives, through collections and archives. We love the idea of language as a spatial, material space in which a person can literally walk around [whilst being] in the city. Just as language exists in our heads, we exist in language. And the concept of the slogan T-shirt fits quite naturally in there.'

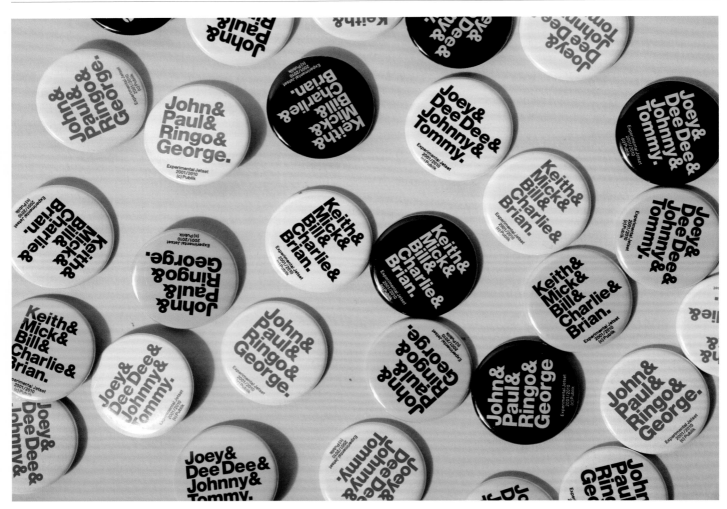

T-shirts and badges kindly supplied by Yoshi Kawasaki at Publik; www.publik.jp • Model: Silvia Ricci

2K by Gingham

www.2kbygingham.com

'Five Boroughs', designed by Stereotype Design (2011)

'2K by Gingham is not
a cult, but if it were it would
be run by artists.'

According to graphic design and art-driven T-shirt specialist 2K by Gingham, the T-shirt is without exception amongst the most noble fashion items readily available to the masses in spite of its own bias towards anti-mass marketing techniques. Instead, this small-scale operation based in Los Angeles, distribute its visually arresting T-shirts to enthusiasts worldwide through a stealthy word-of-mouth dissemination process.

Each season 2K by Gingham commissions a profusion of T-shirt designs from a myriad of artists, including the legendary talents of Yoko Ono and Nick Egan, thus strengthening the idea of the T-shirt as a mobile exhibition space. So in much the same way a gallery represents an artist's repertoire, 2K by Gingham implements the necessary infrastructure to present and deliver the artist's work as faithfully as possible when reproducing their artwork on the T-shirt's surface. Niki Livingston, 2K by Gingham's creative director, illuminates: 'Typographical T-shirts have been a mainstay at 2K from the origin of the company. Because our slogan T-shirts are aesthetically driven, we focus more on the actual typography of the image rather than what is being said.' So

although 2K by Gingham's visual expertise privileges typographical experimentation, the imagification of text captivates through the use of wordplay and a range of diverse graphical styles that equally animates and visualises the text itself.

The 2K by Gingham (formerly 2K) story began circa 1995 when the two founders (Yoshi Kawasaki being one) noticed that museum and popular art design T-shirts started to surface in fashion boutiques across their homeland of Japan. This observation was further cemented by the discovery that art-led T-shirts no longer inhabited the exclusive premises of museum gift shops, but rather could be accessed in alternative milieu such as bookstores and coffee shops. The sense that the fusion between contemporary art and subcultural art practices were emerging as a new type of design-pop-art genre, the 2K duo started to research many of the major art museums across the world as a means to source and export unique T-shirts for retail purposes in Japan. However, they failed to find innovative, contemporary T-shirts that matched their vision, which in turn, impelled them to produce their own art and subculture T-shirt line.

'Juste un Garçon', designed by Curse of the Multiples (2011)

'Juste Une Fille', designed by Curse of the Multiples (2011)

'New Ouch 41% Yeah 59%', designed by Geneviève Gauckler (2009)

'Wedding Album', designed by Yoko Ono (2003)

Although 2K's covetable merchandise had been limited to Japan, demand from around the world generated global expansion. It was in the latter part of 2000 that 2K set up another headquarters in Los Angeles fulfilling a palpable void in the market in the United States.

Several years later 2K changed ownership and suffixed its original name with 'by Gingham'.

Interestingly, the name 2K was assigned by fellow independently-minded enclave, the Amsterdam-based graphic design studio Experimental Jetset, who also contributed many T-shirt designs in the early years. Quite simply, both founders' surnames began with a 'K'.

Nowadays 2K by Gingham continue to carefully select artists and designers whose

artwork and imagery it considers to be imaginative. Livingston sums up 2K by Gingham's own attraction to text-based T-shirts: 'I think slogan T-shirts have weight if you are referencing the societal changing power in the message of the work of someone like Katharine Hamnett. Nonetheless, silly humour is always welcome in our world as well.'

'Eternal', designed by Nat Russell (2010)

'Sincere Sin', designed Margaret Kilgallen (2000)

'Fly', designed by Yoko Ono (2003)

'L/S Revolution' T-shirt with gun/lipstick, designed by Nick Egan (2011)

'Watch This Space', designed by Andy Smith (2008)

'Art', designed by Davide Meucci (2008)

'End', designed by Andy Smith (2008)

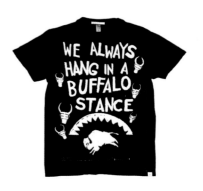

'Tatanka', designed by Frohawk Two-Feathers (2009)

'The Brooklyn Manhattan Queens Brooklyn Statten Island', designed by Stereotype Design (2011)

'Call Me', designed by Deanne Cheuk (2011)

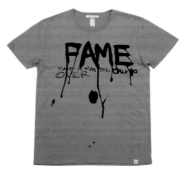

'Fame', designed by Nick Egan (2011)

T-shirts kindly supplied by Indigofera; www.indigoferashowroom.co.uk • Still life images kindly supplied by 2K by Gingham • Model: E-Sinn Soong

Iain R Webb

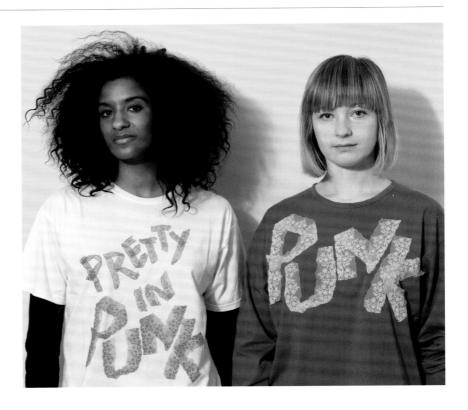

'Whatever I've done in life, words have always had an importance.'

It is fitting that fêted fashion journalist and former fashion editor at UK's *Elle* magazine, Iain R Webb, has transferred his talent as a wordsmith to his T-shirt venture and online showroom cum gallery, orange snow store.

In 2009 Webb officially made a return to the discipline he originally trained in, although as he conclusively states: 'I've always maintained my interest in making things.' And his artistic handiwork demonstrates superlative evidence of this. Upon graduating from Central Saint Martins in London in 1980 with a degree in fashion design, Webb's first métier was as a fashion assistant for a designer but shortly afterwards he 'fell into writing and styling,' he modestly shares. However, it was during his years as a student that the role of words reconfigured his initial plans: 'One of my first year projects was to review the collections in Paris. At the time I was reading a lot of the music press and because punk was rife, the music journalism was very vitriolic, very emotive, so I approached the project in that way and it got a good mark! From then on whenever I designed a collection I wrote something to go with it in parallel, and it felt very natural for me to express myself through text as much as visuals.

I'd always approached fashion, which is why I probably didn't end up in it commercially, from a conceptual point of view and at Saint Martins that was always encouraged. So I think having come back to making things again it was always inevitable that words would be involved.'

The idea of the tag line for Webb's website also serves as his ethos: 'Things to hang on your back and your wall'. The concept was motivated by the idea that Webb's T-shirts could be acquired either as worn items, artworks or apparel that could quite simply be hung on the wall. What's interesting is that the process evolved into other modes of seizing new ideas: 'I often ask myself where does fashion start and art end, or vice versa, and so my idea was always about doing something that was like a piece of art made out of things that I had collected over the years, as I like to hoard. I'm always going to markets and finding bits of lace or old linens, or tapestries that I like, and really it began with me making these embroideries and appliqués which I framed. That led me to think that because these are one-off pieces, why not work with T-shirts but treat them in the same way that I had with my framed pieces. One of my first experiments

was a long-sleeved T-shirt with the word "punk" on it that I had hand stitched using vintage lace, but I thought that is *also* going to be a one-off piece, so only one person can own it, so why not do it as a print using the lace and that's how I came up with the 'Pretty In Punk' T-shirt.' Since the process of layering is crucial to the way Webb works, he rather ingeniously photocopied the original T-shirt with the word marked out in lace, and the text was then printed on the surface of the T-shirt.

Webb's follow-up T-shirt, 'I Want To Be The Next Big Thing' also involved manual reciprocity, this time with the words amplified on the photocopier. Despite this T-shirt design being mass-produced (and incidentally highly coveted), each individual T-shirt was also personalised with an additional tier of customisation with Webb hand stencilling the words 'Art School' over the original text. The T-shirts perform even more intimately once one learns that the words are carefully being

written on the very typewriter his parents gave him as an 18 year-old.

Webb's own colour palette for his designs is *also* carefully selected: 'I like the idea of T-shirts that have been washed and washed, and so I sourced colours which looked like they had once been darker and had now faded.' It was also imperative to Webb that the entire production process was based in Britain: 'They are designed in England, so I like the idea that they are made in England too,' he notes.

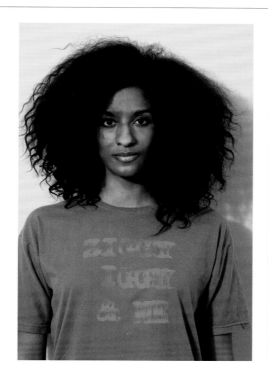
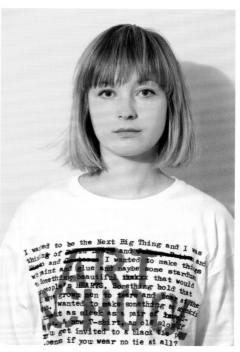

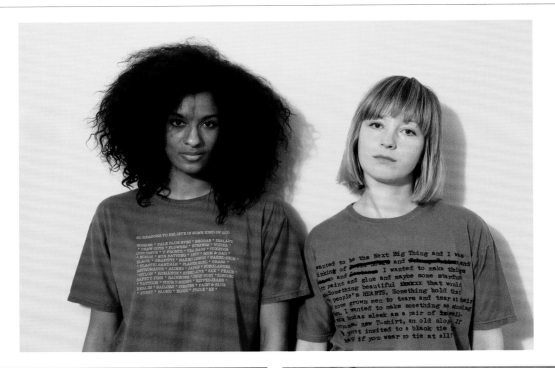

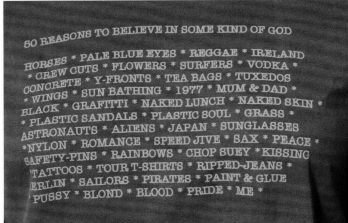

50 REASONS TO BELIEVE IN SOME KIND OF GOD

HORSES * PALE BLUE EYES * REGGAE * IRELAND
* CREW CUTS * FLOWERS * SURFERS * VODKA *
CONCRETE * Y-FRONTS * TEA BAGS * TUXEDOS
* WINGS * SUN BATHING * 1977 * MUM & DAD *
BLACK * GRAFITTI * NAKED LUNCH * NAKED SKIN *
* PLASTIC SANDALS * PLASTIC SOUL * GRASS *
ASTRONAUTS * ALIENS * JAPAN * SUNGLASSES
*NYLON * ROMANCE * SPEED JIVE * SAX * PEACE *
SAFETY-PINS * RAINBOWS * CHOP SUEY *KISSING
*TATTOOS * TOUR T-SHIRTS * RIPPED-JEANS *
ERLIN * SAILORS * PIRATES * PAINT & GLUE
* PUSSY * BLOND * BLOOD * PRIDE * ME *

I wanted to be the Next Big Thing and I was
thinking of ▨▨▨▨ ▨▨▨▨ and ▨▨▨▨ ▨▨▨▨ and
▨▨▨▨ and ▨▨▨▨ I wanted to make things
with paint and glue and maybe some stardust
too. Something beautiful ▨▨▨▨ that would
touch people's HEARTS. Something bold that
would move grown men to tears and tear at their
clothes. I wanted to make something as shocking
as ▨▨▨▨ but as sleek as a pair of ▨▨▨ well-
worn jeans. A new T-shirt, am old slogan If
▨▨▨▨ you get invited to a black tie party
what happens if you wear no tie at all?

T-shirts kindly supplied by Iain R Webb • Models: Lindsay Freeman and Silvia Ricci

Both words and T-shirts have been a constant in Webb's life. As a stylist, Webb administered the T-shirt as a narrative tool. Typically, clothes were chosen to tell a story; nowadays editorials often feature the juxtapositions of occasion-specific garments, such as ball gowns or glamorous sequinned skirts, partnered with informal items such as slogan T-shirts, but it was Webb who was amongst the first to use the sartorial dichotomy between luxury clothes and the modesty of everyday apparel. 'I've always been into T-shirts and I like that they are what they are. I like their simplicity and versatility as well as the utilitarian side of them, but I also like how they can be transformed in lots of ways, especially with messaging and using them as a canvas.' Even on a personal level Webb wears the T-shirt as a 'building block'. He continues: 'I have always used it as a foundation for what I've worn, either on its own or beneath something, even at a formal dinner I'll wear a T-shirt beneath my tuxedo', he adds wittily. And although Webb is a style maven extraordinaire, he is without any snobbery. The myriad of T-shirts he owns consists of both ends of the price scale, including the very low end bought simply for the T-shirt's colour or cut.

The response to Webb's bespoke T-shirts has been astounding; his website enables him to exhibit recent designs as well as older pieces or reissues of those pieces. Also present on his web page are diverse quotes and visuals that possess inspired meaning to him: 'I'm always keeping things like old love letters, and I always write down words from a book or lyrics I like, I make notes all the time. They are, I suppose, fantasy narratives, just things I like, things that have associations, they may be personal to me but they may have other associations for other people – words have power, even one word has power, and whether those words appear on fabrics or within a frame I always find myself attracted to them.'

Antoni & Alison

www.antoniandalison.co.uk

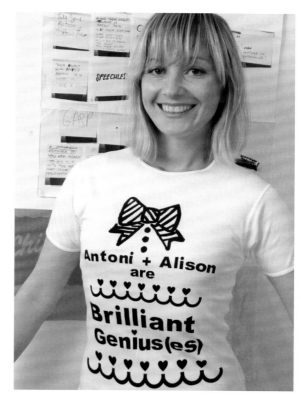

'Antoni & Alison Are Brilliant Geniuses', Spring/Summer (2008), 'The Party Portraits' Collection

'The T-shirt became a piece of paper for us really, and it always worked as a white background like a piece of paper.'

'Fifty-plus collections later and we are still making T-shirts, they have always been an important part of our work,' enthuses Antoni Burakowski, who along with his creative partner Alison Roberts, are the eponymous design duo Antoni & Alison, who received the MBE recipients (Most Excellent Order of the British Empire: an official accolade given for services to the country or community – in their case for services to the fashion industry) in 2008. Although their partnership officially launched in 1987, it was as first year students at London's Central Saint Martins (Burakowski pursued fashion textiles; Roberts trained in fine art) that their mutual interest in each other's work prompted them to set up business together. 'But it was *how* to work with each other and deciding what our common link would be that needed cementing,' imparts Roberts. It transpired that the T-shirt was the ideal medium to combine their talents.

It was the world of ideas rather than the practice of dressmaking or pattern cutting that really motivated Burakowski and Roberts and so, as continues to this day, they wrote down all the things that inspired them which included random words and concepts. 'It all

originates from a piece of paper, no one sees that, they see the silk screenprint – the end product – but to us that piece of paper is integral to our work.' Burakowski elaborates further: 'We loved the idea that whatever we did should be popular, and T-shirts were the perfect item for us to put our two heads together to make something that was a joint effort. It soon became apparent that graphics was a good way of visualising our thoughts.'

The ingenuity of Antoni & Alison's work is their ability to take a generic word or series of words and, through their choice of typography alongside the means in which they express it via design, transform it into something so radiantly modern and iconic. Antoni & Alison's first T-shirt quite simply stated 'Be Happy' across its front, a statement that looked beyond the cyclical nature of fashion. As Roberts remarks: 'At the time there was nothing else like it because suddenly you could have a T-shirt that wasn't a protest piece, it could be an inspirational or visionary piece. We liked the idea of giving people something they hadn't seen before and so we would write really upbeat messages like "Have A Lovely Day" on the label.'

Although Burakowski and Roberts were equipped with abundant enthusiasm, their grasp of how to take the product to market was based on intuition rather than strategy; all the more remarkable given that nowadays universities privilege business acumen over design integrity. Burakowski explains: 'We had very little money and no training in how to build a company, in fact we had no idea how to obtain suppliers, so we thought we'd start outside of London, test it and see if there was a response. We literally took a bin bag filled with our 'Be Happy' tees to Brighton and popped into the first store we liked the look of. The woman placed an order there and then for £200, and making the T-shirts had cost us £200, so we were pretty chuffed. And then a couple of weeks later the woman phoned us up and reordered and she just kept reordering week after week. There had become such a buzz about them that one time we arrived to find a queue outside the shop waiting for our

delivery.' Roberts interjects: 'And in that queue was one of the buyers from Harvey Nichols, she asked for our number and within days she placed an order too. And that was without any press!' Burakowski adds: 'All the meanwhile we were touring around England in Alison's little green car and just knocked on doors. We were *really* that keen.'

During this time Burakowski and Roberts worked from their council flat in Southwark, London, with Roberts at her sewing machine and Burakowski silk screening the T-shirts in the bath. This early period also saw Burakowski and Roberts develop their signature vacuum packaging: 'Being a white T-shirt, they would get really dirty and we couldn't bear it. So we thought, "what is a good way of presenting them to retailers without people touching them?" and we thought of containing them in a kind of transparent envelope.'

Fuelled with confidence and exhilarated by the volume of orders, Burakowski and Roberts

'became obsessed with writing.' Roberts discloses: 'We worked in a fine art way and we just wrote and wrote, we made all these text pieces, and the business just grew and grew. It all became a bit of a phenomenon and with a phenomenon you get people who copy you, and so there were all these horrendous versions, insincere versions. If you went down to Camden Market you saw a million copies of our T-shirt designs. 'Be Happy' had been made into a predictable 'Don't Worry, Be Happy' and we were like "What have we spawned?" So from a really beautiful, pure idea suddenly there were all these cheap imitations and we feared people may not notice the difference between ours and theirs.'

As a response to the plethora of counterfeit merchandise and as a departure from the now contentious, 'Be Happy' T-shirt, Burakowski and Roberts started to explore extreme themes: 'We then decided to go where the plagiarists couldn't follow us. Well you can put anything on a T-shirt

'Woman With Eyeliner Adjusting Her Dress', Spring/Summer (2008), 'The Party Portraits' Collection

'Woman In A Skirt Holding A Balloon', Spring/Summer (2008), 'The Party Portraits' Collection

'Woman With A Good Hairstyle Who's Broken Her Wrist', Spring/Summer (2008), 'The Party Portraits' Collection

'Do Nothing', Autumn/Winter (2004), 'Nothing' Collection

so we thought we would step it up and wrote nonsense things so they wouldn't copy us, things like 'I'm Drinking A Glass Of Water', 'I'm Naked With A Cream Cracker', 'No One Understands Me', 'I Hate My Skirt' ... and funnily enough we felt a total sense of freedom because we thought if these slogans get copied then even better.'

Rather poetically Burakowski and Roberts have always treated the T-shirt like a diary: 'If things got to us or worried us, which they did, we put them on T-shirts to remind us of how we were feeling. People thought we were being really ironic, of course there was irony, there always is, but really it was about us turning a difficult time into something hilarious. Also there was huge pressure because everyone wanted the next thing, but it kept being copied and there was no protection.' Moreover, the work of Antoni & Alison was heading towards the stratosphere with celebrities *du jour* being photographed in their designs, but as Burakowski and Roberts reflect: 'Nowadays in the age of product placement, celebrity endorsement would cost us hundreds of thousands of pounds, but times were really different back then, unlike today where everything has a price tag.'

The first ten years of Antoni & Alison's work is now archived at the V&A Museum in London, testimony that their work is as comfortable in an art gallery as it is in a retail context. 'We never think of our designs as highbrow art pieces, but rather as Pop Art pieces, they are commercial art pieces.' Roberts expands on this topic: 'Having done a fine art degree and having experienced the grilling you get to justify your work, I can't justify our collections in those high art terms, but I don't think there is anything wrong about coming from the same place to create something different.' In Antoni & Alison's world that 'something' references personal narratives and diverse social practices such as British teatime rituals or the stereotypes people adhere to when invited to a fancy dress party; their work doesn't self-reference the fashion industry but rather sources its inspiration from the idiosyncrasies that is life. 'You draw on what you know, although we did do one collection based around Hawaii without ever going there, but we love an armchair approach. We often use different approaches, for instance we're really into the idea of "no knowledge" and "history without knowledge" because we don't believe in history very much as it always gets rewritten.' Roberts embellishes: 'So we set up rules for ourselves and like to partner ideas that don't really relate to each other, sometimes we'll combine a new piece with an old piece, we like the notion of disparate things that wouldn't have met normally. We love anomalies like that.'

One of the factors that make Antoni & Alison's slogan T-shirts so compelling is their playful use of type: 'We used to make our own typefaces, quite badly actually but we really liked that, however that led us to the felt tip pen. Handwriting is a nice direct way to write,' affirms Burakowski whose penmanship animates their design ideas. 'Also, anyone can put a fonted word on a T-shirt, but since handwriting is unique, others can't replicate it in the same way.'

In 2010 Japanese clothing brand Uniqlo commissioned Antoni & Alison to reintroduce twenty of their classic T-shirts. 'When Uniqlo showed us the samples we noticed how they'd straightened our fonts, but we asked them to redo them because everything we had written had been done by eye and we liked those imperfections.' Close to one million T-shirts were sold worldwide with each country generating a different bestseller. In the UK 'I Hate My Hair' resonated with British girls; 'Nobody Understands Me' was the most popular T-shirt in France; 'Antoni & Alison Are Brilliant Geniuses' peaked in Russia and 'Girl Going To Work In An Office' was championed by the US market. 'In every collection we've always kept the T-shirt, T-shirts are as contemporary now as they were then. I still see 'Be Happy' worn on the streets. It's such a simple sentiment, but one that doesn't go out of fashion.'

'Star', Spring/Summer (2010), 'Screen Tests' Collection

'Popular Metal', Autumn/Winter (1996), 'Egg & Chips' Collection

'Do Nothing', Autumn.Winter (2004), 'Nothing' Collection

'Super Modern Piece', Spring/Summer (2005), 'Untitled' Collection

'I Study Postmodern Choreography', Autumn/Winter (2005), 'Uncomplicated' Collection

'Modernist', Autumn/Winter (1994), 'Modernist' Collection

'Monday', 'Tuesday', 'Wednesday', 'Thursday', 'Friday', 'Saturday', 'Sunday', (Spring/Summer 2011), 'Creations' Collection • T-shirts kindly supplied by Antoni & Alison from their archive • Model Silvia Ricci

Toby Mott

www.tobyshop.com

'The success of the brand looked like a clever campaign but it wasn't, it just appealed to people of the time.'

It is rather befitting that designer and artist Toby Mott's handwritten, school-detention line T-shirts made a cameo appearance in an episode of one of the most influential TV series in the last decade; *Sex and the City*. The scene sees Carrie ruminating at her computer, with the words 'I Have Nothing To Wear' repeatedly striating her chest. The irony was not lost on its viewers, nor the show's budget. Mott was thrilled. Celebrity endorsement has been hugely important to the growth of his empire: 'I've built my company on it.'

The increased exposure of celebrity culture in the last decade, and its subsequent proliferation, has seen the power of the slogan T-shirt emerge as a weapon the celebrity wearer can use in response to the media's treatment of them. Inevitably, celebrities who wear T-shirts, sell T-shirts, and likewise lending their names to charitable causes also brings in business.

During the first half of the noughties Mott's coquettish slogans were worn by the fashion cognoscenti as well as media pin-ups across the celebrity spectrum. Without saying a word, supermodel Kate Moss referenced her hedonistic lifestyle with the word 'Painkiller', Spice Girl chanteuse Geri Halliwell famously

displayed the maxim 'Yoga Kills' during a period when her devotion to this activity saw her weight plummet, model turned actress Sienna Miller suitably chose 'Model Turned Actress', whilst French actress Julie Delpy, known for her critical roles, wore the words 'Alpha Female' against a truly feminine shade of hot pink.

However, those who do not have a paparazzi following could still imagine themselves as superstars with statements such as 'I Stop Traffic', 'I Am A Glamour Girl' or even 'I Need The Priory' and this is where the brand's success lies; it enchants the masses. They too can mimic their favourite style icon's sentiments by wearing the very same T-shirt as them.

The label launched as Toby Pimlico in 1999, with six T-shirt samples; a dozen produced of each, inscribed with pithy phrases such as 'I Must Not Chase The Boys', 'I Am Bad', 'I Must Try Harder', 'High Maintenance', 'I Do Things I Shouldn't' and the aforementioned 'I Have Nothing To Wear'. Although the T-shirts had evolved from Mott's artworks, the shift into apparel was principally motivated by commerce. Driven by irony rather than a political agenda, Mott explains how the concept was cemented: 'Since 1995 I had been painting

these 'school line' works with rather personal and bleak messages such as "I Will Ruin Your Life". A couple of friends of mine who owned a boutique in West London really liked them and suggested that I transfer the idea onto women's T-shirts but with more upbeat phrases. Initially I wrote the slogans as both a single line and then as several lines, but I preferred the school lines format as I felt this is what set them apart from other T-shirts – this and the fact that they were printed on long-sleeved, baseball-style T-shirts.'

Formerly Mott had accrued much success as an artist with the East London collective the Grey Organisation, which he had co-founded in the 1980s. Their medium of choice privileged film and video, which would serve him well

years later. However, it was their guerilla acts upon the art establishment that bestowed the Grey Organisation with a degree of recognition. This was shortly followed by a solo career as an internationally acclaimed artist alongside a lengthy spell residing in the States where he worked as an art director at MTV. Around this time he was commissioned to direct music videos for performers such as Public Enemy, A Tribe called Quest and The Rolling Stones – Mott also designed the graphics for De La Soul's iconic *3 Feet High and Rising* album cover. Unsurprisingly, his brand has been created around a recognisable design format.

Backtracking further, Mott spent his formative years preoccupied by punk culture, and although

his label aesthetically and ideologically appears far removed from the anarchic world he once circulated in, he draws a parallel between the two in terms of sentiment wherein both possess a quintessentially 'Englishness' to their cultural fabric. If one contemplates 'youth style' as a marker of refusing dominant cultural expectations, then perhaps wearing a T-shirt adorned with 'I Do Things I Shouldn't' shadows punk's disobedient outlook.

Typically, slogan T-shirts are often associated with bold type, although not exclusively. Nonetheless diverse typographical methods have enabled brands, such as Mott's, to differentiate themselves from their competitors, and as with punk's manual

customisation of T-shirt texts, Mott's own handwritten phrases gently nod to an era when mainstream digitalisation had yet surfaced in fashion. However, the comparison to punk culture more or less halts there since Mott's brand is clearly a commercial enterprise, as he himself states.

As Mott suggests, his version of the slogan T-shirt redefined the medium as a fashion item: 'Basically I came up with something that summed up the zeitgeist. Often this happens by accident rather than design and as it so happened the T-shirts defined the moment in the UK, it was a lucky coincidence. At the time when I first started my T-shirt range I didn't feel that slogan T-shirts were a must-have item, but within six months the business became a global brand. It really was a phenomenon.'

In 2000 Mott exhibited for the first time at London Fashion Week. Slogans such as 'Top Bird 2000' and 'I Am A Naughty Girl' generated huge orders from major stores around the world. However, his presence was not welcome by other designers: 'I encountered a lot of resentment from the fashion world. Our stand was one of the busiest, but I think it also had to with the fact that I have always championed my lack of interest in being "in fashion" or "trendy".' Fuelled by an anti-elitist approach, Mott favours being 'pop' in the true nature of its meaning, as in being 'popular': 'The whole thing about slogan T-shirts is that they are populist. Fashion designers may play with the genre but for me slogan T-shirts are all about their availability and democratic values, everyone can afford them.'

In essence, Mott's T-shirt canvases and visual methods remain the same, it's the slogans themselves that change. In recent years he has donated artwork for a number of charities including Action on Addiction ('Angels Against Addiction'); Amnesty International ('I HEART Amnesty International'); Peace One Day ('I HEART Peace One Day') and Marie Curie Cancer Care ('Painkiller').

Nowadays, Mott licenses his brand. Having recognised that the slogans could be applied and tailored to any surface or product, the range has since expanded to include nightwear, greetings cards and all manner of household items. 'Slogans are all about articulating the mood of the day,' Mott adds, whilst holding a coffee mug that wittily announces 'I am alive and awake'.

T-shirts kindly supplied by Toby Mott • Model: Silvia Ricci

Karen Savage

www.karensavage.com

'Cult Whatever', Spring/Summer (2010), 'Re-Issue' Collection

'I always wanted to dare say what others didn't and the T-shirt was the medium to do that.'

'Slogans have the ability to give voice to a person,' exclaims fashion designer Karen Savage, whose feminist-inspired T-shirts are championed by patrons as disparate from academics to club-goers to mature women who promoted the feminist cause as second-wave activists in the 1960s.

Savage recalls the motive that inspired her first T-shirt design. The T-shirt featured two heavily-lipsticked mouths plastering either breast: 'It came from my days working as a waitress, so many of the male customers used to speak to my chest.' Rather ingeniously, Savage reclaimed this gesture by drawing even more attention to the female anatomy in an exaggerated stroke of defiance and in a highly-feminised aesthetic that flirted with comedic overtones. Confrontational and charged with a tension that cultivated levity and gravity, the T-shirt 'back-chatted' to those whose eye-line had dropped to the wearer's torso, shifting the male gaze back onto itself. This dichotomy has repeatedly nourished Savage's work over the years and propelled the first of many slogan T-shirt collections that straddled dual meaning. 'My ideas are usually in response to personal observations and experiences, and the names of

the collections are also very important to me as a concept.'

In 1993 Savage produced a range of T-shirts called 'Stereotypes with Attitude'. As the name suggested, Savage subverted female stereotypes and imbued them with a generous dose of attitude. Savage reveals the collection's *raison d'être*: 'At that time I observed that a woman was labelled either a virgin or a whore and for me a woman could be both, neither, or an amalgamation of the two if she so desired ... the times were all about female empowerment and not conforming to a single stereotype.' The result had archetypal, feminine descriptions on the front of the T-shirts, whilst their more aggressive counterparts were printed on the back as an unexpected *coup de grâce*. Consequently, 'Baby' was partnered with 'Bitch', 'Virgin' with 'Whore' and 'Angel' with 'Witch'.

Such juxtapositions were often divisive in terms of their acceptance. Although many people acknowledged the feminist connotations that 'Baby' and 'Bitch' et al. implied within a specified context, others considered the brutality of the word 'Bitch' as distasteful. Savage elucidates: 'Words such as "witch" and "whore" are without doubt offensive, but this

was at the heart of the project. The collection "Stereotypes with Attitude" was inspired by Erica Jong's book *Fear of Flying* (1973). One of the chapters talked about negative words used to describe women and this made me think how if you paired them with a positive word you could somehow reposition derogatory labels as insubordinate messages.'

For Savage, the process and meaning underlying her work drives her design output. However, given that meaning often gets lost in translation, the suggestion that perhaps consumers purchased these T-shirts for their visually attractive graphics, thus negating

their initial objective, made no difference to Savage: 'Of course I'd like my work to be understood, and luckily my peers completely got it, but the collection was a commercial enterprise and you just can't control the reasons why people buy your merchandise.' She continues: 'At the end of the day the messages and intentions are visible to those who want to see them and that means everything to me... and if women wear the tees, for no reason other than they just like the look of them, then that's completely fine by me too. I just love that people wear them'.

From an early age Savage's fascination with

feminist theory was evident. She cites her interest in the Pre-Raphaelite art movement as the trigger: 'Those paintings were so mesmeric, but I remember thinking where are the female artists and then it occurred to me that women were always greatly outnumbered in the media. So I took a number of feminist philosophy classes, which I processed on an intuitive level as opposed to an academic one, and indulged in reading feminist literature such as Germaine Greer's *The Female Eunuch*, Simone De Beauvoir's *Second Sex* and Naomi Wolf's *The Beauty Myth* ... but my interest in feminism was never about attacking men

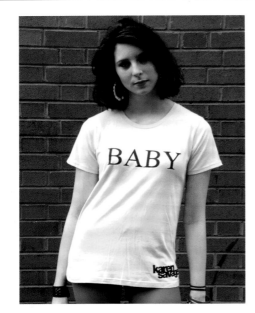

'Baby/Bitch', Spring/Summer (1994), 'Sex Symbol – Sex Target' Collection

'Virgin/Whore', Spring/Summer (1994), 'Sex Symbol – Sex Target' Collection

'Bloody Beautiful', Spring/Summer (2010), 'Re-Issue' Collection

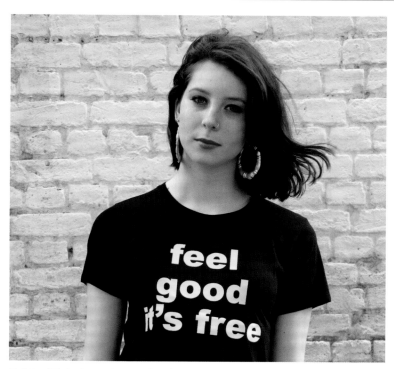

'Feel Good It's Free', Spring/Summer (2010), 'Re-Issue' Collection • T-shirts kindly supplied by Karen Savage • Model Amy Thompson

whatsoever, it was about the right to political, economic social and sexual equality.'

After completing a course in silk screenprinting as well as attending the Prince's Youth Trust business programme, Savage felt equipped to communicate her concerns through her love of fashion: 'To me it just seemed the most natural environment to express myself in and I felt I could apply my interest in feminist ideology to the medium of the T-shirt.'

Within a year Savage started to accrue a devoted following, which was noticed by Radio 4's *Woman's Hour* who invited her as a regular guest to discuss fashion's relationship to feminism. This propelled Savage into the media spotlight as a mouthpiece for a whole new cultural chapter that saw a generation of women addressing issues of gender, image and representation. Female provocateurs such as singers P.J. Harvey and Courtney Love and art-led collectives including the Riot Grrrls and the Guerrilla Girls challenged male-dominanted culture using subversive tactics to oppose and question women's seemingly passive role in society, whilst also exhibiting feisty displays of female sexuality.

It was also a time that saw women dressed provocatively in clubs, once again defying preconceived notions of femininity: 'It made complete sense that my primary market were the club kids, after all night clubs are safe spaces to express yourself in.' Savage concedes that often it was the T-shirts' frontal words that people gravitated towards. Before long major brands exploited Savage's lexicon on their own T-shirt lines but culled the oppositional words on the back, thus decontextualising their original meaning. Savage's signature choice of words were further diluted when these corporations modified the words, so 'Baby', for instance, was shortened to 'Babe'. Consequently, Savage-inspired T-shirts emerged as a mammoth trend, amassing a huge amount of press, and also a backlash. No longer the prestige of a nightclub culture, female-worded T-shirts were a common sight during daylight hours too.

Fashion's cyclical infrastructure saw not only Savage's T-shirts make an exit in the quick turnover of cultural trends, but also the feminist debate that had sparked a furore during the early-mid '90s abated. Savage admits: 'It was devastating because those issues don't suddenly disappear, admittedly I became a little jaded and my slogans took the nature of "seen it all before", I wore my heart on my sleeve, literally.'

Savage's T-shirts continued to be themed and continued to team up two-sided leitmotifs, as illustrated by her following collections; 'Sequins and Leaders', 'Ambition and Chiffon', 'Sugar and Spice' and 'Sex Symbol Sex Target' which raised the 'powerful versus passive' question of a woman's role as depicted in sexual imagery. For Savage the commercial aspect of being a one-woman industry never conflicted with her creative intention. 'I was self-financed and understood the nature of commodification as a means to make a living. At that time there weren't that many female street labels. I always wanted it to be a no-nonsense, female brand and if I could touch a few people on the way, or generate press and discussion around those topics, then I felt that I'd accomplished something worthy.'

These days, alongside her role as senior lecturer in fashion styling at the London College of Fashion, popular demand has seen Savage revive her archive; entitled 'Re-Issue', Savage's current body of work not only reissues past designs but the name refers to her commitment to issue-based discourse. 'I'd noticed that my students were reconnecting with feminist culture and were reading books such as *Living Dolls* and *The New Feminism* by Natasha Walter. Also, my students talk a lot about owning the word feminism and not wanting to deny their femininity, it's been really refreshing to observe this resurgence in feminist politics. *And* what's so great, is that my slogan T-shirt work has been adopted by the youth market of today.'

I Love Boxie

www.iloveboxie.com

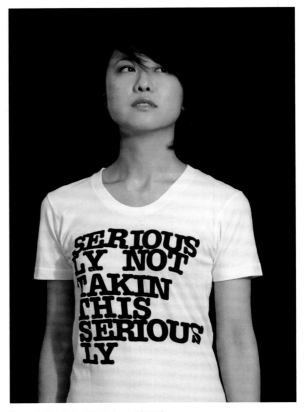

'Seriously Not Takin This Seriously' (2011)

'The idea behind I Love Boxie is that one good line should tell a thousand stories, which is the art of the slogan T-shirt because it means something to everybody.'

A committed interest in the world of stories and documenting those stories upon T-shirts has set the template for Moxie Marks' I Love Boxie T-shirt brand. Conclusively, Marks blends the poignant with a soupçon of droll: 'My T-shirts are all about the art of line writing, they are lines from a bigger story, like a title of a chapter, it's a creative collaboration, other people inspire the text on the T-shirt and I turn their story into a line that gets printed upon a T-shirt.' And it is only the medium of T-shirts that appeals to Marks; the idea of applying her pithy one-liners to bags, as has been suggested, or extending her fashion prowess to other items of clothing holds no interest, because as she remarks it then shifts the essence of her attachment to T-shirt culture.

T-shirts have been a constant in Marks' life, whilst her ability as a raconteur is accomplished: 'I have always been fascinated with T-shirts. I went out with a T-shirt maker about eight years ago and when we split up he made T-shirts out of moments in our relationship, really special stuff. Since I'm a writer, mainly screenplays, I wrote a million pages to say goodbye and he made a T-shirt which summed it up really ... I started to think there is something in this. So

I was in LA one summer, writing a very long screenplay and I was hanging out with another T-shirt maker who reproduced the T-shirts rock stars from the '60s and '70s wore. He was interested in the original stories connected to those '60s and '70s T-shirts as well as the related stories of those who were buying his replicas. And because of the quality of the cotton he used, it felt like you were actually wearing the rock stars' T-shirts themselves. Anyway, once I'd handed in this really long script, the T-shirt maker said to me, "You know what you should do, you should go and write a script about T-shirt making, because you know this world, it's your thing and you keep hanging out with all these guys who make T-shirts". This was about four years ago, so I did start writing about it, but I didn't know where to go with it and somehow it didn't feel right writing about T-shirts and not making T-shirts. Soon after that I had a very big love affair that went dramatically wrong and again I wrote all these pages about my feelings towards this guy and they were all so sad. Then one day I decided to throw away all the pages, but there were five lines I really liked and so I thought I now know what I'm going to do, I'm going to take these lines and print them onto

T-shirts, and my thinking was if I can't say it on a T-shirt then I can't say it full stop, and I may make a thousand T-shirts but all I need to do is make five good T-shirts that leave a mark somewhere, that somebody wears, and that's enough. So then I started to wear the T-shirts around town, because I was displaying my pain on my chest and people were like, "What the fuck happened to you? That's my story", which proves how T-shirts really are *the* place to put across a message, there is nothing else like it.'

The five lines that propelled Marks' business were 'Hey, you and I are going to have a big love affair and it won't work but somewhere in the middle. My god, we tried', 'I need to remember how I forgot you', 'So high and solo', 'Welcome to the shamble' and 'My daddy was a revolutionary I can't get a job'.

Before long, Marks set up a website in which to share her stories that inspired the T-shirts that were now for sale, and also to encourage others to write in with their stories as potential T-shirt material: 'I thought it's actually more interesting for people to tell me their stories and if I feel moved by them, likewise I can conceive them as lines upon T-shirts, so that's what I focus on; people write in everyday. The first T-shirt printed up is always given to the author of the story,' she adds.

Since the majority of the anecdotes share the emotional intimacy of heartache and honour female-voiced stories, it appears inevitable, though not exclusively, that the core audience that purchase the T-shirts are female. However, not all the stories relate to love affairs. 'I had this one girl who wrote in a few months ago, she was only 26 and had just been diagnosed with a brain tumour. She explained to me that she'd been presented with two choices; she could either live with the brain tumour, which meant she had seven years to live, or she could have it removed but there was a massive chance that it could go wrong and she would be a paraplegic. Her parents had given her a religious painting, and although she was not religious this painting had given her great comfort, so I made her the T-shirt 'God I'm not listening but if you can hear me save me'. A little while later she contacted me again and told me that she had worn the T-shirt on the operating table and it was as if this T-shirt was speaking at the very moment when she couldn't speak. Of course the T-shirt didn't save her life, the doctors did, but that T-shirt meant something to her.'

Whilst regarding the T-shirt as one of the most sentimental pieces of clothing people own, Marks also privileges its currency as a garment that speaks volumes about the past: 'Everybody has a T-shirt from an ex-boyfriend, an ex-girlfriend or from college days or from one's holidays, and at times it says where you've been, and other times it doesn't need to because *you know*, and then there are T-shirts that you sleep in or are too afraid to wear anymore because you don't want them to fade out. There are all these things that happen to you in your life, all these special moments; things you put in picture frames, like birthdays and weddings and stories you talk about, and there are all these things that happen in between, just a moment that doesn't really go anywhere, and that's what I want to commemorate – that has to be held somewhere … you're never going to put that picture of the guy you loved and who left you on your wall, but put it as a line on a T-shirt and for a while you wear it and one day you get up and put it away and that's it, that's what is so good about the T-shirt.' According to Marks, the reception to her T-shirts resides in their ability, 'to say something about someone who isn't there anymore. It's a kind of a hopeless message and maybe the T-shirt is wandering about and finds the person who was meant to read it. Slogans are often a chance to be lazy with words, but actually slogan writing should be the sharpest writing there is, and when encapsulated on a T-shirt the power those words can have is remarkable.'

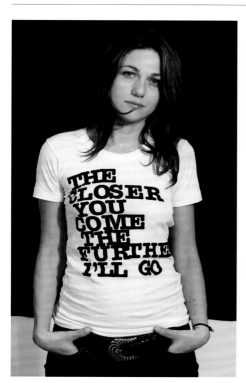

'The Closer You Come The Further I'll Go' (2012)

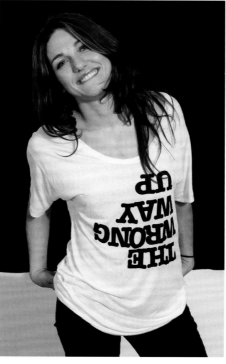

'Up Way Wrong The' (2011)

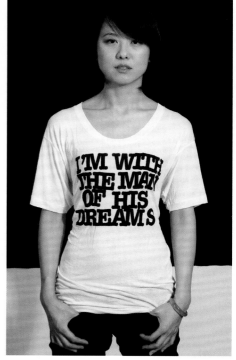

'I'm With The Man Of His Dreams' (2009)

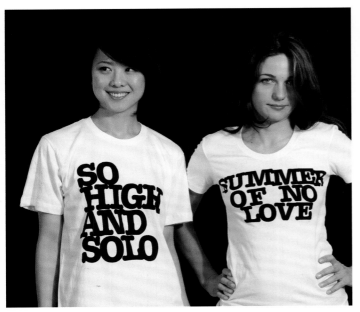

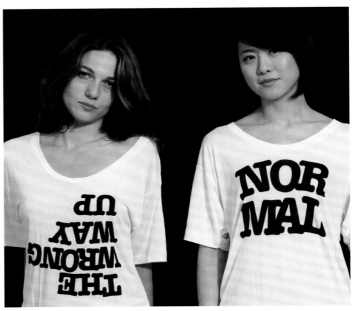

'So High And Solo' (2008) 'Summer Of No Love' (2010) 'Up Way Wrong The' (2011) 'Normal' (2012)

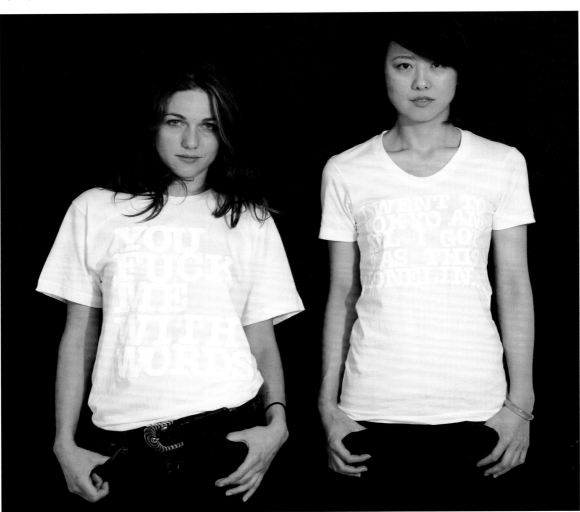

'You Fuck Me With Words' (2011) 'I Went To Tokyo And All I Got Was This Loneliness' (2011)

T-shirts kindly supplied by I Love Boxie • Models: Gosia Cyganowska and Yu Ling Huang

Cassette Playa

www.cassetteplaya.com

'Poison', Autumn/Winter (2011–12), 'Carni Cannibal Palace' Collection

'I never just put a word on a T-shirt, I do a Cassette Playa version of it – it comes out Cassette Playarised.'

'I love using statement words that are abstract or evocative; language that sometimes doesn't make sense. There is a lot of power in the words that I use, for instance sometimes you may not be able to read my text inspired by black-metal or Arabic, but the aesthetic of it is so beautiful and so specific and that is what is attractive to me.' Carri Munden's Cassette Playa clothing label is a techno-tribal cornucopia of sampling anthropological themes. Munden incorporates a wealth of diverse references in her work reflecting her enthusiasm for death metal (aka black metal: a subgenre of heavy metal music), hip hop cultures, '90s skater culture, geometric shapes, patterns and African prints. She also has a propensity for non-Western and ancient cultures, such as Aztec, Celtic, and Egyptian cultures, Islamic art, native American imagery and Norse mythology. Likewise, recognisable icons such as the yin and yang symbols and pentagrams are reinterpreted as part of Munden's unique visual vernacular, as well as an original use of eyeballs. Munden's imagery emerges as bold, cartoonesque motifs, both inspired by technology and using technological production, such as digital printing, to realise them.

The T-shirt is a recurring piece of apparel in Munden's collections quite simply, as she notes, because of its universality and classic shape that enables her to recontextualise her love of print and strong graphics onto the body. Typography plays an important role in Munden's work, both in terms of her choice of words and their graphic execution, but rather than just adorning her T-shirts with established symbols, she skilfully creates her own visual ciphers. Munden's seminal Spring/Summer 2010 collection entitled 'Power Drift Nation' saw T-shirts adorned with fictitious Arabic-influenced lettering. As always with Munden's work, the T-shirts had a very identifiable aesthetic creatively nourished by layers of narrative content. 'That collection was a clash of two cultures, Arabic culture and custom car culture, where they put big lights and sound systems in cars'. The T-shirt designs partnered a Munden-invented Arabic type with the black metal calligraphy that she is a fan of. Although the wording on Munden's T-shirts was fabricated, its imbued essence and the ideas and sentiments behind each created word was critical to her process: 'I create my own meaning in the texts, but I like how people may decode them and may read different levels into them.'

Munden's cultural orbit orientates around an inimitable set of artistic values and colourful characters. In 2004 Munden's graduation collection (Munden studied at the University of Westminster) was bought by preeminent stylist Nicola Formichetti (Lady Gaga's famed art director) for his store SIDE BY SIDE in Tokyo. This was shortly followed by a role as fashion editor at the hyper-hip magazine *SUPERSUPER!* and styling projects for bands such as The Klaxons as well as and producing editorials for *Dazed and Confused* magazine amongst others. Munden has also turned her creative hand to installation work and art direction for clients such as Nike and Stüssy – and her niche following has amplified as a result of these ongoing relationships. Critically acclaimed, rebel chanteuse M.I.A. is another collaborative partnership that has produced triumphant results. In 2006 Munden's role as M.I.A.'s stylist, together with their shared sense of aesthetics, led to Munden designing

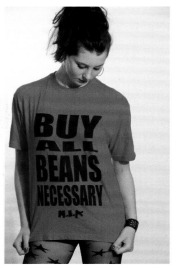

M.I.A. slogans created for Bird Flu music video (2006)

Cassette Playa x Nike Rivals (2009)

Cassette Playa x Stüssy Anniversary (2010)

Cassette Playa x Stüssy Collaboration (2010)

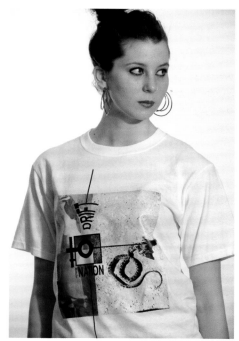

'Made in England', Spring/Summer (2010), 'Power Drift Nation' Collection · Photographic work on T-shirt by James Pearson Howes

'Blingee', Spring/Summer (2010), 'Power Drift Nation' Collection

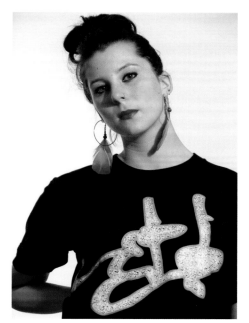

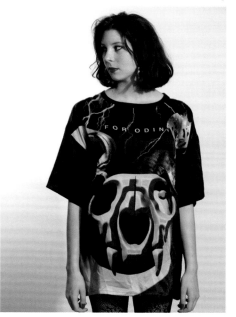

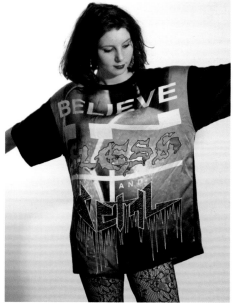

'Rite True Immortal', Autumn/Winter (2009–10), 'Believe in Flesh + Metal' Collection

'For Odin', digital print silk T-shirt, Autumn/Winter (2009–10), 'Believe in Flesh + Metal' Collection

'Believe', digital print silk T-shirt, Autumn/Winter (2009–10), 'Believe in Flesh + Metal' Collection

T-shirts kindly supplied by Cassette Playa · Model: Amy Thompson

a number of T-shirts for M.I.A., including the pictured 'Buy all beans necessary' and 'It takes immigration of millions to hold us back'. Munden divulges: 'This was before I did slogan T-shirts as Cassette Playa. I think why M.I.A. and I work so well together is because our approaches come from very different places, hers is so political and a personal journey, and mine fuses my love of different cultures, so we did twists on her lyrics that were activist in their commentary and printed them on T-shirts ... I want to reach as many people as possible and, in part, the collaborations can do that as they attract other audiences – I like that challenge.'

Dr NOKI

www.novamatic.com

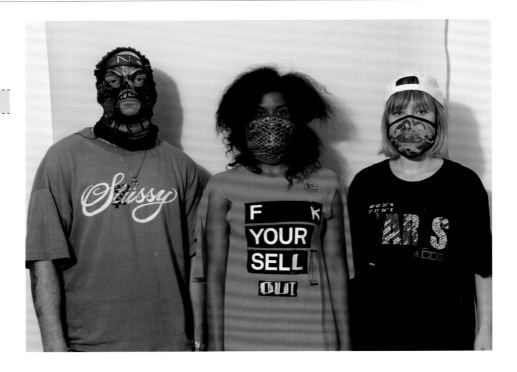

'It became a NOKI mission to patrol the T-shirt with fashion FUNdamentalisim in mind ...'

A critique of consumerism is a complex issue to engage in when the very medium one works in is the object of consumption habits itself. However, Glaswegian-born Dr NOKI's, (anagram of IKON – real name Jonathan 'JJ' Hudson), ethically-charged clothing label NHS (NOKI House of Sustainability) has achieved acclaim since the mid '90s with his recycled, reassembled, one-off garments that have both delighted and disconcerted the fashion firmament.

The humble T-shirt is a prevalent foundation for his work: 'Just like the Dadaist movement I realised the T-shirt held a very important form of information relay... So as an artist I decided the T-shirt was the new information highway, the next powerful page/file/document in the globalised book of revelations. Its printed identity is a force for the good and bad of mankind. Its subversive patrol on every one of us is present everyday of our lives,' informs NOKI in his usual lateral, mercurial manner.

A pivotal moment that propelled NOKI's unique stance materialised after reading *Culture Jam* by Canadian artist Kalle Lasn. 'He talked of Meme warfare, and the globalisation of the world. This was during the very early

'90s pre-mobile and Internet as we now know it as life. His ideas on advertising translated to the T-shirt very easily for me, so I set to work reconstructing the T-shirt as a billboard.' The theme of 'Cultural Jamming' frequently nourishes NOKI's ideology; it imports anti-consumerist strategies to expose, undermine and challenge mainstream cultural production, especially corporate advertising and branding, often using sardonic commentary in tandem with the advertising's *own* original material to subvert meaning.

It was during a period, circa 1996–97, when he worked as a stylist for the popular music channel MTV, that NOKI felt inspired to apply his creative vigor to a self-produced, visual styling magazine called *NOKI-POD (Package of Desire)*. Sadly it never reached publication due to a lack of funding. Nevertheless, this prompted an 'art magazine' which was quite literally two T-shirts sewn together to create a frock: 'The 'Mag-Dress' was the name given to the original NOKI pieces. The idea was that by turning T-shirts into dresses they would then become interactive fashion billboards for something new called NOKI, therefore creating a 360-degree contemporary subversion of

modern branding design and customer value, and the NOKI floodgates streamed into fashion as did my form of "Culture Jamming",' he enthuses.

Almost immediately NOKI's designs captured the curiosity of key fashion players such as stylist Nicola Formichetti and photographer David Simms who shot supermodel Giselle, at the beginning of her career, for i-D magazine in one of his pink, customised 'Champion' T-shirts. 'The important NOKI detail on this T-shirt at the time was the letter "F" cut from another T-shirt and appliquéd below the Champion logo, so the fashion culture jam made the viewer think champion "Fucker". The "ucker" bit was represented by five random hole punches,' illuminates NOKI.

Unlike the homogenised and mass-market merchandise available for purchase, NOKI's non-conformist methods abandon the factory route of manufacturing fashion in favour of personalised, made by hand, traditional fashion techniques: 'Sustainable clothing is a new fashion direction NOKI fits into really well. It has galvanised a new thought process for style creators and design innovators and if NOKI can

bring fashion rock 'n' roll into that platform, showing a new generation how to DIY a culture jamming, grand slamming, new wardrobe into a one-off ... for me, the new future trend will *be* the "one-one" and the sustainable canvas is its precious power point of delivery.'

Drawing on a rich range of cultural sensibilities, NOKI's own work collages political, social and visual references as a means to challenge the dictates of fashion production. Consequently, the genius of NOKI's creations are their seemingly mismatched constructions, that both implicitly and explicitly comment on consumption culture through their rehabilitation and customisation of discarded garments. The results sees eclectic T-shirts stitched together to form dresses alongside NOKI's transformative rendering of them into other types of apparel, thus renovating the T-shirt into a message about itself. 'I've made all sorts of garments out of all sorts of textiles as long as it fits in with a future fashion silhouette. Why cotton? It's a canvas with so much industrial fashion guilt and destructive intent, but we as a consumer generation see it as such a passive basic garment. I thought it

cleaver to be "100 per cent cottoned on" for the NOKI fan forever.'

Imbued by quick-thinking, NOKI's T-shirt work converges the triumvirate of his role as artist, fashion designer and conceptual thinker, underpinned by his distaste for consumer-centred cultures: 'The slogan T-shirt's ability to direct armies of people to the helm of a flagship store creates utter consumerist whores of us all. However, my work collages the corporate wastelands of printed textiles, rejected by the globalised consumer, into a fashion, one-off hybrid of reinvention.'

NOKI's form of resistance restores life to sartorial cast-offs, such as the slogan T-shirt, via composite and disparate material and symbolic elements in which to suit the present. By collapsing chronological measures, the past is no longer rejected but traverses time by conjoining the slogan T-shirt's *multiple* pasts and its relative histories. The salience of NOKI's T-shirt work is in his commitment to reviving the discarded, but as NOKI concludes modestly: 'On the other hand, I'm a simple craftsman, creating an honest piece for an honest consumer for an honest future value.'

Exclusive customisation from Dr NOKI – all explanations and captions in his own words:

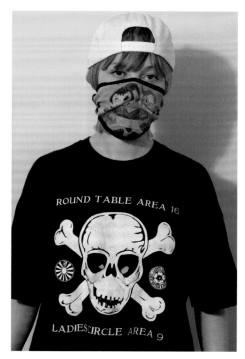 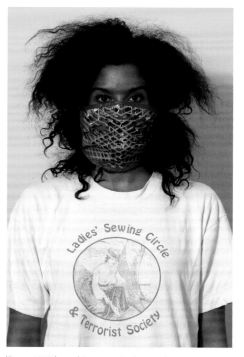 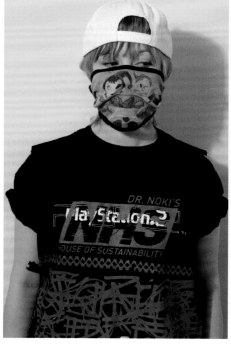

'The NOKI SOB mask (Suffocation of Branding) was once a branded generic T-shirt. Now it is a mask to provoke the viewer to remove it to see who the true human is.'

'From NOKI's archive, two T-shirts subversive in their feminine collection.'

'Cutting into a generic printed statement [NHS, also NOKI's leitmotif] makes the generic a one-off.'

'A "culture jam skulling" activity.'

'Paul Weller and Tom of Finland; love or hate the '60s and '70s.'

'Deadstock Playstation 2 T-shirts becomes a canvas to hand print and reuse the canvas.'

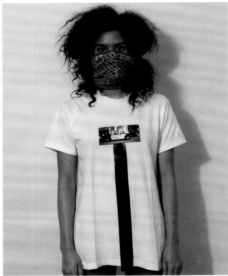

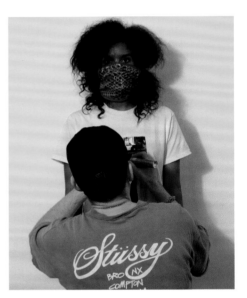

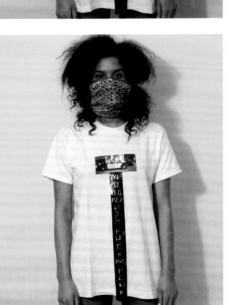

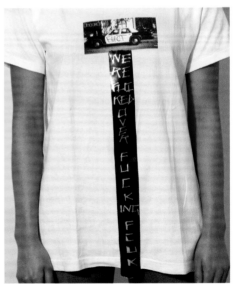

'An original subversive skate label from LA [FUCT] gets completely destroyed by the generic high street brand French Connection, this is a NOKI rebalance of that banal high street takeover for its cheap irony and destruction of true street intention of provocative language words on T-shirt we're fucked over fucking FCUK.'

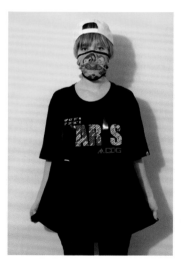
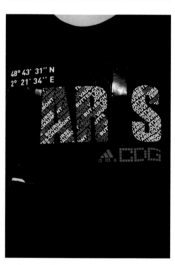

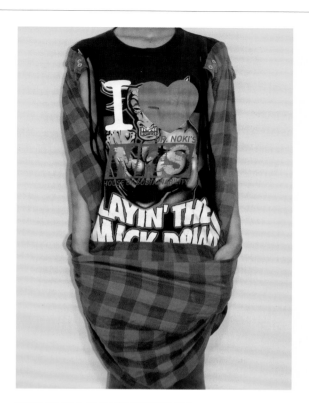

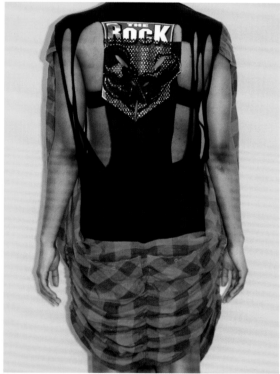

'To take an Adidas through gaffer and pen work Paris become "ars" and Adidas becomes "Aids" to create a wry commentary on true advertising as branding and a positive message relayed to an endangered youth market.'

Dress from Ella Dror, Lovebox 2011 collection, 'Love or hate the fashion bullshit, one-off is the NOKI truth'.

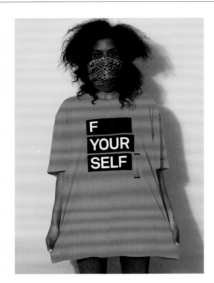
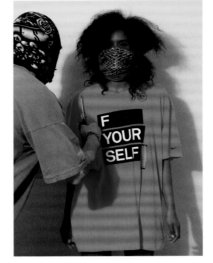
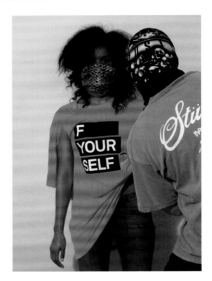
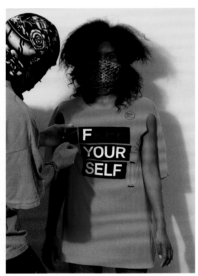
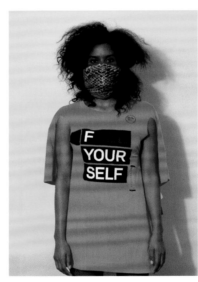
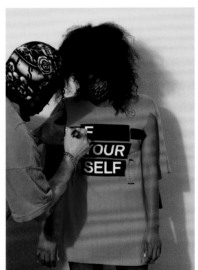
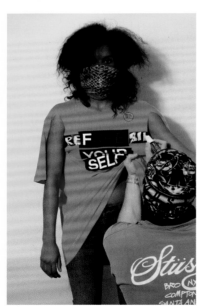
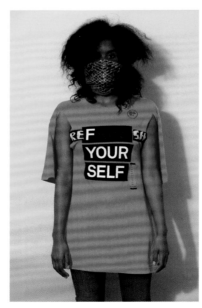

'[The idea was] to take a Nike T-shirt and [use] gaffer tape and graffiti pen to reappropriate the word. Intention as a free flow of consciousness against the branded words by Nike [is then] signed off as a generic production.' T-shirts kindly supplied by Dr NOKI • Models: Lindsay Freeman and Silvia Ricci

Ian Warner and Oliver Miller at SLAB Magazine

www.slabmagazine.net

'The T-shirt has become a symbol – a cultural signifier. Even the name is a symbol: "T". It's a typographic garment.'

'The slogan T-shirts we offer are really just what in German is called a "*Schnappsidee*", meaning the kind of thing you think of in a bar after a few too many drinks. Their presence makes our blog look more like a lifestyle magazine, turning SLAB into something more like SLABWorld. More profoundly, maybe, the T-shirts can be understood as material artefacts serving to substantiate the otherwise immaterial or virtual nature of the blog's production. Everyone needs to leave their mark, and sometimes doing this on a computer screen isn't quite enough,' begins Oliver Miller, a Princeton-educated architect who now owns a table tennis bar called Dr Pong in Berlin and along with graphic designer, and fellow Berlin resident, Ian Warner, has established *SLAB* Magazine as one of the most verbally animated and irreverent architecture blogs circulating the blogosphere.

Miller and Warner's journalistic interest in the urban environment's impact on everyday life was fuelled by the recognition that there were very few formal channels that accommodated 'unqualified' architectural critiques. As they posit: 'SLAB is subjective, heuristic and empirical. Anyone who can claim to have lived in a building is, as far as we're concerned, an expert in the field of architecture because architecture belongs to human culture, so critical reflection should not be reserved for schooled urban theorists or architectural practitioners,' whilst Warner modestly adds: 'I just wanted to find a satirical language for naive architectural criticism.'

Miller and Warner both agree that their architect-worded T-shirts are self-explanatory and cryptic in equal measure. Miller elucidates: 'By printing the names of dead, white architects we're simultaneously heroising them and reducing their identities to a more easily consumable pop cultural state. In the end, the T-shirts infer that we shouldn't be taking these icons of modernist design too seriously.'

In appointing the names of iconic, deceased figures, Miller and Warner's own T-shirts possess a timeless quality, since the names of the deceased are exempt from ageing. This is further heightened through their minimalist, spatial layout of the architect's Christian name followed below by their surname in a font size that allows the words to fit effortlessly above the chest. Even the chosen cut of the T-shirt and the font are classics. Conclusively, Miller and Warner's economic use of text seems apposite to the integrity of modernist values. According

to Miller, conceptually their T-shirts inhabit the domain of being slogan T-shirts, but adds, 'although the confusion about what exactly the T-shirts are trying to say is, I believe, what makes them interesting.' In view of architecture's close associations with the province of art's cerebral and conceptual sensibilities, the notion of whether a T-shirt can be perceived as an art piece is pertinent. Miller posits: 'Anything can, I guess, so why not? This works better if someone famous has worn it, or it was designed by somebody famous and/or if there was a limited run of them.' Conversely, Warner wryly notes: 'Only if art can be framed as a T-shirt.'

According to Miller, not only are slogan T-shirts a way to project an opinion or a point of view of how one see the world textually, but also the view one has of one's self: 'Fashion always serves to express what we think of ourselves to others, basically a medium of expression and communication as much as a "something" serving to protect us from heat, cold or the view of other people. And we sometimes dress in certain ways in order to provoke as well as to feel comfortable. The interesting thing about slogan T-shirts is that they then serve as a medium, a transmission of our characters, that is so explicit as to be textual.'

Furthermore, Miller regards slogan content as being subject to the 'spirit of the times' which has the ability to date quite suddenly, although he deems a superlative slogan T-shirt can develop and mature with age. He adds: 'It really depends upon a number of criteria; from the incisiveness of the slogan to the quality of its design and printing, and how rare the T-shirt is.' Warner interjects: 'They're like good pop music: completely of the moment, and because of this, they stand a good chance of being remembered for ages. Generally they're pretty ephemeral in nature, though the more obscure ones can hold up forever. Perhaps this is the reason why I'm drawn to a simple style, as I grow older I become more fond of a classic aesthetic.'

Although often in agreement, opinion diverges on the subject of mainstream adoption, Miller opens the discussion: 'The mainstreaming of indie culture has been going on for ages and ages. Once it's happened the onus is on the individual creator to then come up with something cooler, better and more meaningful. There isn't really a single creative intention behind slogan T-shirts, anyway, really. They're a channel of communication or of expression that can be used in as many different ways as books can.' However, Warner asserts: 'No, on the contrary, high street slogan T-shirts are wonderfully abstract, almost Dadaistic, if you really start paying attention to what they say. A recurring theme is authenticity, words like "cargo" and "goods" are common, as are phrases alluding to fictional founding dates like "since 2009". Iconographic places are also common, recently in Turkey I saw T-shirts with the phrases 'Los Angeles – Fast and Famous', and another with 'Park View Central City Traditional Liquor Store'. Fantastic! I don't see any devaluation going on there, and find more artistic value in these mainstream tendencies than in any self-proclaimed limited edition, exclusive, boutique posturing. The slogan needs the T. But the T doesn't need the slogan.'

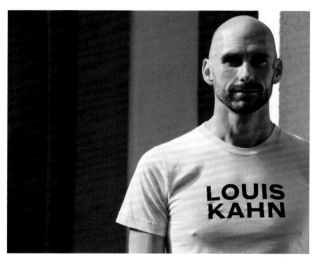

T-shirts kindly supplied by Ian Warner and Oliver Miller at *SLAB* Magazine • Model: Scott Maddux

Delay No More

www.god.com.hk

'The T-shirt can be framed with the head and the arms of the wearer.'

According to Douglas Young, co-founder of Hong Kong-based T-shirt brand Delay No More, a slogan T-shirt can be heroic when it has the courage to make a bold statement *and* take on the consequences. 'We've been arrested by the police for a T-shirt design that they misconstrued as backing Triad gang issues. The 'Triad' T-shirt says 14k in Cantonese, it is drawn on a gold plaque typical of those worn by Chinese brides. The police mistook it to be a logo for the Triad gang of the same name. Of course the real 14k gang would not have a logo nor would they advertise their identity by wearing a T-shirt! That's why the police made a complete fool of themselves and we got accidental publicity.' Young adds wryly.

Taboo subjects drive Delay No More's sloganeering, however Young supports that although taboos are subject to personal positions, it is through exposure and time that they are overcome via their absorption into the mainstream. 'In dealing with taboo issues, creative people can help societies progress and keep in sync with the rest of the world. Taboos are not all positive, hence they are taboos. But with sensitive treatment by the designer, the positive side of them can be brought to

the fore. The artist takes discretion as to what taboos he or she decides to attack. There are of course certain issues, such as race and religion, that I would not want to attack because of my personal convictions,' he asserts.

The visual clarity of Delay No More's typography lends a confrontational feel to the statements, as does the use of the font colour against the palette of the T-shirt itself: 'Certain statements may be meaningful, but if it does not look good graphically, its not going to sell and vice versa.' Self-assured and assertive, the literal meaning of the words followed by Delay No More's textual sign of approval reinforces not only the brand's presence on the T-shirt, but also their endorsement of the slogan's denotation. Young's uncompromising vision is further illustrated by his reasons for choosing certain maxims: 'We often pair positive statements with "Delay No More", our Greenpeace commissioned T-shirt says 'Stop Climate Change Delay No More'. By doing this the urgency aspect is emphasised, one is reminded less of the original profanity. The same can be said of the slogan 'Climb Every Mountain Delay No More' meaning life should be full of explorations.'

However, there is a slogan amongst Young's catalogue that reverses the 'Delay No More' sequence; 'Delay No More Shark's Fin Soup' or as Young informs 'no more shark's fin soup'. Commissioned by Hong Kong's animal rights charity the SPCA, the design was a self-explanatory comment on a cruel practice and was circulated to discourage a barbaric type of cuisine.

Whilst Delay No More's pride in its cultural origins is palpable, the compelling essence of its choice of slogans is that it sentiments are not only universal but are also applicable on an inclusive scale. To fault the notion of 'Save Local Culture' or 'Democracy', one would require a well-informed argument to negate their intentions. Noble gestures are in keeping with Delay No More's approach: 'Our brand has always been about exploring Hong Kong culture in ways that are contemporary and in keeping with world trends. And one way to do this is with language. I have always found our native language [Cantonese dialect] to be extremely colourful and humourous, it's surprising that local designers do not use it more often as inspiration.'

The origins of his own slogan-inspired brand name, also happens to be his favourite slogan: 'I did not invent the term "Delay No More", when I was in high school, we use to joke about it all the time. I've just made it "official" by making it a brand. It's a very common saying in Hong Kong and in other Chinese-speaking communities. You can hear people muttering it all the time. It matches the English slogan almost perfectly from a phonetic point of view. It loosely translates to "Fuck your mother". In English, however, it is a very apt slogan for Hong Kong and Chinese societies, because in many ways, our society is, in my opinion, over-conservative, almost Victorian compared to the rest of the world, hence we need to catch up, we must not delay. Also, Chinese people hate the idea of falling behind world trends or to "miss out on something", to delay is the ultimate "fashion" sin. The fact that it is Delay No More and not the English grammatically correct No More Delay also reflects the way Hong Kong people speak English.'

Born in Hong Kong in 1965 Young is an alumnus of London's Architectural Association. In 1995, together with Delay No More's co-founder Benjamin Lau, he conceived another slogan-inspired enterprise called Goods of Desire, or G.O.D. as it's more affectionately referred to, which specialises in custom-made furniture designs and lifestyle accessories. G.O.D. is the phonetic translation of the Cantonese phrase meaning 'to live better'. Like his slogans, Young arrives at his point succinctly when he concludes that the longevity of the slogan depends on its continued relevance to society, 'as an expression of the society. The longevity of the style of the T-shirt depends on clothing trends.'

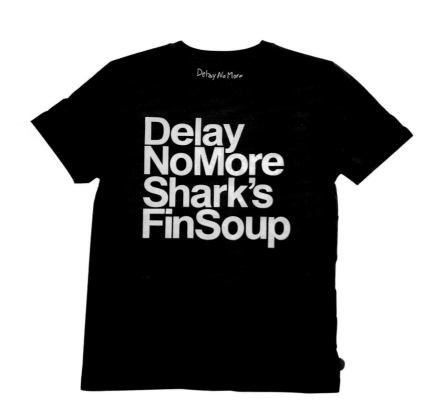

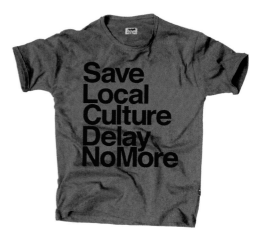

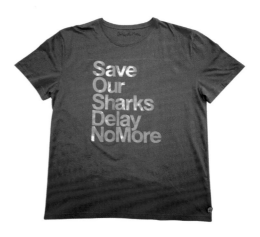

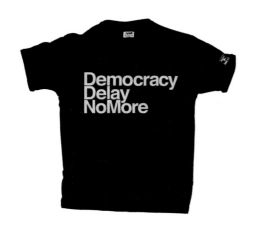
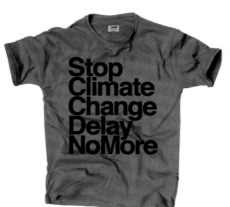
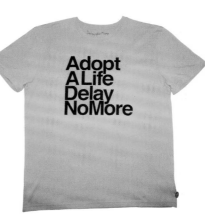

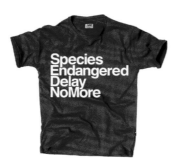
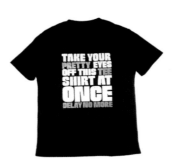
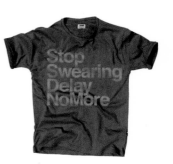
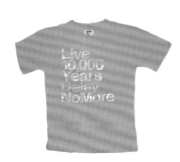
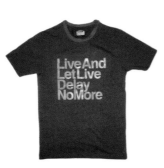
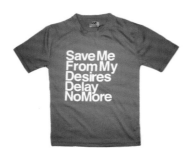
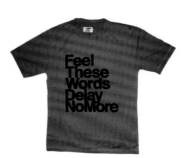

Still life images kindly supplied by Delay No More including the legendary 'Triad' T-shirt on p.171

Topshop

www.topshop.com

'A slogan T-shirt is an instant talking point – it attracts attention and lets people immediately know what you're about. It can get your point across without you having to *say* a word.'

Unlike the twice-yearly catwalk collections that shape future fashion, high street fashion is eternally rushing to arrive at a future which is subsequently ahead of itself *and* of those international high-fashion trends that inform it. British high street chain Topshop is often regarded as the apex of style in terms of mainstream fashion. Its ability to direct trends with its sartorial prowess has seen it expand from its origins in 1964, in the basement of a department store in Sheffield, to a retail empire with more than 300 stores worldwide. Unsurprisingly, given Topshop's broad demographic, the mass appeal of the ultimate people's garment – the T-shirt – is amongst its best sellers. In fact slogan T-shirts retail so well for Topshop that they are available as a trans-seasonal item throughout the year as part of their main collections.

Each year a high number of units are produced with designs that reflect the popular culture characteristics that serve to capture the given zeitgeist. As Jacqui Markham, Topshop's design director shares: 'Our slogan T-shirts tend to be playful, fun and of a time, they are designed to be thrown on and worn with nonchalance. We tend to

look for phrases or words that are a little tongue-in-cheek and relevant for the present moment. They may be inspired by a film or TV show, or simply something we've heard around the office.' Markham elaborates, 'Slogan T-shirts consistently sell well for us at Topshop in the UK, and sell just as well in all of our international markets. They have a truly universal appeal and can be worn in very different ways. Our slogans vary, so one season we may do quite bold slogans, for instance 'OMG', alongside more feminine slogans, such as 'Bisous' or 'Fall From Grace'. Our slogan T-shirts are always popular.'

Currently high streets encourage non-conformist fashion practices through a 'mix 'n' match' approach to fashion trends, which its relatively low price point facilitates. In a similar way to contemporary pop music, the high street slogan T-shirt borrows, samples, remixes, recycles and fuses different, and sometimes disparate, genres and styles, thus enabling consumers to construct their own niche fashions and adopt an array of personas. And Topshop is one of the premier high street spaces that encourages personal experimentation.

Although self-evidently all high street chains are governed by market forces, the style connoisseur reputation of Topshop incites an epic level of consumer loyalty and, arguably, has become the market standard for leading edge, mainstream fashions and covetable status-led lifestyle products. Furthermore the outward manifestations of Topshop's signature-style décor and packaging, such as its carrier bags and shoe boxes (as designed by illustrator Daisy de Villeneuve) operate as uniforms of affiliation and statuses of taste.

As customers wait for the new season's clothes, the consumer classic — the T-shirt — while democratic although not, as often reported, classless on account of its price spectrum, transpires as a high street commodity manoeuvring and mediated within mainstream fashion as a symptom of changing cultural trends.

According to Markham, the power of slogans is increased when they are adopted by the masses on account of the collective attitude; they are given strength by the number of people who believe in their sentiment. Equally, the command a slogan T-shirt possesses for the individual, who may sport a message that feels personal message to them, is not to be undervalued.

For Topshop the image value of the slogan T-shirt is centred upon its ability to encapsulate the mood of the moment, as Markham elucidates: 'In particular, the slogan T-shirt can be worn *en masse* to draw attention to a particular issue or raise awareness of a charitable cause. At Topshop we tend to focus on the more fun, light-hearted messages, but they can certainly have a very impactful cultural value. The message may be ephemeral in that it is particularly resonant at that point in time, but I think slogan T-shirts will always be around in some guise.'

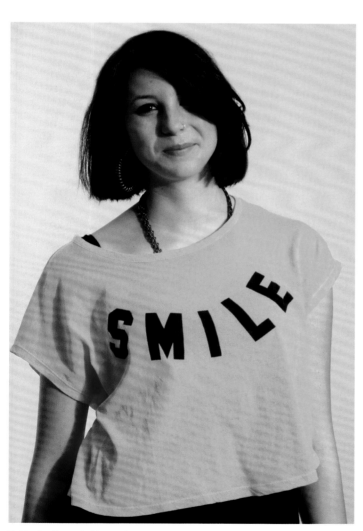

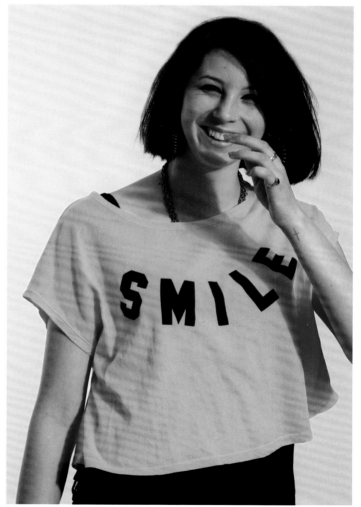

T-shirts kindly supplied by Topshop • Model: Amy Thompson

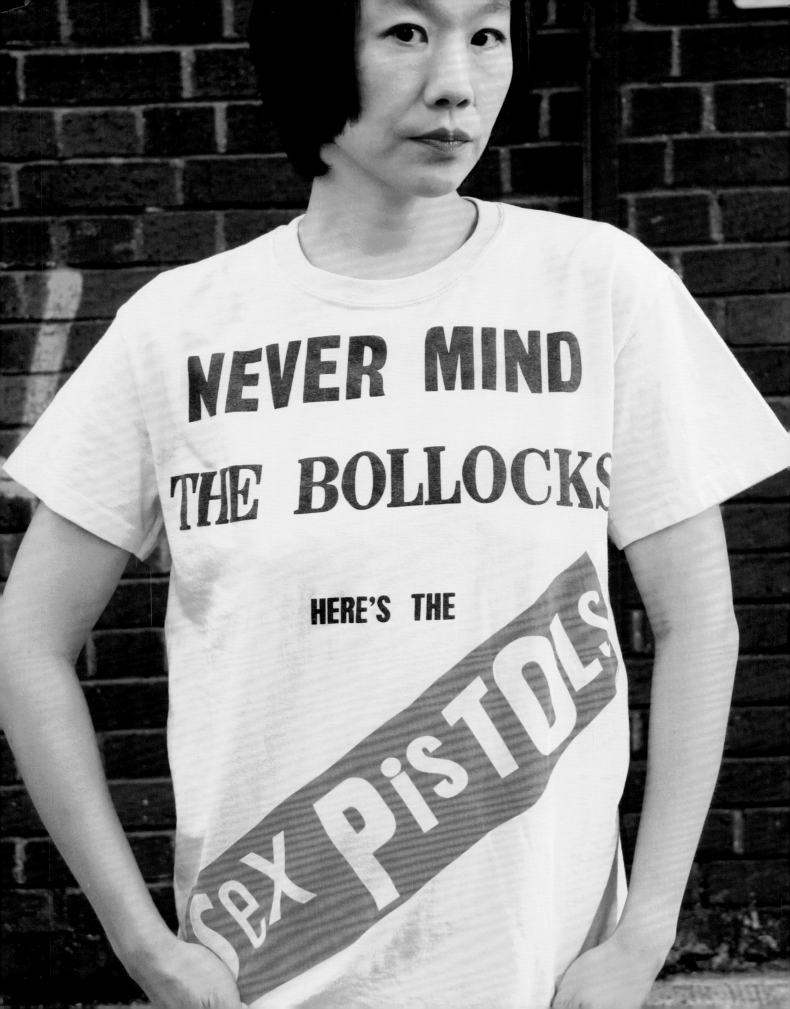